Chantal Akerman//Roland Barthes//Jean Baudrillard//
Raymond Bellour//Anton Giulio Bragaglia//Victor
Burgin//Henri Cartier-Bresson//Gregory Crewdson//
Catherine David//Gilles Deleuze//Régis Durand//
Thierry de Duve//Sergei Eisenstein//Mike Figgis//
Susanne Gaensheimer//Nan Goldin//Tom Gunning//
Siegfried Kracauer//Chris Marker//Jonas Mekas//
Christian Metz//Laura Mulvey//László Moholy-Nagy//
Beaumont Newhall//Uriel Orlow//Pier Paolo Pasolini//
Constance Penley//Richard Prince//Steve Reich//
Carlo Rim//Susan Sontag//Blake Stimson//Michael
Tarantino//Agnès Varda//Jeff Wall//Wim Wenders//
Peter Wollen

The Cinematic

Whitechapel
London
The MIT Press
Cambridge, Massachusetts

Edited by David Campany

THE CINEMATIC

Documents of Contemporary Art

Co-published by Whitechapel and The MIT Press

First published 2007
© 2007 Whitechapel Ventures Limited
Texts © the authors, unless otherwise stated

Whitechapel is the imprint of Whitechapel
Ventures Limited

ISBN 978-0-85488-152-9 (Whitechapel)
ISBN 978-0-262-53288-4 (The MIT Press)

A catalogue record for this book is available from
the British Library

Library of Congress Cataloging-in-Publication Data

The cinematic / edited by David Campany.
 p. cm. – (Documents of contemporary art,
Whitechapel)
Includes bibliographical references and index.
ISBN 978-0-262-53288-4 (pbk. : alk. paper)
1. Cinematography. 2. Photography, Artistic.
3. Whitechapel Art Gallery. I. Campany, David.
TR850.C4685 2007
778.5'3—dc22
 2006033346

10 9 8 7 6 5 4 3 2 1

Series Editor: Iwona Blazwick
Commissioning Editor: Ian Farr
Project Editor: Hannah Vaughan
Designed by SMITH
Printed in Slovenia

Cover: Philip-Lorca diCorcia, *deBruce*, 1999
© Philip-Lorca diCorcia. Courtesy Pace/MacGill
Gallery, New York

Whitechapel Ventures Limited
80-82 Whitechapel High Street
London E1 7QZ
www.whitechapel.org
To order (UK and Europe) call +44 (0)207 522 7888
or email MailOrder@whitechapel.org
Distributed to the book trade (UK and Europe only)
by Cornerhouse
www.cornerhouse.org

The MIT Press
55 Hayward Street
Cambridge, MA 02142
MIT Press books may be purchased at special
quantity discounts for business or sales
promotional use. For information, please email
special_sales@mitpress.mit.edu or write to Special
Sales Department, The MIT Press, 55 Hayward
Street, Cambridge, MA 02142

Documents of Contemporary Art

In recent decades artists have progressively expanded the boundaries of art as they have sought to engage with an increasingly pluralistic environment. Teaching, curating and understanding of art and visual culture are likewise no longer grounded in traditional aesthetics but centred on significant ideas, topics and themes ranging from the everyday to the uncanny, the psychoanalytical to the political.

The Documents of Contemporary Art series emerges from this context. Each volume focuses on a specific subject or body of writing that has been of key influence in contemporary art internationally. Edited and introduced by a scholar, artist, critic or curator, each of these source books provides access to a plurality of voices and perspectives defining a significant theme or tendency.

For over a century the Whitechapel Gallery has offered a public platform for art and ideas. In the same spirit, each guest editor represents a distinct yet diverse approach – rather than one institutional position or school of thought – and has conceived each volume to address not only a professional audience but all interested readers.

Series editor: Iwona Blazwick
Editorial Advisory Board: Roger Conover, Neil Cummings, Emma Dexter, Mark Francis
Commissioning editor: Ian Farr

ART HAS MIMICKED EVERYTHING ABOUT CINEMA

THE
SIZE
THE
SCALE

THE MEANS OF PRODUCTION

THIS GOES BACK TO THE IDEA OF THE MIMETIC IMPULSE IN
ART ITS INSISTENT ATTEMPT TO LOOK LIKE SOMETHING ELSE

David Campany
Introduction//When to be Fast? When to be Slow?

The encounter between two disciplines doesn't take place when one begins to reflect on another, but when one discipline realizes that it has to resolve, for itself and by its own means, a problem similar to one confronted by the other.
– Gilles Deleuze[1]

Film and photography have had perhaps the richest and strangest of relationships among the arts. Their connections run so deep at times that we can barely distinguish between them. Yet, there also seem to be so many strikingly obvious differences. What makes matters even more complex is that across the twentieth century, film and photography have remained significant for each other not just technically but aesthetically and artistically. Each has borrowed from and lent to the other. Each has envied the qualities of the other. And at key moments each has relied upon the other for its self-definition.

The advanced photography and film of the first half of the twentieth century was shaped profoundly by the modern idea of speed. To be contemporary and progressive was to make use of the latest media and be reactive, instantaneous, *fast*. That impulse motivated the kaleidoscopic city films of Dziga Vertov (*Man with a Movie Camera*, 1929) and Walter Ruttmann (*Berlin: Symphony of a Great City*, 1927), the dynamic cutting between shots in avant-garde cinema (see the essay by Sergei Eisenstein) and photography's puruit of the rapid snapshot. If the speed of modernity was experienced as a series of switches in tempo and shocks to perceptual habits, then progressive art was obliged to match and parry with switches and shocks of its own. In the 1920s the *photo-eye* and the *kino-eye* (film-eye) were the driving metaphors for a new and dynamic intimacy between 'man' and optical machine. Old culture, old media, old seeing and old time were to be swept up into an often contradictory mix of technological, social and artistic idealism.

After the Second World War, European and North American culture began to be dominated by the ideologies of mainstream cinema, television, lifestyle culture, saturation advertising and mass distraction. In this new situation speed lost much of its critical edge and most of its artistic credentials. To be radical in this new situation was to be *slow*. A stubborn resistance to the pace of spectacle and money-driven modernization seemed the only creative option and it came to characterize the landmarks of art and film in the latter decades of the last century. Slowness has structured the cinema of Vittorio de Sica, Roberto

Rossellini, Ingmar Bergman, Robert Bresson, Michelangelo Antonioni, Pier Paolo Pasolini, Chantal Akerman, Andrei Tarkovsky, Wim Wenders, Krzysztof Kieslowski, Aleksandr Sokhurov, Bela Tarr, and many others. A drop in tempo was a way to hold on to the decreasing opportunities for serious artistic reflection. Cinema's potential for the uninterrupted long take was cherished for its slowness and its honesty. The slowed look it offered was also a means of meditation on the fraught relationship between the appearance of the world and its meanings. As Wim Wenders once put it: 'When people think they've seen enough of something, but there's more, and no change of shot, then they react in a curiously livid way'.[2]

Resistance to speed was also at the heart of the experimental films of Andy Warhol, Michael Snow, Stan Brakhage, Danièle Huillet and Jean-Marie Straub, Hollis Frampton and others, all of whom took cinema into direct dialogue with the stillness of the photographic image. More recently contemporary video art has shown a compulsion to return to the origins of cinema (in what has been called a 'Lumière drive'). The long shot has become a characteristic of the work of artists such as Bill Viola, Mark Lewis, David Claerbout, Fiona Tan, Gillian Wearing, Fischli and Weiss, Sam Taylor Wood, Shirin Neshat, Victor Burgin, Steve McQueen, Stan Douglas, and others. Much of this too has been lured by the base quality of photographic stillness embedded in the moving image (see the essays by Michael Tarantino and Susanne Gaensheimer).

With the films of the brothers Auguste and Louis Lumière cinema started out as what we might call the depiction of ongoing moments. Their locked off, single reel views stared at the world unfolding or passing before the camera. Their first film to be screened in public, *Workers Leaving a Factory* (1895) was, in effect, a *moving photograph* of a fixed building out of which flowed the people. Soon after, editing or *montage*, so vital to the development of both cinema and photography, opened new possibilities for the construction of a more synthetic time and space. Right from the start the fixity of the still photograph presented challenges – technical and aesthetic – for the depiction of time. Should the medium avoid moving subjects altogether? Should movement be arrested by a quick shutter, as it was in the work of 'chronophotographers' of the late nineteenth century such as Eadweard Muybridge and Étienne-Jules Marey, and then the reportage photographers of the twentieth century? (see the texts by Carlo Rim, Henri Cartier-Bresson and Tom Gunning.) Should movement flow through a long exposure and leave its traces? (see Anton Giulio Bragaglia's writings on Photodynamism.) Does photography have one fundamental relation to time or many? (see Thierry de Duve.) In the introduction to his book *The Decisive Moment* (1952) Cartier-Bresson wrote of the potential of the well-timed snapshot to fuse an elegance of geometry with a poetics of subject matter.

Conjuring epiphanies out of the almost-nothing of the everyday, his photography embodied all that was nimble, quick, light, mobile and reactive about photography. He spoke openly of his debt to movies. Indeed the whole turn towards instantaneous photography in the 1920s and 30s can be seen as a response to the dominance of cinema. Moving images transformed the nature of the photographic image, turning its stillness into *arrestedness*. Where cinema exploited movement, photography could exploit stillness. For several decades the quick snapshot became the basis of amateurism and reportage, defining for mass audiences what was thought essential in the medium. I outline in my own essay reprinted here how in more recent times this idea has been somewhat eclipsed. Few art photographers adhere to its credo, preferring large formats, tripods, preconception and slow deliberation. Meanwhile reportage photography has ceded the role of bearing news to television and the internet. It has all but given up the instantaneous in the process. Instead it has assumed important functions as a second wave of slower representation made after the world's events have happened. Once the epitome of all that was modern, photography now finds itself a relatively simple and primitive medium. Certainly it takes its place as a component in the hybrid stream of contemporary imagery but where it singles itself out – as it does most clearly in contemporary art – it embraces not the moment but slower rhythms of observation and premeditation.

How has cinema understood photography? Raymond Bellour has spoken of the way the cinematic spectator is made *pensive* by the appearance on screen of the still image. Whether it takes the form of a freeze frame or a filmed photograph, the still is a pause in the flow. In such pauses our relation to the image and cinematic time is released from the momentum of movement but restructured by other means. So frequent are the appearances of the still image in cinema that it begs the question of whether film might in fact be fascinated by, or need something from the photograph. Perhaps film sees photography as something it had to give up in order to become what it did. Is it the photograph's stillness that film finds so compelling? Its clarity? Its uncertainty? Its privileged status as record or memory? Its stoicism? Its inscrutibility? Certainly these are the qualities of photography to which filmmakers, both mainstream and avant-garde, have been drawn most often. They are also the qualities that much film theory has focused upon. In her essay Constance Penley makes clear the way influential writers such as Siegfried Kracauer and André Bazin understood cinema as inescapably rooted in the real by way of the indexical status of the photographic image as a trace of its referent in the world. Similarly Roland Barthes, who always preferred the still image to the movies (at least in his writings), made that indexical connection the basis of his views on photography. When he did write about film imagery in the essay 'The Third Meaning',

published in *Artforum* in 1973, it was to consider that aspect of film that does not move: the individual film frame. Barthes' study of stills from the films of Sergei Eisenstein has much in common with Kracauer and Bazin but he proposed something much more unsettling. Photographs, when projected twenty-four frames per second, and structured by the conventions of narrative, captions and sound, 'behave' correctly. Deprive a frame of its place in that order and any amount of latent signification is made manifest. The extracted photograph is anarchic, untamed with a surfeit of radically open meanings. Cinema, Barthes implies, domesticates the essential wildness of photography.

In its assembly of shots, cinematic montage emphasized the partial, fragmentary nature of the single image. And while the single shot is the basis of photography, that singularity was also a problem photography sought to overcome if it was to articulate more complex ideas. Away from the poetic epiphanies of the decisive moment, photography of the inter-war years evolved as an art of assembly, usually on the pages of magazines and books. Most of photography's significant artistic achievements in the twentieth century were not single images but orchestrations of numbers of images. They were serial, sequential or at least rooted in the editing and ordering of parts. We may think of landmark projects such as László Moholy-Nagy's *Painting, Photography, Film* (1925), Germaine Krull's *Métal* (1928), August Sander's *The Face of Our Time* (1929), Albert Renger Patzsch's *The World is Beautiful* (1928), Bill Brandt's *The English at Home* (1936), Walker Evans' *American Photographs* (1938), Alexey Brodovitch's *Ballet* (1945), William Klein's *New York* (1955), Roy de Carava and Langston Hughes' *The Sweet Flypaper of Life* (1955), Ed van der Elsken's *Love on the Left Bank* (1956), Robert Frank's *The Americans* (1958/9), Danny Lyon's *The Bikeriders* (1968), Daido Moriyama's *Bye Bye Photography* (1972), Duane Michals' photo sequence publications or Nan Goldin's *The Ballad of Sexual Dependency* (1986). Most of these were projects conceived as books or magazine spreads, rather than gallery or museum exhibits. Their various forms were in general organized as a 'para-cinema' of the page. Many photographers and magazine editors were influenced directly by cinema's assembly of images and its articulation of time and space. For Moholy-Nagy there was 'no more surprising, yet, in its naturalness and organic sequence, simpler form than the photographic series'. It was for him 'the logical culmination of photography – vision in motion'.[3] Yet, as Blake Stimson points out, the real potential of the photo-sequence lay as much in its difference from narrative cinema. The intrinsic gaps and ruptures between still elements allow the photo-sequence to be allusive and tangential. Indeed, telling a straightforward story with a sequence of stills is notoriously difficult, despite the popularity of cinematic spin-offs such as the photonovel. Static photographs *show* far more than they

tell, so the photo essay relies as much on ellipsis and association as coherent argument or story.

In recent decades, largely through the influence of photographic artists such as Cindy Sherman and Jeff Wall, photography has evolved a new articulation of time very different from the decisive snap and the photo-sequence. Taking its cue from cinema's frames and film stills, a narrative staged photography emerged in art at the end of the 1970s. Blending performance, sculpture, theatre and cinema, the narrative photographic tableau has become one of art photography's most widespread forms and one of its most accomplished characteristics (see the texts by Régis Durand, Catherine David and Jeff Wall). Sherman's references to cinema were explicit, particularly in her still influential series the *Untitled Film Stills*. She blended filmic acting with photographic posing to recast herself in a range of stock femininities familiar from cinema. In one sense her medium was photography but it was also film and her own body. Wall's photographs rarely have the look of cinema or film stills. Nevertheless he grasped early on that all cinematic images are basically photographic and that the collaborative and preparatory image construction typical of narrative cinema could be put at the service of photography.

In the years since art has forced photographic time to fold in on itself. This is most evident where images work allegorically. When allegory returned to photographic art in the 1970s and 1980s it took the form of overt appropriation and quotation (think of the subversive re-photography of Richard Prince and Sherrie Levine, or the semi-cinematic photo-texts of Victor Burgin). It is still present but is now discernible in the diverse ways in which image-makers are in dialogue with different pictorial genres. Few genres are unique to the medium (street photography may be the only one) so working generically inevitably means connecting with painting, cinema, theatre and literature. For example, in their gestures and enactments the photographs of Philip-Lorca diCorcia, Hannah Starkey and Gregory Crewdson forge hybrid visual tableaux from a range of sources. Their references are rarely explicit, rather the images draw from a storehouse of popular imagery past and present. There is a commitment to social description here but in the mixing of artifice and realism the sense of the present is revealed as an accumulation of past experiences.

Binary oppositions are at their most illuminating when they begin to break down. It is then that they reveal to us our motivations for wanting to keep things apart in the first place. Certainly there is a great deal to be gained from thinking in terms of the differences between film and photography. For example Christian Metz's suggestive essay 'Photography and Fetish' shows just how much can be gleaned from a careful and perceptive contrast of the two. Twenty years after it was written Metz's writing still fascinates but now it points us equally towards

the overlaps and commonalities. Is film really a medium of the present while photography is always oriented to the past? Is a film, now that you can buy it and do as you wish with it, any less of an object than a photograph? Is filmic movement implicitly narrative? Is the stasis of the still photograph implicitly anti-narrative? Is the gaze of photography essentially fetishistic while film's is essentially voyeuristic?

In their exchange of enthusiasms and anxieties, the filmmaker Mike Figgis and photographer Jeff Wall discuss the shifting relationship between art and cinema. There are moments when it appears the two are in some kind of stand-off, compelled to signal their differences even while they inform each other. At other moments the boundaries seem to disappear in the fluidity of the dialogue. Wall and others construct images that may involve months or a year of work and great expense. Meanwhile Figgis is one among many directors to take advantage of lightweight digital video to cut budgets, cut crew and cut pre-production in pursuit of more spontaneous and 'independent' ways to make movies. A photographic art shoot may resemble a film set. A film shoot may be almost as invisible as a street photographer. Yet both camps keep their options open. Although there is no correspondence between cost of production and artistic merit, certain images can be achieved cheaply while others require money.

Chris Marker's short film *La Jetée* (1962) has become a touchstone for many reflections on film and photography (see the texts by Agnès Varda, Peter Wollen, Uriel Orlow and Marker himself). Comprised almost entirely of stills this short film subverts all the received oppositions between the two. Half science fiction, half love story, it moves between past, present and future, between fantasy and reality, between lived time and the time of the imagination. Marker draws almost unlimited potential from the apparent restrictions of the simple photographic sequence and voice-over. However what has made *La Jetée* compelling for so many image makers and writers has as much to do with its themes as its form. It is one of cinema's (and one of photography's) most profound reflections on the trauma of loss, the status of history, the enigma of desire and the place of images in the making and unmaking of our sense of self. As questions of time and memory have come to dominate discussions of visual culture, Marker's short film occupies a unique place.

Laura Mulvey discusses the ways in which the history of cinema is being reconfigured by new viewing. In many ways all media are historicized through newer technologies. Modern art history was made possible firstly by the displacement and assembly implicit in the museum, then by photographic reproduction and publication. Similarly, cinema studies got going in the 1970s when academics gained access to tabletop Steenbeck viewers. No longer was it necessary to sit in the dark and take in everything in one viewing. The field

blossomed soon after in the era of seminar room video playback. Movies could be stopped, started, forwarded, reversed and repeated at will. For a while cinema studies preserved the fantasy of the integral film (because that was how the general public still encountered film) even while it took them apart and analysed them bit by bit. But that position is now untenable, such is the extent to which the new methods of viewing are reshaping the old objects. Cinema is now atomized not just by specialists but in its general consumption via domestic video and DVD. At the same time film and photography are aligning themselves like never before as they come increasingly to share the same technological base. Most new digital cameras shoot photos and movies which hybridize in our experience of the computer screen and internet.

For nearly a century film was identified with a particular mode of viewing: *the cinema*. It had a big screen, dimmed lighting, rows of seats and a characteristic means of cultural and economic organization. Photography, on the other hand, was always much more dispersed. It spread rapidly through a multitude of forms – books, albums, archives, magazines, postcards, posters and all the rest. Today however the cinema is only one among many contexts in which films are viewed. The large auditorium takes its place alongside television, computer screens, in-flight entertainment, lobbies, shop windows, galleries and mobile phones. Together they form what Victor Burgin calls in his essay a 'cinematic heterotopia' – a network of separate but overlapping interfaces and viewing habits. In this environment films are as likely to be viewed in fragments as whole, across a spectrum of attention that runs from the indifferent absorption of bits and pieces to highly specialized and active 'reading' of films. Burgin proposes we think of memory in terms of short 'sequence-images' composed according to the displacements and condensations typical of dream logic. For all Hollywood's obsession with narrative and perfect endings, films are not remembered that way. They intersect with the complexities of our lived experience through unconscious processes governed by the *psychical* rather than the *physical* laws of time and space. Belonging neither to the chronology of film narrative nor the arrest of the photographic still, Burgin's concept points us beyond one of the great myths of our time, that photography is somehow instrinsically closer to the processes of memory than film.

With all the recent revolutions in the making and viewing of film and photography it is not unreasonable to think that we are in a period of unprecedented change. Nevertheless unprecedented change has been the very nature of modernity, which has taken film and photography as its defining modes of expression. Nearly every history of film and photography, whether written in the 1920s or last year, has ended with a prediction of great change to come. Sound, colour, television, video, digitization, the internet, along with the

turns in economic and political climate, have all brought crises and renewal. It is the nature of these media, if we can call them that, to remain permanently unsettled. The essays gathered here are a testament and a guide to that restlessness.

1 Gilles Deleuze, 'The Brain is the Screen. An interview with Gilles Deleuze', in Gregory Flaxman, ed., *The Brain is the Screen: Deleuze and the Philosophy of Cinema* (London: Routledge, 1997).
2 Wim Wenders, 'Time Sequences: Continuity of Movement' (1971), reprinted in this volume, 88–90.
3 László Moholy-Nagy, 'Image sequences; series' (1946), reprinted in this volume, 83.

I AM A CAMERA

I am a camera with its shutter open, quite passive, recording, not thinking. Recording the man shaving at the window opposite and the woman in the kimono washing her hair. Some day, all this will have to be developed, carefully printed, fixed

Christopher Isherwood, *Goodbye to Berlin*, 1939

MOTION PICTURES

Tom Gunning
Never Seen This Picture Before: Muybridge in Multiplicity//2003

Shortly after his death Eadweard Muybridge received the title 'father of the motion picture'.[1] Although Muybridge himself, a few years before he died, made the connection between his photographic records of human beings and animals in motion and newly appearing devices such as the Kinetoscope, Vitascope and Cinématographe, there is little doubt that he would have been surprised by the suggestion that these inventions were the culmination of his work.[2] Nor should an exploration of Muybridge in relation to the history of cinema take such a narrow view, regarding his work as significant only in so far as it serves as harbinger of the work of Thomas Edison and the Lumière brothers, let alone that of Orson Welles, Stan Brakhage or Steven Spielberg.

A case of disputed paternity

As if questionable paternity were fated to pursue Muybridge both literally and figuratively in life and beyond the grave, the epithet 'father' must be deemed problematic from almost every point of view. The term drags with it a biological teleology that recent approaches to history strive to avoid, not to mention more than a hint of patriarchalism. Further, what is meant by 'motion pictures' stands in need of explication, a task that reveals a great deal about the ambivalent nature of Muybridge's innovations and pictures, which evoke or represent motion in a number of different manners. One might claim that to see Muybridge as the father of the film industry constricts the nature of his work rather than expands it, given that his photography relates more strongly to late nineteenth-century painting and sculpture, the science of physiology, the technical development of still photography, not to mention social ideas about gender and the body, than it does to the future development of Hollywood. But rather than dismissing Muybridge's position in relation to the origins of motion pictures, the task becomes one of redefinition, examining the ambiguities of the myths of origin in order to discover a broader understanding of motion pictures.

Rather than a bearded patriarch, a certified point of paternity, Muybridge appears as a sort of crazy uncle, the site of many intersections between photography, science, art and new forms of mass entertainment. The image of Eadweard Muybridge haunts us, beckoning to us from the space between things, the interstices and gaps that appear, unexpectedly, within actions and between instants.

It was Muybridge, more than any other figure, who introduced what Walter

Benjamin, decades later, termed 'the optical unconscious', revealing that much of everyday life takes place beneath the threshold of our conscious awareness:

> Even if one has a general knowledge of the way people walk, one knows nothing of a person's posture during the fractional second of a stride. The act of reaching for a lighter or a spoon is a familiar routine, yet we hardly know what really goes on between hand and metal, not to mention how this fluctuates with our moods. Here the camera intervenes with the resources of its lowerings and liftings, its interruptions and isolations, its extensions and accelerations, its enlargements and reductions. The camera introduces us to unconscious optics as does psychoanalysis to unconscious impulses.[3]

Benjamin wrote in the 1930s, aware that the camera had first filtered such unconscious behaviour through the lens of instantaneous photography, demonstrating for all to see what really happens while our bodies walk and our minds are elsewhere.

By the late nineteenth century the optical devices of modern science that first appeared in the seventeenth century had already explored both the infinitesimal and the extraterrestrial through the optics of enlargement, but these discoveries of the previously unseen were spatially removed into realms outside human experience, due either to vast distance or microscopic size. Muybridge, in contrast, conquered time, rather than spanning or penetrating space, as he exposed the tiniest intervals of motion. His discoveries rely upon a modern rational and scientific mastery of space and time in which each has been calculated and charted in relation to the other. This modern conception of a unified, standardized and measurable space and time formed the basis not only for pure scientific research but also for claims of private property and calculation of industrial efficiency. Muybridge's photography also makes visible a drama that would otherwise remain invisible: the physical body navigating this modern space of calculation. His images of the nude human body framed within a geometrically regular grid capture the transformations of modern life brought on by technological change and the new space/time they inaugurated, as naked flesh moves within a hard-edged, rational framework.

Hollis Frampton has described the extraordinary abstraction of the space of Muybridge's later photographs: 'a uniform grid of Cartesian coordinates, a kind of universal "frame of reference", ostensibly intended as an aid in reconciling the successive images with chronometry, that also destroys all sense of scale (the figures could be pagan constellations in the sky), and utterly obliterates the tactile particularity that is one of photography's paramount traits, thereby annihilating any possible feeling of place.'[4] If this all-too-visible contrast of flesh

and abstraction seems too melodramatic, let us recall again the essentially interstitial nature of Muybridge's work. He remains a figure poised between paradigms, operating in the ambiguous interval that separates (or possibly joins) different discourses.

First of all, Muybridge was an accomplished artist working in a new medium whose technical demands served as arguments both for and against its truly being an artform. As a photographer and artist he is best known for his work that had scientific aspirations. In an era in which art and science appeared to flirt with each other before finalizing what seemed like an ultimate divorce, Muybridge's straddling of artistic and scientific practice may provide an object lesson. In this respect, his difference from a trained scientist like Étienne-Jules Marey, so clearly pointed out by Marta Braun, does not make him any less fascinating and may in fact be essential in defining his uniquely ambiguous fascination.[5]

Secondly, Muybridge's work as both artist and scientist addresses peculiarly modern issues of visibility. From the scientific point of view, he offered his photographs as visible evidence. But photography here intersects with an issue that had haunted scientific representation ever since the microscope and telescope. If the human serves as the model of the visual, how does this term apply to images that the human eye cannot see without mediation? The claim (always disputed, even if widely accepted) that photography offered a record of human vision reaches one of several crises with Muybridge's work and with instantaneous photography generally. What sort of image was a photograph that showed something the eye could not verify? This and related questions opened a complex theoretical issue, which Muybridge's own practices served to make even more complex. What in a photograph makes it evidence, and in what way is this evidence visual? While these issues remain vexed even today, Muybridge had to confront them in a manner that called into question the assumed meanings of these terms. Thus the ambiguities of visual evidence reach back in many ways to his contested position between the artistic and the scientific.

Thirdly, let us return to our starting point, the claim that Muybridge was the 'father of motion pictures'. If this claim is to have any meaning beyond the wrangling of lawyers in early twentieth-century patent suits, it must confront the interaction between stillness and movement in Muybridge's work. How significant is the actual projection of motion pictures by his zoopraxiscope, and where does that significance lie? If Muybridge is to be seen as inspiring Edison, does this offer another figure with whom he can be compared: the inventor and entrepreneur? Artist, scientist, showman – Muybridge was none of these exclusively but worked in relation to all of them. Likewise, his 'motion pictures' must be approached through their interstitial nature. They existed both as still

images and, in certain conditions, as illusions of motion, but always as pictures that had been animated, images whose trick of taking on life was demonstrated to the audience, never taken for granted.

Finally, as the harbinger of the optical unconscious, Muybridge simultaneously analysed motion into its components, like a good scientist, and then re-endowed it mechanically with motion, which fools our eyes. His art employs almost contradictory energies, seizing and parsing out motion into still images, then accumulating these individual images at such a rate of speed that they seem once more to move. There is something obsessive about this circular fascination, something that almost recalls Penelope weaving and unweaving her tapestry. This final antinomy, the exploration of the zone between stillness and motion, may supply us with a key to Muybridge's fascination for the contemporary viewer. For surely he is what we make of him, and what has been made of him varies from generation to generation and context to context. I believe that for recent generations of American artists Muybridge served as a model of a way to move beyond art as self-expression towards an art that, flirting again with science, seeks to demonstrate its essential conditions. If this seems to arc back to an image of Muybridge as scientist, however, that may be an illusion. It may be what the photograph does not show, what cannot be seen, that truly constitutes the optical unconscious. [...]

1 The creation of Muybridge's reputation as the father or inventor of motion pictures is traced in Robert B. Haas, *Muybridge: Man in Motion* (Berkeley and Los Angeles: University of California Press, 1976) 187–203, with the first such claims appearing in 1910 through Muybridge's friend and advocate Benjamin Carter. The earliest use of the term *father* Haas cites comes from F.A. Talbot's 1914 book *Moving Pictures*. It has a long career after that, culminating in Gordon Hendricks, *Eadweard Muybridge: The Father of the Motion Picture* (New York: Grossman Publishers, 1975).

2 See Muybridge's letter to the British *Journal of the Camera Club*, printed in the 9 November 1897 issue, quoted in Haas, op. cit., 185. Muybridge reiterated these claims in the prefaces to his last publications, *Animals in Motion* (1899) and *The Human Figure in Motion* (1901). In spite of his printed claims of priority in motion picture devices, Carter admitted that 'he looked upon the invention of the motion pictures as a mere incident in his work of investigation of animal movements for the purposes of science and art'. (Haas, op. cit., 189.)

3 Walter Benjamin, 'The Work of Art in the Age of Mechanical Reproduction' (1935), in *Illuminations*, ed. Hannah Arendt, trans. Harry Zohn (New York: Schocken Books, 1969) 237.

4 Hollis Frampton, 'Eadweard Muybridge: Fragments of a Tesseract', in Frampton, *Circles of Confusion: Film, Photography, Video: Texts, 1968–1980* (Rochester: Visual Studies Workshop, 1983) 77.

5 Marta Braun, *Picturing Time: The Work of Étienne-Jules Marey* (1830–1904) (Chicago:

University of Chicago Press, 1992), esp. 232–56. In case it is not obvious, I want to acknowledge how much Braun's work has inspired this essay.

Tom Gunning, 'Never Seen This Picture Before: Muybridge in Multiplicity', in Phillip Prodger, ed., *Time Stands Still: Muybridge and the Instantaneous Photography Movement* (New York: Oxford University Press, 2003) 223–8.

Anton Giulio Bragaglia
Futurist Photodynamism//1913

To begin with, Photodynamism cannot be interpreted as an innovation applicable to photography in the way that chronophotography was.[1] Photodynamism is a creation that aims to achieve ideals that are quite contrary to the objectives of *all* the representational means of today. If it can be associated at all with photography, cinematography and chronophotography, this is only by virtue of the fact that, like them, it has its origins in the wide field of photographic science, the technical means forming common ground. All are based on the physical properties of the camera.

We are certainly not concerned with the aims and characteristics of cinematography and chronophotography. We are not interested in the precise reconstruction of movement, which has already been broken up and analysed. We are involved only in the area of movement which produces sensation, the memory of which still palpitates in our awareness.

We despise the precise, mechanical, glacial reproduction of reality, and take the utmost care to avoid it. For us this is a harmful and negative element, whereas for cinematography and chronophotography it is the very essence. They in turn overlook the trajectory, which for us is the essential value.

The question of cinematography in relation to us is absolutely idiotic, and can only be raised by a superficial and imbecilic mentality motivated by the most crass ignorance of our argument.

Cinematography does not trace the shape of movement. It subdivides it, without rules, with mechanical arbitrariness, disintegrating and shattering it without any kind of aesthetic concern for rhythm. It is not within its coldly mechanical power to satisfy such concerns.

Besides which, cinematography never analyzes movement. It shatters it in the frames of the film strip, quite unlike the action of Photodynamism, which analyses movement precisely in its details. And cinematography never synthesizes movement, either. It merely reconstructs fragments of reality, already coldly broken up, in the same way as the hand of a chronometer deals with time even though this flows in a continuous and constant stream.

Photography too is a quite distinct area; useful in the perfect anatomical reproduction of reality; necessary and precious therefore for aims that are absolutely contrary to ours, which are artistic *in themselves*, scientific in their researches, but nevertheless always directed towards art.

And so both photography and Photodynamism possess their own singular

qualities, clearly divided, and are very different in their importance, their usefulness and their aims.

Marey's chronophotography, too, being a form of cinematography carried out on a single plate or on a continuous strip of film, even if it does not use frames to divide movement which is already scanned and broken up into instantaneous shots, still shatters the action. The instantaneous images are even further apart, fewer and more autonomous than those of cinematography, so that this too cannot be called analysis.

In actual fact, Marey's system is used, for example, in the teaching of gymnastics. And out of the hundred images that trace a man's jump, the few that are registered are just sufficient to describe and to teach to the young the principal stages of a jump.

But although this may be all very well for the old Marey system, for gymnastics and other such applications, it is not enough for us. With about five extremely rigid instantaneous shots we cannot obtain even the *reconstruction* of movement, let alone the *sensation*. Given that chronophotography certainly does not reconstruct movement, or give the sensation of it, any further discussion of the subject would be idle, except that the point is worth stressing, as there are those who, with a certain degree of elegant malice, would identify Photodynamism with chronophotography, just as others insisted on confusing it with cinematography.

Marey's system, then, seizes and freezes the action in its principal stages, those which best serve its purpose. It thus describes a theory that could be equally deduced from a series of instantaneous photographs. They could similarly be said to belong to different subjects, since, if a fraction of a stage is removed, no link unites and unifies the various images. They are *photographic, contemporaneous*, and appear to belong to *more* than one subject. To put it crudely, chronophotography could be compared with a clock on the face of which only the quarter hours are marked, cinematography to one on which the minutes too are indicated, and Photodynamism to a third on which are marked not only the seconds, but also the *intermovemental* fractions existing in the passages between seconds. This becomes an almost infinitesimal calculation of movement.

In fact it is only through our researches that it is possible to obtain a vision that is proportionate, in terms of the strength of the images, to the very tempo of their existence, and to the speed with which they have lived in a space and in us.

The greater the speed of an action, the less intense and broad will be its trace when registered with Photodynamism. It follows that the slower it moves, the less it will be dematerialized and distorted.

The more the image is distorted, the less real it will be. It will be more ideal and lyrical, further extracted from its personality and closer to *type*, with the

same evolutionary effect of distortion as was followed by the Greeks in their search for their type of beauty.

There is an obvious difference between the photographic mechanicality of chronophotography – embryonic and rudimentary cinematography – and the tendency of Photodynamism to move away from that mechanicality, following its own ideal, and completely opposed to the aims of all that went before (although we do propose to undertake our own scientific researches into movement).

Photodynamism, then, analyses and synthesizes movement at will, and to great effect. This is because it does not have to resort to disintegration for observation, but possesses the power to record the continuity of an action in space, to trace in a face, for instance, not only the expression of passing states of mind, as photography and cinematography have never been able to, but also the shifting of volumes that results in the immediate transformation of expression.

A shout, a tragical pause, a gesture of terror, the entire scene, the complete external unfolding of the intimate drama, can be expressed in one single work. And this applies not only to the point of departure or that of arrival – nor merely to the intermediary stage, as in chronophotography – but continuously, from beginning to end, because in this way, as we have already said, the *intermovemental* stages of a movement can also be invoked.

In fact, where scientific research into the evolution and modelling of movement are concerned, we declare Photodynamism to be exhaustive and essential, given that no precise means of analysing a movement exists (we have already partly examined the rudimentary work of chronophotography).

And so – just as the study of anatomy has always been essential for an artist – now a knowledge of the paths traced by bodies in action and of their transformation in motion will be indispensable for the painter of movement.

In the composition of a painting, the optical effects observed by the artist are not enough. A precise analytical knowledge of the essential properties of the effect, and of its causes, is essential. The artist may know how to synthesize such analyses, but within such a synthesis the skeleton, the precise and almost invisible analytical elements, must exist. These can only be rendered visible by the scientific aspect of Photodynamism.

In fact, every vibration is the rhythm of infinite minor vibrations, since every rhythm is built up of an infinite quantity of vibrations. In so far as human knowledge has hitherto conceived and considered movement in its *general rhythm*, it has fabricated, so to speak, an algebra of movement. This has been considered *simple and finite* (cf. Spencer: First *Principles – The Rhythm of Motion*).[2] But Photodynamism has revealed and represented it as *complex*, raising it to the level of an *infinitesimal calculation of movement* (see our latest works, e.g., *The Carpenter, The Bow, Changing Positions*).

Indeed, we represent the movement of a pendulum, for example, by relating its speed and its tempo to two orthogonal axes.

We will obtain a continuous and infinite sinusoidal curve. But this applies to a theoretical pendulum, an immaterial one. The representation we will obtain from a material pendulum will differ from the theoretical one in that, after a longer or shorter (but always *finite*) period, it will stop.

It should be clear that in both cases the lines representing such movement are continuous, and do not portray the reality of the phenomenon. In reality, these lines should be composed of an infinite number of minor vibrations, introduced by the resistance of the point of union. This does not move with smooth continuity, but in a jerky way caused by infinite coefficients. Now, a *synthetic* representation is more effective, even when its essence envelops an *analytically divisionist* value, than a synthetic impressionist one (meaning divisionism and impressionism in the philosophical sense). In the same way the representation of realistic movement will be much more effective in synthesis – containing in its essence an analytical divisionist value (e.g., *The Carpenter, The Bow*, etc.), than in analysis of a superficial nature, that is, when it is not minutely interstatic but expresses itself only in successive static states (e.g.. *The Typist*).

Therefore, just as in Seurat's painting the essential question of chromatic divisionism (synthesis of effect and analysis of means) had been suggested by the scientific inquiries of Ogden Rood, so today the need for movemental divisionism, that is, synthesis of effect and analysis of means in the painting of movement, is indicated by Photodynamism. But – and this should be carefully noted – this analysis is infinite, profound and sensitive, rather than immediately perceptible.

This question has already been raised by demonstrating that, just as anatomy is essential in static reproduction, so the anatomy of an action – intimate analysis – is indispensable in the representation of movement. This will not resort to thirty images of the same object to represent an object in movement, but will render it *infinitely multiplied and extended*, while the figure *present* will appear *diminished.*

Photodynamism, then, can establish results from positive data in the construction of moving reality, just as photography obtains its own positive results in the sphere of static reality.

The artist, in search of the forms and combinations that characterize whatever state of reality interests him, can, by means of Photodynamism, establish a foundation of experience that will facilitate his researches and his intuition when it comes to the dynamic representation of reality. After all, the steady and essential relationships which link the development of any real action with artistic conception are indisputable, and are affirmed independently of formal analogies with reality.

Once this essential affinity has been established, not only between artistic conception and the representation of reality, but also between artistic conception and application, it is easy to realize how much information dynamic representation can offer to the artist who is engaged in a profound search for it.

In this way light and movement in general, light acting as movement, and hence the movement of light, are revealed in Photodynamism. Given the transcendental nature of the phenomenon of movement, it is only by means of Photodynamism that the painter can know what happens in the intermovemental states, and become acquainted with the *volumes of individual motions*. He will be able to analyse these in minute detail, and will come to know the *increase in aesthetic value of a flying figure*, or its *diminution*, relative to light and to the dematerialization consequent upon motion. Only with Photodynamism can the artist be in possession of the elements necessary for the construction of a work of art embodying the desired synthesis. [...]

1 Chronophotography was a technique developed in the 1880s by the French physiologist Étienne Jules Marey (1830–1904). Using a camera designed to make instantaneous, repeating exposures, he captured on a single photographic plate the sequential stages of human and animal movement. Marey's chromophotographs were well known to French painters and to the Italian futurist painters.

2 Herbert Spencer (1820–1903), a British philosopher and sociologist, was the author of *First Principles of a New System of Philosophy* (1862). A chapter of the book, 'The Rhythm of Motion', examined the importance of movement in every field of life phenomena.

Anton Giulio Bragaglia, *Fotodinamismo futurista* (Rome: Natala Editore, 1913) 18–26; 28–31; trans. Caroline Tisdall, in Christopher Phillips, ed., *Photography in the Modern Era: European Documents and Critical Writings, 1913–1940* (New York: The Metropolitan Museum of Art, 1989) 287–92.

Sergei Eisenstein
Montage is Conflict//1929

The shot is by no means an *element* of montage.

The shot is a montage *cell.*

Just as cells in their division form a phenomenon of another order, the organism or embryo, so, on the other side of the dialectical leap from the shot, there is montage.

By what, then, is montage characterized and, consequently, its cell – the shot?

By collision. By the conflict of two pieces in opposition to each other. By conflict. By collision.

Before me lies a crumpled yellowed sheet of paper. On it is a mysterious note: 'Linkage – P' and 'Collision – E'.

This is a substantial trace of a heated bout on the subject of montage between P (Pudovkin) and E (myself).

This has become a habit. At regular intervals he visits me late at night and behind closed doors we wrangle over matters of principle. A graduate of the Kuleshov school, he loudly defends an understanding of montage as a *linkage* of pieces. Into a chain. Again, 'bricks'. Bricks, arranged in series to *expound* an idea.

I confronted him with my viewpoint on montage as a *collision.* A view that from the collision of two given factors *arises* a concept.

From my point of view, linkage is merely a possible *special* case.

Recall what an infinite number of combinations is known in physics to be capable of arising from the impact (collision) of spheres. Depending on whether the spheres be resilient, non-resilient or mingled. Amongst all these combinations there is one in which the impact is so weak that the collision is degraded to an even movement of both in the same direction.

This is the one combination which would correspond with Pudovkin's view.

Not long ago we had another talk. Today he agrees with my point of view. True, during the interval he took the opportunity to acquaint himself with the series of lectures I gave during that period at the State Cinema Institute ...

So, montage is conflict.

As the basis of every art is conflict (an 'imagist' transformation of the dialectical principle). The shot appears as the *cell* of montage. Therefore it also must be considered from the viewpoint of *conflict.*

Conflict within the shot is potential montage, in the development of its intensity shattering the quadrilateral cage of the shot and exploding its conflict into montage impulses *between* the montage pieces. As, in a zigzag of mimicry,

the *mise-en-scène* splashes out into a spatial zigzag with the *same* shattering. As the slogan, 'All obstacles are vain before Russians', bursts out in the multitude of incident of *War and Peace.*

If montage is to be compared with something, then a phalanx of montage pieces, of shots, should be compared to the series of explosions of an internal combustion engine, driving forward its automobile or tractor: for, similarly, the dynamics of montage serve as impulses driving forward the total film.

Conflict within the frame. This can be very varied in character: it even can be a conflict in – the story. As in that 'prehistoric' period in films (although there are plenty of instances in the present, as well), when entire scenes would be photographed in a single, uncut shot. This, however, is outside the strict jurisdiction of the film-form.

These are the 'cinematographic' conflicts within the frame:

Conflict of graphic directions.

(Lines – either static or dynamic)

Conflict of scales.

Conflict of volumes.

Conflict of masses.

(Volumes filled with various intensities of light)

Conflict of depths.

And the following conflicts, requiring only one further impulse of intensification before flying into antagonistic pairs of pieces:

Close shots and long shots.

Pieces of graphically varied directions. Pieces resolved in volume, with pieces resolved in area.

Pieces of darkness and pieces of lightness.

And lastly there are such unexpected conflicts as:

Conflicts between an object and its dimension – and conflicts between an event and its duration.

These may sound strange, but both are familiar to us. The first is accomplished by an optically distorted lens, and the second by stop-motion or slow-motion.

The compression of all cinematographic factors and properties within a single dialectical formula of conflict is no empty rhetorical diversion. We are now seeking a unified system for methods of cinematographic expressiveness that shall hold good for all its elements. The assembly of these into series of common indications will solve the task as a whole. Experience in the separate elements of the cinema cannot be absolutely measured.

Whereas we know a good deal about montage, in the theory of the shot we are still floundering about amidst the most academic attitudes, some vague

tentatives, and the sort of harsh radicalism that sets one's teeth on edge. To regard the frame as a particular, as it were, molecular case of montage makes possible the direct application of montage practice to the theory of the shot.

And similarly with the theory of lighting. To sense this as a collision between a stream of light and an obstacle, like the impact of a stream from a fire-hose striking a concrete object, or of the wind buffeting a human figure, must result in a usage of light entirely different in comprehension from that employed in playing with various combinations of 'gauzes' and 'spots'.

Thus far we have one such significant principle of conflict: *the principle of optical counterpoint.*

And let us not now forget that soon we shall face another and less simple problem in counterpoint: *the conflict in the sound film of acoustics and optics.*

Sergei Eisenstein, from 'The Cinematographic Principle and the Ideogram' (1929); trans. Jay Leyda, in Leyda, ed., *Film Form* (New York: Harcourt Brace, and World Inc., 1949); reprinted edition (New York: Meridien Books, 1957) 37–40.

Michael Tarantino
A Few Brief Moments of Cinematic Time//1999

Suddenly

The importance of cutting and editing as a creative process was perhaps the most widely recognized revelation of *Potemkin*. The sensation of fear on the quarter-deck, panic and machine-like murder on the steps, tension on the waiting ship could only have been communicated by this revolutionary cutting method. What must be remembered is that the total construction and the frame compositions of *Potemkin* ... were gauged and carried out with most of the eventual juxtapositions in mind.'[1]

Jay Leyda goes on to say that before Eisenstein the progression of a film had depended on the 'logical' development of shots from beginning to end. 'Eisenstein now created a new film-rhythm by adding to this content the sharply varying lengths and free associations of the shots, a technique growing directly from his interest in psychological research.'[2]

What I remember most vividly from repeated viewings of *Battleship Potemkin* (1925) is not the Odessa Steps sequence, not the baby pram rolling down those steps amid the slaughter, not the broken glasses of the screaming woman, not the stone lions coming to life ... it is the single intertitle announcing the Steps sequence, the emotional and historical climax of the film: SUDDENLY.

It was as if this word, signifying an abrupt change in space and time, also inititiated another kind of vision that would be necessary to see, to read what was to follow. One needed to follow these images not merely chronologically, but associatively. SUDDENLY, one's whole notion of spatial and temporal continuity was shattered. Eisenstein's purposeful combination of events that were happening successively and simultaneously forces the spectator to construct another time frame: one which is bound by the limits of the film and not by the always doomed attempt to mimic real time.

Out of the blue

This [the shower sequence in Hitchcock's *Psycho*] is the most violent scene of the picture. As the film unfolds, there is less violence because the harrowing memory of this initial killing carries over to the suspenseful passages that come later.[3]

Psycho's equivalent of *Potemkin's* SUDDENLY is the moment when Marion Crane (Janet Leigh) is taking a shower and we see, through the shower curtain, a figure enter the room. Like *Potemkin*, from that moment on, our position as

viewer is inalterably changed. We have been watching the film develop in a relatively straightforward manner (woman having an affair, steals some money, flees and takes refuge at a motel, etc.) and 'suddenly' everything changes, ('I think that the thing that appealed to me and made me decide to do the picture was the suddenness of the murder in the shower, coming, as it were, out of the blue'.)[4] Shots are coming at us at a speed which sharply contrasts with the slow pace of the film up to that point; and the actress, the star of the film, is being killed, after less than half its running length; and it is brutally direct, even if there is not actually a shot of the knife cutting her body. The hand slipping down the tiles on the wall, the shower curtain breaking away from its hooks, the screams, the Bernard Hermann music ... all of this makes an indelible impression on the viewer, makes his/her experience of the rest of the film's narrative a voyage through a kind of dream landscape, in which time is always measured by the possibility of another violent eruption of shots.

When Hitchcock talks about the viewer's sensation of time passing being conditioned by memory, i.e. the shock of experiencing speed (usually communicated by montage) or the pleasure of experiencing slowness (the long take, the moving camera), he is really talking about a kind of anticipation. We expect a rhythm based on what we have seen.

Douglas Gordon's *24 Hour Psycho* (1993) is, of course, a reversal of this procedure. Here the artist plays on our memory of the original film (just as Gus Van Sant does in his almost shot-by-shot 'remake' of 1998) by extending the entire time frame to that of a twenty-four hour day. Thus sequences which we have experienced as 'slow' become even more attenuated. 'Fast' sequences, such as the shower scene, become excruciatingly 'slow' with, paradoxically, the violence achieving levels of shock which, for some, may surpass the original. Gordon shows that it is not just a succession of fast images which can jolt the spectator into another time rhythm: it is the combination of speeds and the interplay between the film and where we think we are going.

Washing dishes: anxiety and reality

And now, only one more remark on the problem of anxiety. Neurotic anxiety has changed in our hands into realistic anxiety, into fear of particular external situations of danger. But we cannot stop there, we must take another step – though it will be a step backward. We ask ourselves what it is that is actually dangerous and actually feared in a situation of danger of this kind. It is plainly not the injury to the subject as judged objectively, for this need be of no significance psychologically, but something brought about by it in the mind.[5]

In Chantal Akerman's *Jeanne Dielman, 23 Quai du Commerce, 1080 Bruxelles*

(1975), one has a completely different sensation of time. A tip-off of what is to come may be found in the title, which is simply the address of the subject of the film, complete with postal code. Akerman's 'portrait of a life (and she would later use excerpts from *Jeanne Dielman* in her own *Self-Portrait* video installation in 1998) extends the viewer's notion of completeness, of time itself. Jeanne taking a bath, Jeanne washing the dishes, cleaning the house ... these events, normally excised from film narratives or greatly reduced, seem to take place in real time.

When I first saw the film at the Museum of Modern Art, New York, in 1975, many of the viewers left during the screening, unable to deal with its three hour and twenty minute length and its 'demands' on them. Perhaps they were unable to see where the narrative was leading. Perhaps they could not make sense of why these 'non-narrative' events were elevated to such an important level. Those who did stay, however, let out a collective scream at the climax of the film, when Jeanne, who has, by this time, been revealed as a prostitute, kills one of her clients. This moment of extreme action and violence is made all that more effective by the static moments that have preceded it. The anxiety produced by our watching time pass for three hours sets us up for the horrendous event that is to come. It is as if the consequences of a conscious tracking of time are inescapable: fear and anxiety lead to violence.

Invisible man / blind spots

In James Coleman's *La tache aveugle* (1978/90), a scene from James Whale's film *The Invisible Man* (1933) is broken down, through the use of two, computer-driven slide projectors, into what appears to be an abstract image. A shot which, in the original film, takes a fraction of a second, is extended to eight hours. What is curious about Coleman's choice of shots is that it is, in fact, one of the least important, at least in diegetic terms, shots of the film. As the invisible man flees the townspeople, he goes into a barn. The camera moves past a column, a stack of hay in the background, finally to settle on the spot where he lays down (which we see by the indentation on the hay). The first part of this shot, when we first see the inside of the barn – the one that Coleman has chosen – is already 'forgotten' as the narrative comes to a sudden climax.

By drawing out that moment, that establishing shot, the artist renders the very act of seeing to be problematic. It is a moment which is almost 'out of time'. The artist fetishizes it by making us regard an image we cannot read, cannot, with any degree of certainty, describe. The fact that the image is changing, through the use of a series of dissolves, over the course of eight hours, makes it even more enigmatic. We expect clarity to be a function of change. We expect to be able to decipher the (nearly) static image. We expect time to empower our

sense of vision, but it does not. It only reveals our blind spot (*tache aveugle*), our inability comprehensively to see or understand a given image.[6]

A few moments in time

In Willie Doherty's installation *Somewhere Else* (1998), one screen shows the city lights at night in the distance. We cannot tell where we are until, periodically, the headlights of a car illuminate the road and the hill overlooking Derry, Northern Ireland.

In Sergio Leone's *Once Upon a Time in the* West (1968), the opening credit sequence extenuates a brief moment in time to ten minutes, as a gang of killers waits for the train to arrive in a deserted station.

Michelangelo Antonioni's *L'Aventura* (1960), in which the heroine disappears, is never found, and the film unfolds in a series of languorous searches of the surrounding landscape, Here one's sense of time passing is that it is endless. The film's version of 'real time' seems almost hallucinogenic.

Andy Warhol's *Empire* (1965), when the lights in the building are turned on.

Michael Snow's *Wavelength* (1967), where a forty-five minute moving camera shot into a photograph on the wall allows all sorts of narratives to develop in the space off-screen. Marguerite Duras' *Le Camion* (1977), with the interminable yet fascinating series of conversations between Gerard Depardieu and the author/director.

All of John Cassavetes' conversations, in which characters talk until they are blue in the face, until they reveal facets of their personalities/characters that, in most fiction films, seem artificial and forced. The way in which the camera stays on Gena Rowlands' face in *Woman under the Influence* (1974) allowing us to see the cracks below the surface, to witness her disintegration over time.

The opening shot of Wim Wenders' *Die Angst des Tormanns beim Elfmeter* (1972), where we watch the goalkeeper, from behind, as the game unfolds ahead of him, out of our sight. He waits, he waits, he waits. He tenses as the action returns to his end. And, suddenly, out of the blue, the ball whizzes by him, into the net. Or …

Stuck in the middle

My earliest memories of going to the cinema revolve not around particular films (of course, I remember those as well … *20,000 Leagues Under the Sea* [1954], *The Ten Commandments* [1956], the incredibly insipid *Tammy and the Bachelor* [1957] with Debbie Reynolds, etc.) but of the experience of walking into a film after it had started and staying until the next show arrived the point I had entered. I usually went with my father, who, for some reason, never took account of the starting times. 'Going to the movies' was just that … a kind of generic

experience in which the film would be different each time and the moment of arrival and departure was meant to fit into the day's schedule (my father's time) rather than the fixed narrative time of the film.

Thus the film's time had to be completely flexible. We always walked in in the middle of something. The submarine had sunk. Moses had talked with God on the mountain. Tammy had fallen in love. It was always the same. We had to provide the time past for the time unfolding in front of our eyes. And then, following the film to its conclusion, we had to sit through the lights coming up, people leaving, new people coming in, previews of films to come, and finally the film starting again.

It was this last part of our visit that was perhaps the most satisfying. For now we saw the scenes unfold in front of our eyes that we imagined had taken place. Most of the time, of course, we had accurately predicted what we had missed in the first part of the film. It's not so difficult when you know the end. But when we reached the point at which we had entered the cinema, entered the narrative, it was sublime. Everything had come full circle. Everything made sense. Time was predictable and it was on our side.

1 Jay Leyda, *Kino. A History of Russian and Soviet Film* (New York, 1960) 196.

2 Ibid.

3 François Truffaut, *Alfred Hitchcock* (New York, 1967) 210.

4 Ibid., 205

5 Sigmund Freud, *Anxiety and Instinctual Life*, reprinted in *New Introductory Lectures on Psychoanalysis* (London, 1964) 125–6.

6 Coleman's use of the title *tache aveugle* is taken from Georges Bataille. For further reference see Denis Hollier, *Against Architecture. The Writings of Georges Bataille* (Cambridge, Massachusetts, 1989).

Michael Tarantino, 'A Few Brief Moments of Cinematic Time', in *Moments in Time: On Narration and Slowness*, ed. Helmut Friedel (Munich: Städtische Galerie im Lenbachhaus und Kunstbau München/Ostfildern-Ruit: Hatje Cantz Verlag, 1999) 137–41.

I PROWLED THE STREET ALL DAY, FEELI
VERY STRUNG UP AND READY TO POUNC
DETERMINED TO 'TRAP' LIFE, TO PRESER
IT IN THE ACT OF LIVING. ABOVE ALL
CRAVED TO SEIZE THE WHOLE ESSENC
IN THE CONFINES OF ONE SING
PHOTOGRAPH, OF SOME SITUATION TH
WAS IN THE PROCESS OF UNROLLING ITSE

BEFORE MY EYE

THE CAPTIVE MOMENT

Carlo Rim
On the Snapshot//1930

A lady, sporting a bird's nest on her chignon and a small cushion on her posterior, lifts up her heavy skirt to cross a totally deserted Place de la Concorde. A gentleman with a gendarme's moustache follows her with light and airy footstep. He wears a coachman's stiff hat, a stiff white celluloid collar, a vast topcoat with narrow lapels set quite high, and the long, pointy, flexible half-boots of Little Tich ...[1] This old snapshot dates from twenty-five years ago. That is quite an age for a photograph. What has become of the gentleman and the lady? Did the gentleman accost the lady? Did the lady not rebuff the gentleman? Did they fall in love? Did they have children? I would pay a handsome price for a snapshot of the couple, now in their fifties, whose first meeting was once caught by a random street photographer. I hear what you are murmuring. No, I am no more of a busybody than anyone else. Don't get the idea that the private affairs of your contemporaries are any special concern of mine, nor that I enjoy gossiping about other people's doings. What I should like, however, is to be able to extend my friendship or my love to people I do not know, will never know, do not wish to know. Their name, age, tastes don't matter to me. Try to understand me. For me, they cannot just be human creatures like others.

There is the photograph between us.

If some day on a deserted shore, among the wreckage cast up there, or perhaps at the bottom of an old chest, someone were to find a roll of film preserved by miracle from the damage of water and time, a roll with twelve snapshots taken down the course of the ages and at particular moments, then a legend at one and the same time more precise and more fantastic would take the place of another legend, and the realm of love and dream would not only be preserved safe and sound but would once more become the lion's share. Should that day come, the bronze doors of the bone-chilling Pantheons and the museums would be shut for good and all, and the Caesar at Place Vendôme,[2] restored to his fellow men, would slide down the length of his greased amusement-park pole and take his place among us once again.

The advent of modern times dates from the moment the first daguerreotype appeared on the scene. The camera lens, capturing the appearances of fleeting instants, has marked out the past with a succession of presents. The day photography was born humanity won a precious victory over time, its most redoubtable enemy. To be able to perpetuate for even a relative eternity

humankind's most ephemeral aspects, was this not a way of stopping time, a little at least, in its dread course? The first snapshot made that victory decisive. In the posed photograph time still held its own, because its benevolent collaboration was asked for. But the snapshot flies in the face of time, violates it.

Photography has given a material guise and body to time, which otherwise eludes our human grasp. It has given them to time the better to take them back again. And so it has destroyed the confused and eminently literary notion we have of the past. Thanks to the photograph, yesterday is no more than an endless today. And like the cable that ties a balloon down to earth, our sensitive and precise photographic apparatus lets us survey the most difficult terrain, creating a kind of vertigo very much its own.

Our culture has become visual. Which means that photography (in its two forms: static and dynamic) arrived at the right moment, in a world neither too old nor too young to understand and cherish it. Our five senses, which took off all together from the starting line at a pistol shot, soon went their separate ways. Touch, a hefty lout of a jockey, has already shown his bum to the field; smell rears back at the hurdles; taste slows down to browse the field and saunters through a leisurely race; hearing, after an admirable takeoff, runs out of wind, staggers, and loses ground. While sight itself, fresh as a daisy's eye, makes it to the winning post 'in an armchair', as racing fans say.

Photography alone, at once objective and typical, will express for the tender-hearted mechanics we are the neo-romanticism of our day, the saraband of ciphers made flesh in zero's own moonlight.

There is the posed photo and the snapshot, just as there is sculpture and the foot race. The snapshot has invaded that ultimate refuge of the pose: the family album. Twenty million Kodaks have clicked this summer on all the beaches of the world. The family albums from now on will be peopled by silly grimaces and human hams. The plaster-of-Paris rock, the green park monochrome backdrop, the cable release, and Gerschel's black cloth are all being relegated to the museum.

The snapshot is something complete in itself.

A film is a succession of snapshots more or less *posed*, and it only very rarely gives us the illusion of the unexpected and rare. Ninety films out of a hundred are merely interminable poses. One doesn't premeditate a photograph like a murder or a work of art.

Photography is rather like those huge American department stores where you find all you want: old master paintings, locomotives, playing cards, tempests, gardens, opera glasses, pretty girls. But steer clear at all costs of the floorwalkers. They are terrible chatterbox bores who have no idea what they are saying.

A photographer for the *Daily Mirror* said to me: 'The most beautiful photos

I've ever taken were on a day I had forgotten my film.'

That photographer is a poet perhaps, but quite certainly an imbecile.

The photographer's personality?

Obviously each of them blows his nose in his own fashion. But the most successful photographs are not those that required the most trouble.

That would be just too easy.

1 Little Tich was a popular English clown.
2 The 'Caesar' is the statue of Napoleon atop the Vendôme column in Paris.

Carlo Rim, 'De l'instantané', *L'Art vivant*, no. 137 (Paris, 1 September 1930), trans. Robert Erich Wolf, 'On the Snapshot', in Christopher Phillips, ed., *Photography in the Modern Era: European Documents and Critical Writings, 1913–1940* (New York: The Metropolitan Museum of Art, 1989) 37–40.

Henri Cartier-Bresson
Images à la sauvette[1]//1952

There is nothing in this world without a decisive moment.
– Cardinal Retz

I, like many another boy, burst into the world of photography with a Box Brownie, which I used for taking holiday snapshots. Even as a child, I had a passion for painting, which I 'did' on Thursdays and Sundays, the days when French school children don't have to go to school. Gradually, I set myself to try to discover the various ways in which I could play with a camera. From the moment that I began to use the camera and to think about it, however, there was an end to holiday snaps and silly pictures of my friends. I became serious. I was on the scent of something, and I was busy smelling it out.

Then there were the movies. From some of the great films, I learned to look, and to see. *Mysteries of New York,* with Pearl White; the great films of D.W. Griffith – *Broken Blossoms*; the first films of Stroheim; *Greed*; Eisenstein's *Potemkin*; and Dreyer's *Jeanne d'Arc* – these were some of the things that impressed me deeply. [...]

The picture story
What actually *is* a photographic reportage, a picture story? Sometimes there is one unique picture whose composition possesses such vigour and richness, and whose content so radiates outward from it, that this single picture is a whole story in itself. But this rarely happens. The elements which, together, can strike sparks from a subject, are often scattered – either in terms of space or time – and bringing them together by force is 'stage management', and, I feel, contrived. But if it is possible to make pictures of the 'core' as well as the struck-off sparks of the subject, this is a picture-story. The page serves to reunite the complementary elements which are dispersed throughout several photographs.

The picture-story involves a joint operation of the brain, the eye and the heart. The objective of this joint operation is to depict the content of some event which is in the process of unfolding, and to communicate impressions. Sometimes a single event can be so rich in itself and its facets that it is necessary to move all around it in your search for the solution to the problems it poses – for the world is movement, and you cannot be stationary in your attitude towards something that is moving. Sometimes you light upon the picture in seconds; it might also require hours or days. But there is no standard plan, no

pattern from which to work. You must be on the alert with the brain, the eye, the heart, and have a suppleness of body.

Things-as-they-are offer such an abundance of material that a photographer must guard against the temptation of trying to do everything. It is essential to cut from the raw material of life – to cut and cut, but to cut with discrimination. While working, a photographer must reach a precise awareness of what he is trying to do. Sometimes you have the feeling that you have already taken the strongest possible picture of a particular situation or scene; nevertheless, you find yourself compulsively shooting, because you cannot be sure in advance exactly how the situation, the scene, is going to unfold. You must stay with the scene, just in case the elements of the situation shoot off from the core again. At the same time, it's essential to avoid shooting like a machine-gunner and burdening yourself with useless recordings which clutter your memory and spoil the exactness of the reportage as a whole.

Memory is very important, particularly in respect to the recollection of every picture you've taken while you've been galloping at the speed of the scene itself. The photographer must make sure, while he is still in the presence of the unfolding scene, that he hasn't left any gaps, that he has really given expression to the meaning of the scene in its entirety, for afterwards it is too late. He is never able to wind the scene backwards in order to photograph it all over again.

For photographers, there are two kinds of selection to be made, and either of them can lead to eventual regrets. There is the selection we make when we look through the view-finder at the subject; and there is the one we make after the films have been developed and printed. After developing and printing, you must go about separating the pictures which, though they are all right, aren't the strongest. When it's too late, then you know with a terrible clarity exactly where you failed; and at this point you often recall the telltale feeling you had while you were actually making the pictures. Was it a feeling of hesitation due to uncertainty? Was it because of some physical gulf between yourself and the unfolding event? Was it simply that you did not take into account a certain detail in relation to the whole set-up? Or was it (and this is more frequent) that your glance became vague, your eye wandered off?

For each of us space begins and slants off from our own eye, and from there enlarges itself progressively towards infinity. Space, in the present, strikes us with greater or lesser intensity and then leaves us, visually, to be closed in our memory and to modify itself there. Of all the means of expression, photography is the only one that fixes forever the precise and transitory instant. We photographers deal in things that are continually vanishing, and when they have vanished, there is no contrivance on earth that can make them come back again. We cannot develop and print a memory. The writer has time to reflect. He can

accept and reject, accept again; and before committing his thoughts to paper he is able to tie the several relevant elements together. There is also a period when his brain 'forgets', and his subconscious works on classifying his thoughts. But for photographers, what has gone is gone forever. From that fact stem the anxieties and strength of our profession. We cannot do our story over again once we've got back to the hotel. Our task is to perceive reality, almost simultaneously recording it in the sketchbook which is our camera. We must neither try to manipulate reality while we are shooting, nor manipulate the results in a darkroom. These tricks are patently discernible to those who have eyes to see.

In shooting a picture-story we must count the points and the rounds, rather like a boxing referee. In whatever picture-story we try to do, we are bound to arrive as intruders. It is essential, therefore, to approach the subject on tiptoe – even if the subject is still-life. A velvet hand, a hawk's eye – these we should all have. It's no good jostling or elbowing. And no photographs taken with the aid of flashlight either, if only out of respect of the actual light – even when there isn't any of it. Unless a photographer observes such conditions as these, he may become an intolerably aggressive character. [...]

Composition

[...] In photography there is a new kind of plasticity, the product of instantaneous lines made by movements of the subject. We work in unison with movement as though it were a presentiment of the way in which life itself unfolds. But inside movement there is one moment at which the elements in motion are in balance. Photography must seize upon this moment and hold immobile the equilibrium of it.

The photographer's eye is perpetually evaluating. A photographer can bring coincidence of line simply by moving his head a fraction of a millimeter. He can modify perspectives by a slight bending of the knees. By placing the camera closer to or farther from the subject, he draws a detail – and it can be subordinated, or he can be tyrannized by it. But he composes a picture in very nearly the same amount of time it takes to click the shutter, at the speed of a reflex action.

Sometimes it happens that you stall, delay, wait for something to happen. Sometimes you have the feeling that here are all the makings of a picture – except for just one thing that seems to be missing. But what one thing? Perhaps someone suddenly walks into your range of view. You follow his progress through the viewfinder. You wait and wait, and then finally you press the button – and you depart with the feeling (though you don't know why) that you've really got something. Later, to substantiate this, you can take a print of this picture, trace on it the geometric figures which come up under analysis, and

you'll observe that, if the shutter was released at the decisive moment, you have instinctively fixed a geometric pattern without which the photograph would have been both formless and lifeless. [...]

The customers

The camera enables us to keep a sort of visual chronicle. For me, it is my diary. We photo-reporters are people who supply information to a world in a hurry, a world weighted down with preoccupations, prone to cacophony, and full of beings with a hunger for information and needing the companionship of images. We photographers, in the course of taking pictures, inevitably make a judgement on what we see, and that implies a great responsibility. We are, however, dependent on printing, since it is to the illustrated magazines that we, as artisans, deliver raw material.

It was indeed an emotional experience for me when I sold my first photograph (to the French magazine *Vu*).That was the start of a long alliance with magazines. The magazines produce for us a public, and introduce us to that public; and they know how to get picture-stories across in the way the photographer intended. But sometimes, unhappily, they distort them. The magazine can publish exactly what the photographer wanted to show; but the photographer runs the risk of letting himself be moulded by the taste or the requirements of the magazine.

In a picture-story, the captions should invest the pictures with a verbal context, and should illuminate whatever relevant thing it may have been beyond the power of camera to reach.

Unfortunately, in the sub-editor's room, mistakes sometimes slip in that are not just simple misspellings or malapropisms. For these mistakes the reader often holds the photographer responsible. Such things do happen.

The pictures pass through the hands of the editor and the layout man. The editor has to make his choice from the thirty or so pictures of which the average picture-story consists. (It is rather as though he had to cut a text article to pieces in order to end up with a series of quotations!) For a picture-story, as for a novel, there are certain set forms. The pictures of the editor's choice have to be laid out within the space of two, three or four pages, according to the amount of interest he thinks they are likely to arouse, or the current state of paper shortage.

The great art of the layout man lies in his knowing how to pick from this pile of pictures the particular one which deserves a full-page or a double-page spread; in his knowing where to insert the small picture which must serve as an indispensable link in the story. (The photographer, when he is actually taking the pictures for his story, should never give a thought to the ways in which it will be possible to lay out those pictures to the most advantage.) The layout man will

often have to crop one picture so as to leave only the most important section of it – since, for him, it is the unity of the whole page or of the whole spread that counts above all else. A photographer can scarcely be too appreciative of the layout man who gives his work a beautiful presentation of a kind which keeps the full import of the story; a display in which the pictures have spatially correct margins and stand out as they should; and in which each page possesses its own architecture and rhythm.

There is a third anguish for a photographer – when he looks for his story in a magazine.

There are ways of communicating our photographs other than through publication in magazines. Exhibitions, for instance; and the book form, which is almost a form of permanent exhibition.

I have talked at some length, but of only one kind of photography. There are many kinds. Certainly the fading snapshot carried in the back of a wallet, the glossy advertising catalogue, and the great range of things in between, are photography. I don't attempt to define it for everyone. I only attempt to define it to myself:

To me, photography is the simultaneous recognition, in a fraction of a second, of the significance of an event as well as of a precise organization of forms which give that event its proper expression.

I believe that, through the act of living, the discovery of oneself is made concurrently with the discovery of the world around us, which can mould us, but which can also be affected by us. A balance must be established between these two worlds – the one inside us and the one outside us. As the result of a constant reciprocal process, both these worlds come to form a single one. And it is this world that we must communicate.

But this takes care only of the content of the picture. For me, content cannot be separated from form. By form, I mean a rigorous organization of the interplay of surfaces, lines and values. It is in this organization alone that our conceptions and emotions become concrete and communicable. In photography, visual organization can stem only from a developed instinct.

1 Cartier-Bresson's original title in French of the book published in English as *The Decisive Moment* (taken from the epigram) was *Images à la sauvette*. There is no exact translation of this phrase, which means salvaged images, or photographs taken without being seen. As Cartier-Bresson came to feel that the English title unduly influenced the reading of his work, it has been left in the original French at the request of his family.

Henri Cartier-Bresson, *Images à la sauvette*, trans. *The Decisive Moment* (New York: Simon and Schuster, 1952) 20; 23–8; 32–3; 40–3; reprinted in *The Mind's Eye* (New York: Aperture, 1999).

Roland Barthes
The Face of Garbo//1957

Garbo still belongs to that moment in cinema when capturing the human face still plunged audiences into the deepest ecstasy, when one literally lost oneself in a human image as one would in a philtre, when the face represented a kind of absolute state of the flesh, which could be neither reached nor renounced. A few years earlier the face of Valentino was causing suicides; that of Garbo still partakes of the same rule of Courtly Love, where the flesh gives rise to mystical feelings of perdition.

It is indeed an admirable face-object. In *Queen Christina*, a film which has again been shown in Paris in the last few years, the make-up has the snowy thickness of a mask: it is not a painted face, but one set in plaster, protected by the surface of the colour, not by its lineaments. Amid all this snow at once fragile and compact, the eyes alone, black like strange soft flesh, but not in the least expressive, are two faintly tremulous wounds. In spite of its extreme beauty, this face, not drawn but sculpted in something smooth and friable, that is, at once perfect and ephemeral, comes to resemble the flour-white complexion of Charlie Chaplin, the dark vegetation of his eyes, his totem-like countenance.

Now the temptation of the absolute mask (the mask of antiquity, for instance) perhaps implies less the theme of the secret (as is the case with the Italian half mask) than that of an archetype of the human face. Garbo offered to one's gaze a sort of Platonic Idea of the human creature, which explains why her face is almost sexually undefined, without however leaving one in doubt. It is true that this film (in which Queen Christina is by turns a woman and a young cavalier) lends itself to this lack of differentiation; but Garbo does not perform in it any feat of transvestism; she is always herself, and carries without pretence, under her crown or her wide-brimmed hats, the same snowy solitary face. The name given to her, *the Divine*, probably aimed to convey less a superlative state of beauty than the essence of her corporeal person, descended from a heaven where all things are formed and perfected in the clearest light. She herself knew this: how many actresses have consented to let the crowd see the ominous maturing of their beauty. Not she, however; the essence was not to be degraded, her face was not to have any reality except that of its perfection, which was intellectual even more than formal. The Essence became gradually obscured, progressively veiled with dark glasses, broad hats and exiles: but it never deteriorated.

And yet, in this deified face, something sharper than a mask is looming: a

kind of voluntary and therefore human relation between the curve of the nostrils and the arch of the eyebrows; a rare, individual function relating two regions of the face. A mask is but a sum of lines; a face, on the contrary, is above all their thematic harmony. Garbo's face represents this fragile moment when the cinema is about to draw an existential from an essential beauty, when the archetype leans towards the fascination of mortal faces, when the clarity of the flesh as essence yields its place to a lyricism of Woman.

Viewed as a transition the face of Garbo reconciles two iconographic ages, it assures the passage from awe to charm. As is well known, we are today at the other pole of this evolution: the face of Audrey Hepburn, for instance, is individualized, not only because of its peculiar thematics (woman as child, woman as kitten) but also because of her person, of an almost unique specification of the face, which has nothing of the essence left in it, but is constituted by an infinite complexity of morphological functions. As a language, Garbo's singularity was of the order of the concept, that of Audrey Hepburn is of the order of the substance. The face of Garbo is an Idea, that of Hepburn, an Event.

Roland Barthes, 'The Face of Garbo' *Mythologies* (Paris: Éditions du Seuil, 1957), trans. Annette Lavers (New York: Hill & Wang, 1972) 56–7.

Jonas Mekas
Movie Journal: Warhol Shoots *Empire*, 30 July//1964

Last Saturday I was present at a historic occasion: the shooting of Andy Warhol's epic *Empire*. From 8 p.m. until dawn the camera was pointed at the Empire State Building, from the 41st floor of the Time-Life Building. The camera never moved once. […] The following are excerpts from a conversation with the Warhol crew:

John Palmer: Why is nothing happening? I don't understand. *Henry X*: What would you like to happen? *John*: I don't know. *Henry*: I have a feeling that all we're filming is the red light. *Andy Warhol*: Oh, Henry!!! *Henry*: Andy?! NOW IS THE TIME TO PAN. *John*: Definitely not! *Henry*: The film is a whole new bag when the lights go off. *John*: Look at all that action going on. Those flashes. Tourists taking photos. *Andy*: Henry, what is the meaning of action? *Henry*: Action is the absence of inaction. *Andy*: Let's say things intelligent. *Gerard Malanga*: Listen! We don't want to deceive the public, dear. *John*: We're hitting a new milestone. *Andy*: Henry, say Nietzsche. *Henry*: Another aphorism? *John*: B movies are better than A movies. *Andy*: Jack Smith in every garage. *Marie Desert*: Someday we're all going to live underground and this movie will be a smash.

John: The lack of action in the last three 1200-foot rolls is alarming! *Henry*: You have to mark those rolls very carefully so as not to get them mixed up. *Jonas*: Did you know that the Empire State Building sways? *Marie*: I read somewhere that art is created in fun. *Jonas*: What? *Gerard*: During the projection we should set up window panes for the audience to look through. *Andy*: The Empire State Building is a star! *John*: Has anything happened at all? *Marie*: No. *John*: Good! *Henry*: The script calls for a pan right at this point. I don't see why my artistic advice is being constantly rejected. *Henry to Andy*: The bad children are smoking pot again. *John*: I don't think anything has happened in the last hundred feet. *Gerard*: Jonas, how long is this interview supposed to be? *Jonas*: As much as you have. *Andy*: An eight-hour hard-on! *Gerard*: We have to maintain our cool at all times. *John*: We have to have this film licensed. *Andy*: It looks very phallic. *Jonas*: I don't think it will pass. *John*: Nothing has happened in the last half hour. *John*: The audience viewing *Empire* will be convinced after seeing the film that they have viewed it from the 41st floor of the Time-Life Building, and that's a whole bag in itself. Isn't that fantastic? *Jonas*: I don't think the last reel was a waste. *Henry to John*: I think it's too playful.

Jonas Mekas, 30 July 1964 'Movie Journal' column reprinted in Jonas Mekas, *Movie Journal: The Rise of the New American Cinema 1959–1971* (New York: Collier Books, 1972) 150–51.

Andy The Empire State Building is a star!

John Has anything happened at all?

Marie No.

Andy Warhol and film crew, quoted by Jonas Mekas in *Movie Journal*, July 1964

Thierry de Duve
Time Exposure and Snapshot: The Photograph as Paradox//1978

Commenting on Harold Rosenberg's *Tradition of the New*, Mary McCarthy once wrote, 'You cannot hang an event on the wall, only a picture.' It seems, however, that with photography, we have indeed the paradox of an event that hangs on the wall.

 Photography is generally taken in either of two ways: as an event, but then as an odd looking one, a frozen gestalt that conveys very little, if anything at all, of the fluency of things happening in real life; or it is taken as a picture, as an autonomous representation that can indeed be framed and hung, but which then curiously ceases to refer to the particular event from which it was drawn. In other words, the photograph is seen either as natural evidence and live witness (picture) of a vanished past, or as an abrupt artefact (event), a devilish device designed to capture life but unable to convey it. Both notions of what is happening at the surface of the image have their counterpart in reality. Seen as live evidence, the photograph cannot fail to designate, outside of itself, the death of the referent, the accomplished past, the suspension of time. And seen as deadening artefact, the photograph indicates that life outside continues, time flows by, and the captured object has slipped away.

 As representatives of these two opposite ways in which a photograph is perceived, the funerary portrait would exemplify the 'picture'. It protracts onstage a life that has stopped offstage. The press photograph, on the other hand, would exemplify the 'event'. It freezes onstage the course of life that goes on outside. Once generalized, these examples suggest that the time exposure is typical of a way of perceiving the photograph as 'picture-like', whereas the instantaneous photograph is typical of a way of perceiving it as 'event-like'.

 These two ways are mutually exclusive, yet they coexist in our perception of any photograph, whether snapshot or time exposure. Moreover, they do not constitute a contradiction that we can resolve through a dialectical synthesis. Instead they set up a paradox, which results in an unresolved oscillation of our psychological responses towards the photograph.

 First, let us consider the snapshot, or instantaneous photograph. The snapshot is a theft; it steals life. Intended to signify natural movement, it only produces a petrified analogue of it. It shows an unperformed movement that refers to an impossible posture. The paradox is that in reality the movement has indeed been performed, while in the image the posture is frozen.

 It is clear that this paradox derives directly from the indexical nature of the photographic sign.[1] Using the terms of Charles Sanders Peirce's semiotics,

though the photograph appears to be an icon (through resemblance) and though it is to some extent a symbol (principally through the use of the camera as a codifying device), its proper sign type, which it shares with no other visual representation (except the cast and, of course, cinema), is the index, i.e. a sign causally related to its object. In the case of photography, the direct causal link between reality and the image is light and its proportionate physical action upon silver bromide. For a classical post-Saussurian semiology, this would mean that, in the case of photography, the referent may not be excluded from the system of signs considered. Certainly, common sense distinguishes an image from reality. But why does common sense vanish in front of a photograph and charge it with such a mythical power over life and death? It is not only a matter of ideology or of naïveté. Reality does indeed wedge its way into the image. The referent is not only that to which the sign refers, but also that upon which it depends.

Therefore we ought to introduce a slightly different vocabulary from the usual semiological terminology in order to attempt a theoretical description of the photograph. We shall consider the semiotic structure of the photograph to be located at the juncture of two series. (It is not the place here to justify the choice of the word *series*. Let us say only that it is the dynamic equivalent of a line, and that the crossing of two lines is necessary to organize a structural space or matrix.)

The first series is image-producing. It generates the photograph as a semiotic object, abstracted from reality, the surface of the photograph so to speak. Let us call it the *superficial series*. The second series is reality-produced (one might even say reality-producing, in so far as the only reality to be taken into account is the one framed by the act of taking a photograph). It generates the photograph as a physical sign, linked with the world through optical causality. Let us call it the *referential series*.

We may now return to the paradox of an unperformed movement and an impossible posture. When in the late 1870s, Eadweard Muybridge's snapshots of animal locomotion, especially the studies of the horse's different gaits, came to be known in France and the United States, they occasioned a considerable furor among painters and photographers.[2] Whether or not a horse should be depicted in the unexpected, yet 'true' postures that were revealed by the infallible eye of the camera, whether or not the artist – including the photographer when he strives for artistic recognition – should remain faithful to nature as recorded rather than interpret it, were the main issues under debate. Yet these aesthetic controversies are symptomatic of what was felt as an unbearable disclosure: that of the photograph's paradoxical treatment of reality in motion.

The nineteenth-century ideology of realism prescribed, among other things, the attempt to convey visual reality adequately. And to that end, photography

was sensed – either reluctantly or enthusiastically – as establishing a rule. But with the onset of motion photography, artists who were immersed in the ideology of realism found themselves unable to express reality and obey the photograph's verdict at the same time. For Muybridge's snapshots of a galloping horse demonstrated what the animal's movements were, but did not convey the sensation of their motion. The artist must have felt squeezed between two incompatible truths that can be approached in terms of a contradiction in aesthetic ideology. But basically this contradiction is grounded in the paradoxical perception of photography in general, for which the example of Muybridge is simply an extreme case.

The paradox of the unperformed movement and the impossible posture presents itself as an unresolved alternative. Either the photograph registers a singular event, or it makes the event form itself in the image. The problem with the first alternative is that reality is not made out of singular events; it is made out of the continuous happening of things. In reality, the event is carried on by time, it doesn't arise from or make a gestalt: the discus thrower releases the disc. In the second case, where the photograph freezes the event in the form of an image, the problem is that this is not where the event occurs. The surface of the image shows a gestalt indeed, emerging from its spatial surroundings, and disconnected from its temporal context: the discus thrower is caught forever in the graceful arc of his wind-up.

The referential series of the photograph is purely syntagmatic, whereas the superficial series is an absolute paradigm. Contrary to what happens in a painted or drawn image, there is no dialectic between syntagm and paradigm, though both series cross at one point. In other words, this is how we live through the experience of this unresolved alternative, while looking at a photograph: Either we grasp at the thing (or its sign, or its name); the gallop of the horse; but this thing does not occur in the referential series which in fact contains only the verb: the horse gallops. Or if we wish to grasp the verb, the flux, the movement, we are faced with an image from which this has escaped: the superficial series contains only the name, the shape, the stasis. The paradox sets in at the crossing-point of both series, where they twist to form an unnatural, yet nature-determined sign, accounting for what Roland Barthes calls the 'real unreality' of photography.[3] The snapshot steals the life outside and returns it as death. This is why it appears as abrupt, aggressive and artificial, however convinced we might be of its realistic accuracy.

Let us now consider the time exposure, of which the photo-portrait is a concrete instance. Whether of a live or dead person, the portrait is funerary in nature, a monument. Acting as a reminder of times that have died away, it sets up landmarks of the past. This means it reverses the paradox of the snapshot,

series to series. Whereas the snapshot refers to the fluency of time without conveying it, the time exposure petrifies the time of the referent and denotes it as departed. Reciprocally, whereas the former freezes the superficial time of the image, the latter releases it. It liberates an autonomous and recurrent temporality, which is the time of remembrance. While the portrait as *Denkmal*,[4] monument, points to a state in a life that is gone forever, it also offers itself as the possibility of staging that life again and again in memory.

An asymmetrical reciprocity joins the snapshot to the time exposure: whereas the snapshot stole a life it could not return, the time exposure expresses a life that it never received. The time exposure doesn't refer to life as process, evolution, diachrony, as does the snapshot. It deals with an imaginary life that is autonomous, discontinuous and reversible, because this life has no location other than the surface of the photograph. By the same token it doesn't frame that kind of surface-death characteristic of the snapshot, which is the shock of time splitting into *not any more* and *not yet*. It refers to death as the state of what has been: the fixity and defection of time, its absolute zero.

Now that we have brought the four elements of the photographic paradox together, we can describe it as a double branching of temporality. 1. In the snapshot, the present tense, as hypothetical model of temporality, would annihilate itself through splitting: always too early to see the event occur at the surface; always too late to witness its happening in reality. 2. In the time exposure, the past tense, as hypothetical model, would freeze in a sort of infinitive, and offer itself as the empty form of all potential tenses.

Photography not only overthrows the usual categories of time. As Roland Barthes suggests, it also produces a new category of space-time: 'an illogical conjunction of the *here* and *the formerly*'.[5] To what Barthes says, we can add that this formula adequately describes only half of the photographic paradox, namely the space-time of the snapshot. The space-time of the time exposure would in turn be described as another illogical conjunction: *now* and *there*.

Here denotes the superficial series as if it were a place: the surface of projection of the photographed event, once it is made clear that the event never occurs there. The surface of the image is received as a fragment of space that cannot be inhabited, since inhabiting takes time. As the snapshot locks time in the superficial series, it allows it to unreel in the other one. *Formerly* denotes the referential series as if it were a time: a past tense enveloped by the present and in continuity with it. *Formerly* refers to a past sequence of events that are plausible but deprived of any location.

Now denotes the superficial series as if it were a time, but without any spatial attachment, cut from its natural link with here. Therefore, it is not a

present but a virtual availability of time in general, a potential ever-present to be drawn at will from the referential past.

There denotes the referential series as if it were a place, i.e., the referential past as frozen time, a state rather than a flow, and thus a space rather than a time.

When we bear in mind that these two illogical conjunctions, which we have been trying to specify with the help of opposite models (time exposure vs. snapshot) are at work in every photograph, then we shall be able to restate these models in less empirical terms. To look at a photograph as if it were instantaneous (a snapshot) would mean to apprehend the superficial series as spatial and the referential series as temporal; to look at a photograph as if it were a time exposure would mean the reverse. The significant difference between 'instantaneous' and 'time exposure' would be the commutation of time and space along the axis of either surface or referent, or reciprocally, the jump in focusing on surface or on referent, along the axis of either time or space.

What does the twist in the categories of time and space imply in terms of psychological response? We are not dealing here with the *reading* of a photograph, which belongs to the field of semiology. Barthes remains in that field when he states that the illogical conjunction of the here and the formerly is a type of *consciousness* implied by photography. But we are dealing with something more basic to the understanding of photography. That more fundamental aspect can be said to be on the level of the unconscious; but of course the unconscious is involved in *reading* too. What is in question here is the affective and phenomenological involvement of the unconscious with the external world, rather than its linguistic structure. It is most probable that the necessity of stressing this aspect once again proceeds from the indexical nature of the photograph.[6]

The word *here*, used to describe the kind of space embodied in the snapshot, does not simply refer to the photograph as an object, a thing endowed with empirical measurements that we are holding, *here*, in our hands. Because the photograph is the result of an indexical transfer, a graft off of natural space, it operates as a kind of ostensive gesture, as when we point with the index finger at an object, to indicate that it is this one, *here*, that we mean. In a sense, the very activity of finding a 'focal point' – that is, selecting one particular plane out of the entire array of the world spread in depth before us – is itself a kind of pointing, a selection of this cut through the world at this point, here, as the one with which to fill the indexical sign. Finding the point of focus is in this sense a procedural analogue for the kind of trace or index that we are aware of when we hold the printed snapshot in our hands. Both poles of this phenomenon – the means to the image and the result – have in common a contraction of space itself into a point: *here* as a kind of absolute.

The aesthetic ideal of instantaneous photographs is *sharpness*. Though there is a trend in photography that tends to blur the image in order to express motion, this contradicts the built-in tendency of snapshots towards sharpness, and relates to the practice of time exposure. Some years ago, there was an aesthetic controversy among photographers as to whether a completely blurred photograph of moving objects should be acceptable or not. Those who rejected this practice claimed that there must be one point of sharpness and that this is enough. Theoretically they are right. Photography may not become totally abstract, because that would constitute a denial of its referential ties. One point of sharpness suffices to assert its own space, for the essence of the point is precision.

How does one relate to a space of such precision? One thing is certain: it doesn't give way to a *reading* procedure. For an image to be read requires that language be applied to the image. And this in turn demands that the perceived space be receptive to an unfolding into some sort of narrative. Now, a *point* is not subject to any description, nor is it able to generate a narration. Language fails to operate in front of the pin-pointed space of the photograph, and the onlooker is left momentarily aphasic. Speech in turn, is reduced to the sharpness of a hiccup. It is left unmoored, or better, suspended between two moorings that are equally refused. Either it grasps at the imaginary by connecting to the referential series, in order to develop the *formerly* into a plausible chronology, only to realize that this attempt will never leave the realm of fiction. Or it grasps at the symbolic by connecting to the superficial series, in order to construct upon the *here* a plausible scenography; and in this case also the attempt is structurally doomed. Such a shock, such a breakdown in the symbolic function, such a failure of any secondary process – as Freud puts it – bears a name. It is trauma.

We know certain photographs to be truly traumatic: scenes of violence, obscenity, etc. However, I wish to claim that the photograph is not traumatic because of its content, but because of immanent features of its particular time and space. The trauma effect is of course a limit, but an internal one, enhanced by the subject matter of the photograph, yet not dependent upon it. As an example, one might recall the famous press photograph from the war in Vietnam, in which we see a Saigon police officer about to shoot a Vietcong soldier. This is certainly a traumatic photograph. But although the traumatism seems to be generated by the depiction of the atrocities of war and assassination, it depends instead on the paradoxical 'conjunction of the here and the formerly': I'll always be too late, in real life, to witness the death of this poor man, let alone to prevent it; but by the same token, I'll always be too early to witness the uncoiling of the tragedy which, at the surface of the photograph, will of course never occur. Rather than the tragic content of the photograph, even enhanced by the knowledge that it really happened ('We possess then, as a kind of precious

miracle', says Barthes, 'a reality from which we are ourselves sheltered'), it is the sudden vanishing of the present tense, splitting into the contradiction of being simultaneously too late and too early, that is properly unbearable.

Time exposure implies the antithesis of trauma. Far from blocking speech, it welcomes it openly. Only in time exposure (portrait, landscape, still life, etc.) may photography appear with the continuity of nature. The portrait, for example, may look awkward, but not artificial, as would be the case of a snapshot of an athlete caught in the midst of a jump. When continuity and nature are perceived, speech is apt to body forth that perception in the form of a narrative that meshes the imaginary with the symbolic and organizes our mediation with reality.

The word *now*, used to describe the kind of temporality involved in time exposures, doesn't refer to actual time, since it is abstracted from its natural link with *here: hic et nunc.* It is to be understood as a pause in time, charged with a potential actualization, which will eventually be carried out by speech (or memory as interior speech), and is most probably rooted in the time-consuming act of looking.

The aesthetic ideal of time exposure is thus a slight *out-of-focus.* The blurred surroundings that belonged to the nineteenth-century style of photo-portrait act as a metaphor for the fading of time, in both ways, i.e. from presence to absence and from absence to presence. Whenever photography makes use of blurring or related softening techniques, it endeavours to regain some of the features through which painting traditionally enacts time. The chiaroscuro, for example, is not the background of shape, but its temporality. It loosens the fabric of time and allows the protruding shape to be alternately summoned and dismissed. The blurring of the image in photography is the same. The painterly illusionism of depth finds its photographic equivalent in the lateral unfurling of the photograph's resolution, not only its blurred margins, but also its overall grain.[7] It allows the viewer to travel through the image, choosing to stop here and there, and in so doing, to amplify the monumentality of a detail, or to part from it. The kind of time involved by this *travail* is cyclic, consisting in the alternation of expansion and contraction, diastole and systole.

This particular surface temporality of photography is congenial with the ebb and flow of memory. For a portrait (as typified by the funerary image) does not limit its reference to the particular time when the photograph was taken, but allows the imaginary reconstruction of any moment of the life of the portrayed person. (That is the charm of a photo-album; each photograph is a landmark in a lifetime. But memory shuffles in between landmarks, and can erect on any of them the totality of this life.)

So photography in this instance is a consoling object. This movement in

systole and diastole is also the one that runs alongside what Freud called the *work of mourning*. To put it simply, what happens in the mourning period is a process in which the subject learns to accept that the beloved person is now missing forever, and that in order to survive, he must turn his affection towards someone or something else. In the course of this process, substitutive objects, like things that 'have belonged to the deceased, or an image of the deceased, can help obey the demands of reality. In Freudian terms, this means that a certain quantity of libidinal affect must be withdrawn from the object to which it was attached (*de-cathexis*), awaiting to be refastened to a new object. Meanwhile, the loosened affect temporarily affixes itself to 'each single one of the memories and expectations in which the libido is bound to the object'.[8] This process Freud calls *hyper-cathexis*. We can assume that the substitutive objects of the deceased can act as representations of these 'memories and expectations', and thus, that they are themselves, *hyper-cathected*.

We may suppose – again because of the indexical nature of photography – that there is something like a mourning process that occurs *within* the semiotic structure of the photograph, as opposed to what would happen with other kinds of images, like drawing or painting. A real mourning process can obviously make use of any kind of image as substitutive object. The mourning process then remains exterior to the semiotic structure of the image. But photography is probably the only image-producing technique that has a mourning process built into its semiotic structure, just as it has a built-in trauma effect. The reason is again that the referent of an index cannot be set apart from its signifier. Though it is better exemplified by the time exposure, any photograph is thus prone to a process of mourning, whatever its content might be, whatever its link with real events as well. That the portrait be funerary or not, or for that matter, that the photograph be a portrait at all, is a matter of internal limits, which can be no more than emphasized by the subject matter.

Within the semiotic structure of the photograph, the referential series acts as 'lost reality', whereas the superficial series acts as 'substitutive object'. So what the diastolic look accomplishes when it summons the shape and inflates it, is the hyper-cathexis of the superficial series of the photograph; and what the systolic look accomplishes when it revokes the shape and 'kills' it, is the de-cathexis of the referential series.

Trauma effect and mourning process as photography's immanent features induce two opposite libidinal attitudes. The mourning process is that of melancholy, or more generally, that of depression. As to the shock of the traumatism, it is followed by a compulsive attempt to grasp at reality. The superficial series being suddenly wiped out of consciousness, it provokes a manic *anti-cathexis* of the referential series, as a defence reaction.

We now begin to understand that the paradoxical apprehension of time and space in photography is akin to the contradictory libidinal commitment that we have towards the photograph. On a presymbolic, unconscious level, it seems that our dealing with the photograph takes effect as an either/or process, resulting in an unresolved oscillation between two opposite libidinal positions: the manic and the depressive.

In Szondi's typology of basic drives (the Szondi-test, by the way, is the only so-called projective test to use photographic material), the manic-depressive dimension appearing in human psychopathology and in human experience has been called *contact-vector*. This is generally understood in phenomenological terms, as representing the fundamental attitudes of our being-in-the-world. According to Szondi and other psychologists, this manic-depressive vector is mostly presymbolic, and is the realm of *Stimmung*, mood. It is also believed to be the terrain in which aesthetic experience, especially visual, is nurtured.

More than any other image-producing practice, the photograph puts the beholder in contact with the world, through a paradoxical object which, because of its indexical nature, belongs to the realm of uncoded things, and to the sphere of codified signs.

We have discovered the manic-depressive functioning of the photograph by insisting on the didactic opposition of snapshot and time exposure. And we have seen that the trauma and the response to it in form of a manic defense reaction acted as an internal limit of the snapshot's instantaneity; while on the other hand, the mourning process, which partakes of the funerary nature of photography and induces the depressive position, acted as an internal limit on the time exposure. But of course there is no such thing as an empirical definition of snapshot and time exposure. One cannot decide on a shutter speed that will operate as a borderline between them. These were only didactic models provided by intuition, but they were used to unravel one of the paradoxes of photography. These models do not point to technical or aesthetic standards; their concern is photography in general. Yet they helped to label two opposite attitudes in our perceptual and libidinal apprehension of the photograph. Though these attitudes coexist in front of every photograph, they can be told apart. Moreover, the alternative character of mania and depression suggest that though both attitudes are coextensive, they do not mingle. Photography doesn't allow an intermediate position, or a dialectic resolution of the contradiction.

Hegel's prophecy that art was about to come to an end was published in 1839, the very same year in which Talbot and Daguerre independently made public the invention of photography. It might be more than mere coincidence.

1 In 'Notes on the Index: Seventies Art in America' *(October*, no. 3 and 4), Rosalind Krauss stressed the importance of the indexical nature of the photographic sign, and its impact on contemporary art since Duchamp.

2 See Beaumont Newhall, *History of Photography* (New York: The Museum of Modern Art, 1949) 83–94; Van Deren Coke, *The Painter and the Photograph* (Albuquerque: University of New Mexico Press, 1964) 156–9; Aaron Scharf, *Art and Photography* (Baltimore: Penguin Books, 1971) 211–27.

3. Roland Barthes, 'Rhetoric of the Image', *Image/Music/Text*, trans. Stephen Heath (New York: Hill and Wang, 1977) 44.

4. The German word *Mal* (which yields *malen,* to paint) comes from the Latin *macula,* stain, from which the trench *maille* (mesh) also derives.

5. Barthes, 'Rhetoric of the Image', op. cit., 44.

6. In her 'Notes on the Index', Rosalind Krauss reaches similar conclusions: 'Whatever else its power, the photograph could be called sub- or pre-symbolic, ceding the language of art back to the imposition of things'. See *October,* no. 3 (Spring 1977) 75.

7. Since chiaroscuro is the temporality of shape, that part of the painterly illusionism of depth that relies on it (chiaroscuro itself, atmospheric perspective, *sfumato,* etc., as opposed to linear perspective) is ultimately founded on the time-consuming practice of painting. The *taking* of the photograph doesn't allow such a *practice.* Hence the tact that those photographers who aimed at pictorial equivalence repeatedly insisted on preparatory operations and especially on laboratory work, which surround the push-the-button moment of taking a photograph. The aesthetic of blurring brings the photo-portrait closer to the painted portrait, and was defended mostly by the pictorialists. Nevertheless, the process does not imitate painting, but shows that great portraitists such as Cameron, Carjat, Nadar or Steichen had a remarkable intelligence for the medium. Beaumont Newhall relates that Julia Cameron 'used badly made lenses to destroy detail, and appears to have been the first to have them specially built to give poor definition and soft focus.' See Newhall, *History of Photography,* op. cit., 64.

8. 'Reality-testing has shown that the loved object no longer exists, and it proceeds to demand that all libido shall be withdrawn from its attachments to that object ... [Its orders] are carried out bit by bit, at great expense of time and cathectic energy, and in the meantime the existence of the lost object is psychically prolonged. Each single one of the memories and expectations in which the libido is bound to the object is brought up and hypher-cathected, and detachment of the libido is accomplished in respect of it'. Sigmund Freud, 'Mourning and Melancholia' (1917 [1915), *The Standard Edition of the Complete Psychological Works,* vol. XIV, trans. James Strachey (London: The Hogarth Press, 1957) 244–5.

Thierry de Duve, 'Time Exposure and Snapshot: The Photograph as Paradox', *October,* no. 5 (Cambridge, Massachusetts: The MIT Press, Summer 1978) 113–25.

Agnès Varda
On Photography and Cinema//1984

Photogenies magazine questionnaire

I
In which film, or films, do you think the photograph (the activity of photography) has its most just role?

II
Does photography teach you something about cinema? Or vice versa?

III
Photography and Cinema: first cousins or inimical brothers?

Agnès Varda

I
I really liked *Blow-up* (1967). There Antonioni showed the ridiculous excesses of the high-fashion photographer as well as the serious obsessiveness of his activity. Due to the scenario, photography becomes a mysterious surface. The photographic image retains its secrets, defends itself against the gaze.

I like photographs that resist; it's for this reason that I liked filming *Ulysse* (1982), which after 22 minutes of looking and puzzling still remains a dream-world to explore. The more you approach the image the more it recedes.

It's for this that I like films where the photographic image is one of the subjects – and the very substance of emotion. For example, in *Olstyn, Pologne*, a short film by Vincent Tamisier, or in Wim Wenders' *Alice in the Cities* (1973). Or from a comic angle in *Pain et Chocolat*, (Franco Brusati, 1974), where the poor Manfredi is summoned to the police station because he turned out to be in the background of a polaroid taken by a novice priest ... and we see – the photo proves it – that he had dared to piss on a Swiss tree!

And then there are films made with photographs, of which Chris Marker's admirable *La Jetée* (1962) dares – in the midst of all those still images – to film in motion a woman's face as she opens her eyes.

II
Photography never ceases to instruct me when making films. And cinema reminds me at every instant that it films motion for nothing, since every image becomes a memory, and all memories congeal and set.

In all photography there's the suspension of movement, which in the end is the refusal of movement. There motion is in vain.

In all film there's the desire to capture the motion of life, to refuse immobility.

But in film the still image is in vain, like the foreboding of a car breakdown, like watching out for death.

III

Cinema and photography throw back to each other – vainly – their specific effects.

To my mind cinema and photography are like a brother and sister who are enemies ... after incest.

Agnès Varda, response to '3 Questions sur: Photo et Cinéma', in *Photogénies*, no. 5, ed. Raymond Bellour, Sylvain Roumette, Catherine Sentis (Paris: Centre National de la Photographie, April 1984) n.p. Translated by Ian Farr, 2006.

Gilles Deleuze
Beyond the Movement-Image//1985

Between an empty space or landscape and a still life properly so called there are certainly many similarities, shared functions and imperceptible transitions. But it is not the same thing; a still life cannot be confused with a landscape. An empty space owes its importance above all to the absence of a possible content, whilst the still life is defined by the presence and composition of objects which are wrapped up in themselves or become their own container: as in the long shot of the vase at the end of *Late Spring* (Yasujiro Ozu, 1949). Such objects are not necessarily surrounded by a void, but may allow characters to live and speak in a certain soft focus, like the still life with vase and fruit in *The Woman of Tokyo* (1933), or the one with fruit and golf clubs in *What Did the Lady Forget?* (1937). It is like Cézanne, the landscapes – empty or with gaps – do not have the same principles of composition as the full still lifes. There comes a point when one hesitates between the two, so completely can their functions overlap each other and so subtle are the transitions that can be made: for instance, in Ozu, the marvellous composition with the bottle and the lighthouse, at the beginning of *A Story of Floating Weeds* (1959). The distinction is nonetheless that of the empty and the full, which brings into play all the nuances or relations in Chinese and Japanese thought, as two aspects of contemplation. If empty spaces, interiors or exteriors, constitute purely optical (and sound) situations, still lifes are the reverse, the correlate.

The vase in *Late Spring* is interposed between the daughter's half smile and the beginning of her tears. There is becoming, change, passage. But the form of what changes does not itself change, does not pass on. This is time, time itself, 'a little time in its pure state': a direct time-image, which gives what changes the unchanging form in which the change is produced. The night that changes into day, or the reverse, recalls a still life on which light falls, either fading or getting stronger (*That Night's Wife, Passing Fancy*, 1930). The still life is time, for everything that changes is in time, but time does not itself change, it could itself change only in another time, indefinitely. At the point where the cinematographic image most directly confronts the photo, it also becomes most radically distinct from it. Ozu's still lifes endure, have a duration, over ten seconds of the vase: this duration of the vase is precisely the representation of that which endures, through the succcession of changing states. A bicycle may also endure; that is, represent the unchanging form of that which moves, so long as it is at rest, motionless, stood against the wall (*A Story of Floating Weeds*). The

bicycle, the vase and the still lifes are the pure and direct images of time. Each is time, on each occasion, under various conditions of that which changes in time. Time is the full, that is, the unalterable form filled by change. Time is the 'visual reserve of events in their appropriateness'.[1] Antonioni spoke of 'the horizon of events', but noted that in the West the word has a double meaning, man's banal horizon and an inaccessible and always receding cosmological horizon. Hence the division of western cinema into European humanism and American science fiction.[2] He suggested that it is not the same for the Japanese, who are hardly interested in science fiction; one and the same horizon links the cosmic to the everyday, the durable to the changing, one single and identical time as the unchanging form of that which changes. It is in this way that nature or stasis was defined, according to Schrader, as the form that links the everyday in 'something unified and permanent'. There is no need at all to call on a transcendence. In everyday banality, the action-image and even the movement-image tend to disappear in favour of pure optical situations, but these reveal connections of a new type, which are no longer sensory-motor and which bring the emancipated senses into direct relation with time and thought. This is the very special extension of the opsign [pure optical image]: to make time and thought perceptible, to make them visible and of sound. [...]

1 [footnote 31 in source] cf. Antonioni, 'The Horizon of Events', *Cahiers du cinéma*, no. 290 (Paris, July 1978) 11. [...]
2 [32] Paul Rozenberg sees in this the essence of English romanticism: *Le romantisme anglais*, (Paris: Larrouse, 1973).

Gilles Deleuze, *Cinéma II: L'image-temps* (Paris: Éditions de Minuit, 1985), trans. H. Tomlinson and B. Habberjam, *Cinema 2: The Time-Image* (London: Athlone Press, 1989) 16-18.

Nan Goldin
The Ballad of Sexual Dependency//1986

The Ballad of Sexual Dependency is the diary I let people read. My written diaries are private; they form a closed document of my world and allow me the distance to analyse it. My visual diary is public; it expands from its subjective basis with the input of other people. These pictures may be an invitation to my world, but they were taken so that I could see the people in them. I sometimes don't know how I feel about someone until I take his or her picture. I don't select people in order to photograph them; I photograph directly from my life. These pictures come out of relationships, not observation.

People in the pictures say my camera is as much a part of being with me as any other aspect of knowing me. It's as if my hand were a camera. If it were possible, I'd want no mechanism between me and the moment of photographing. The camera is as much a part of my everyday life as talking or eating or sex. The instant of photographing, instead of creating distance, is a moment of clarity and emotional connection for me. There is a popular notion that the photographer is by nature a voyeur, the last one invited to the party. But I'm not crashing; this is my party. This is my family, my history.

My desire is to preserve the sense of people's lives, to endow them with the strength and beauty I see in them. I want the people in my pictures to stare back. I want to show exactly what my world looks like, without glamourization, without glorification. This is not a bleak world but one in which there is an awareness of pain, a quality of introspection.

We all tell stories which are versions of history – memorized, encapsulated, repeatable and safe. Real memory, which these pictures trigger, is an invocation of the colour, smell, sound and physical presence, the density and flavour of life. Memory allows an endless flow of connections. Stories can be rewritten, memory can't. If each picture tells a story, then the accumulation of these pictures comes closer to the experience of memory,, a story without end.

I want to be able to experience fully, without restraint. People who are obsessed with remembering their experiences usually impose strict self-disciplines. I want to be uncontrolled and controlled at the same time. The diary is my form of control over my life. It allows me obsessively to record every detail. It enables me to remember. […]

Nan Goldin, Introduction, *The Ballad of Sexual Dependency* (New York: Aperture Foundation, Inc., 1986) 6.

Jean Baudrillard
Cool Memories//1987–90

You have to be a perfect dancer to dance immobility, like these solitary breakdancers ... Their bodies only move at long intervals, like the hand of a clock stopping for a minute on every second, spending an hour on each position. This is freeze-act, as elsewhere one finds the freeze-phrase (the fragment which fixes the writing) or the freeze-frame in cinema, which fixes the entire movement of the city. This immobility is not an inertia, but a paroxysm which boils movement down into its opposite. The same dialectic was already present in Chinese opera or in animal dances – an art of stupor, slowness, bewitchment. This is the art of the photograph too, where the unreal pose wins out over real movement and the 'dissolve', with the result that a more intense, more advanced stage of the image is achieved in photography today than in cinema. [...]

Jean Baudrillard, *Cool Memories II, 1987–1990* (Paris: Éditions Galilée, 1990); trans. Chris Turner (Durham, North Carolina: Duke University Press, 1996) 44.

Susanne Gaensheimer
Moments in Time//1999

How could recollection only arise after everything is over?
– Henri Bergson

In 1978 James Coleman created the first version of his slide projection *La tache aveugle,* in which thirteen frames from a sequence of about half a second from the 1933 film *The Invisible Man* by James Whale are projected onto a large wall for a period of more than eight hours. The plot of *The Invisible Man* is based on the novel of the same name by H.G. Wells, first published in 1897. The short scene which Coleman uses in *La tache aveugle* contains that fateful moment of transformation when the protagonist finds himself on the borderline between invisibility and visibility. Trapped in a barn, he falls into the hands of his pursuers and is shot. At that moment, he loses the protection of invisibility and with it, his life, for his visibility returns at the moment of death.

By extending this brief sequence of about half a second over a duration of more than eight hours, the intervals between the individual frames are stretched to more than 36 minutes. The succession of images, which in film creates an illusion of continuity by being transported at a particular speed, namely 24 frames per second, is slowed down so much in *La tache aveugle* (by remaining more than half an hour at one single image) that perception of a continuous event is made impossible. The individual frame, whose function in film is to constitute an overall movement, becomes autonomous and is transformed from a moving into a static, still image. With reference to Henri Bergson, who in *Creative Evolution* (1907) describes perception as a cinematographic process whereby we take 'snapshots' from the 'passing' reality and 'string them on a becoming, abstract, uniform and invisible, situated at the back of the apparatus of knowledge',[1] Gilles Deleuze calls the single image in film an 'instantaneous section'.[2] It is an 'immobile section of movement'[3] reflecting an action in one of innumerable instants. Thus, alongside the single images, or instantaneous sections, the second precondition of film is to set those in motion. Borrowing almost literally from Bergson, Deleuze describes movement in a film as an 'impersonal, uniform, abstract, invisible or imperceptible' time which 'is "in" the apparatus, and "with" which the images are made to pass consecutively'.[4]

Technically speaking, Deleuze defines the medium of film as a number of snapshots (as opposed to the long-exposure photograph), which are transferred to a framework (that is, the film) at an equal distance from one another and

transported by a mechanism for moving the images. 'It is in this sense that the cinema is the system which reproduces movement as a function of any-instant-whatever that is, as a function of equidistant instants, selected so as to create the impression of continuity.'[5] Deleuze defines the frame in film as 'any-instant-whatever' because it is one of innumerable instants of a movement at an equal distance to one another. It is neither the motif nor the particular position that grant significance to the individual image, but its function as a constitutive fraction of a comprehensive sequence of movement.

Unlike the classical panel painting, the individual image in film is not the illusionist synthesis of a narrative context but a single and, according to Deleuze, incidental moment ('any-instant-whatever') in an overall narrative structure. It is an instantaneous section of movement, not conceived as an autonomous image. When a film is projected in the conventional manner, for example in cinema, the individual image is not perceptible. In the slide projection *La tache aveugle*, however, it is made not only visible, but also monumental, due to the unusual duration and size of the projection. An image whose conventional function is to constitute the representation of movement itself becomes a carrier of meaning. Given that the sequence Coleman uses from *The Invisible Man* is itself only a fraction of a more comprehensive event which in turn is also only partially visible (namely, the transformation from invisibility to visibility), what one expects to perceive is reduced to a minimum. The meaning that the single image in *La tache aveugle* transports in the context of the entire scene is not perceptible. The fictional non-visibility of the protagonist in *The Invisible Man* at the moment of his transformation – the blind spot – has a conceptual parallel in the observer's actual inability to see it. Yet although no event is perceptible in *La tache aveugle* and the narrative structure is obliterated, the installation actually does retain movement, even if slowed down almost to a standstill and thus to the point of being unrecognizable.

In *24 Hour Psycho* (1993) Douglas Gordon projects a video copy of Alfred Hitchcock's film *Psycho* in extreme slow motion and without sound onto a free-standing 3 x 4 metre screen. The otherwise unaltered tape is played at the greatly reduced speed of about two frames per second, so that the projection of the whole film lasts 24 hours. The screen is visible from the front and the back. By extending the intervals between the frames to two per second instead of 24, the movement is slowed down in the extreme, similarly to Coleman's *La tache aveugle*. Although the intervals between the individual images are not so extended that they can be perceived autonomously, as in the latter, they are nevertheless long enough to abolish the continuity of the action. In *24 Hour Psycho* it is not the single image that becomes independent, but individual

elements of the overall action – such as gestures or parts of movements – into which the images condense. The unusually slow (for our cognitive conventions) rhythm of the film makes it impossible to read an integral plot. Instead this is split up into its individual components: An embrace, a scream, a look of fear – gestures and facial expressions free themselves from the narrative structure of the film and linger silently on the large screen in the dark room.

Unlike in *La tache aveugle*, we can perceive individual actions or parts of actions in *24 Hour Psycho*, but the slowing down of the movement dissolves the relationships between them. What event gave rise to that anxious look, who are the wide eyes looking at, is there someone else in the room? Even if we were to remain in front of the installation for several hours and try to follow the plot, we could not grasp the dramatic form and psychology of those relations. In Deleuze's analysis of film, movement and relation are directly related. As the frame is an immobile, 'instantaneous' section of movement, so movement is a mobile section of duration.[6] Deleuze defines duration in terms of relations. In his sense therefore, reducing the movement means dissolving the relations; the meaning-giving link between the actions disintegrates. It is remarkable that with Hitchcock's *Psycho* Gordon has selected a classic example of narrative cinema, only to render it unreadable. In Hitchcock's films in particular, it is not so much the motifs themselves as their inter-relations that constitute the subject of the film. Of central importance are not so much the action or the one who carried out the action (the 'whodunit') as the set of relations between them. Deleuze points out that the psychological and emotional reactions of the viewer, his affection, also play a significant role in this set, like a third instance. Thus a trinity is formed of representation, meaning and interpretation, corresponding to the ternary structure in Peirce's semiotics. According to Charles Sanders Peirce, the sign consists not only of a signifier and a signified, but also of a third, mediating instance, the interpretant. However, if the readability of the film's narrative is eliminated, making an interpretation in the traditional sense impossible, then its semiotic structure is altered and a new, different meaning construed.

The slowing down of the rhythm of images by technically extending the intervals between them is also a stylistic means used in Bill Viola's *The Greeting*. This 1995 installation is a large-format projection showing the encounter of three women. The scene was originally shot on 35 mm film and then transferred to a laser disk. A wind-like sound is added to the scene. Unlike Coleman's *La tache aveugle* and Gordon's *24 Hour Psycho*, *The Greeting* is not based on existing film footage. Viola himself has filmed a staged scene at 300 frames per second. Thus it was possible to produce extreme slow motion and at the same time maintain the pristine pictorial quality of a film made at the normal speed

of 24 frames per second. The scene's real time of about 45 seconds is drawn out in the video to last ten minutes.

Initially *The Greeting* shows two women against a vast urban backdrop. As they talk to one another, a third younger woman, who seems to know one of the two older women, appears on the scene. These two greet one another with an embrace and start up an intimate conversation, during which the third woman seems to retreat more and more into the background. As explained in detail by Irene Netta in her essay 'Time in the Work of Jan Vermeer and Bill Viola' [in *Moments in Time: On Narration and Slowness*, Munich, 1999], with *The Greeting* Bill Viola makes a reference to the mannerist depiction of a Visitation by Jacopo Pontormo from the years 1528–29. Without referring directly to this link, Viola gave his work the neutral title *The Greeting*, leaving the Christian iconography of the scene in the dark, as it were.

As in *24 Hour Psycho,* the action in *The Greeting* is drawn out to such an extent that its totality and continuity disintegrate. Through the extreme slowing down of the movement, the greeting between the women seems to become divided up into a wealth of individual elements: each look, each movement, each fraction of a facial expression is released from the overall context of the story and stands out as meaningful. The beginning and end of the scene merge into an uninterrupted string of individual and independent moments. Not their meaning within the story, but they themselves become dominant. The viewer oscillates, therefore, between the attempt to grasp the narrative of the scene at each moment of the movement, and the temptation to abandon himself to the seductive power of the latter. Intensified by the hypnotic effect of the wind-like sound, *The Greeting* conjures up such a strong presence of the moment that an atmosphere of contemplation is created. Thus, although the narrative organization of the scene is dissolved by the extreme reduction of motion, and its concrete reference to a theme in Christian iconography is veiled, the contemplative effect of the work hints at a transcendent dimension. In this way the dissolution of the narrative structure in the slow motion creates a second, less concrete, more intuitable than readable meaning next to the foreground motif of the greeting.

By manipulating the classical narrative techniques of film – that is, creating meaning through the organization of movement, time and space – Steve McQueen also introduces a meta-level in his ten-minute black and white film *Bear* (1993). This 16 mm film, transferred to a laser disc and projected onto a large wall, shows a scene that is formally reminiscent of the classical boxing match in popular films: From a mostly low angle, which simulates the perspective of a fictional observer 'close to the ring', the camera focuses on two

naked men in a match-like situation. What one initially perceives as the beginning of a fight soon becomes an ambiguous game of desire, intimacy and aggression. The men circle and approach one another, finally falling into an intimate embrace that suddenly turns into a wrestling match. The harsh lighting of the scene underscores details – the sweat on the skin of the wrestling bodies, the subtle expressions on their faces – only to fade them out abruptly in shrill refractions. In addition to the mainly low camera position, one also sees close-ups of the faces or unusual angles on the scene from below. The movements of the bodies in space are mostly shown in slow motion, the close-ups of the faces and bodies in almost static shots. At some points, during an exchange of blows, for example, the long shots are interrupted by a series of brief cuts.

On the one hand, McQueen is using the immanent narrative features of film to tell a story, and on the other, to undermine their traditional function by using them in an unconventional manner. As in the projections by Coleman, Gordon and Viola, the slowing down of the movement in *Bear* removes the individual moment from its overall context. This process is supported by the framing of the camera takes, which focus on individual details in the action and thus break up the scene as a whole, a closed form. Also, there is no introductory beginning and no explanatory end. The scene starts and finishes in the middle of the plot, so that it seems like a section from a larger, all-embracing context. In terms of content too, McQueen revokes any kind of explicitness that might initially appear to be inherent in the narrative structure of the scene. The relationship between the two men and their actions remains opaque, their nakedness removes the scene from any concrete context, the camera does not adopt one coherent perspective. Every attempt at an interpretation wavers in uncertainty. Not so much the action itself as its individual elements and the angle from which these are observed seem to be the subject of the film.

In his informative essay "'It's the way you tell'em". Narrative cliché in the films of Steve McQueen',[7] Jon Thompson emphasizes the meaning of the 'act of making' in *Bear*. 'This issue, as far as he is concerned, is always one of narrative intelligibility. Not [...] packaged Hollywood-style as a form of story-telling, but narrative which is pursued in and through the act of making, almost as a form of tactile, psycho-visual enquiry. Every decision is made as a part of a process, and the process is itself evidence of the presence of narrative'.[8]

The process of filmic observation (i.e., the subjective perspective on the event and its psychological dimensions) is represented by the specific manipulation of the stylistic means. By linking representation and what is represented, observer and observed, an identification between subject and object comes about within the story – an identification which is supported by the fact that Steve McQueen himself plays one of the two wrestlers. Subjectivity

in *Bear*, however, is only expressed 'between the lines'. What you see is not what is represented.

'This "linguistic" problem is the starting point of all my work – not only in the sense of spoken or written language, but also in terms of different media and idioms of knowledge.' [Stan Douglas.][9] In a complex interweaving of different narrative levels and linguistic and visual codes, Stan Douglas outlines a historical-literary panorama in his 1996 video installation *Nu.tka.*, which oscillates constantly between history and fiction, between readability and concealment. *Nu.tka.* consists of two components: the video projection of scenes of a coastal landscape in north western America originally taken on 35 mm film, and the quadrophonic reproduction of two monologues, in which different texts are spoken simultaneously. The landscape sequence shows Nootka sound on the west coast of Vancouver Island, a historically significant location which was discovered and occupied by competing European colonial powers in the eighteenth century. The monologues consist of historical documents and autobiographical texts by the commander of the first Spanish occupiers, José Estéban Martínez, and his prisoner, the English captain James Colnett.

Whereas the already delirious Englishman hovers between the traumatic recollection of his capture and his hope of escape, the Spanish conqueror exhibits more and more signs of a paranoid fear of not being able to master the sublime power of the unknown. The landscape scenes – smooth camera tracks along the coastal panorama – are projected slowly, in opposite directions, one on top of the other. The images are rastered and shown either on the 'even' or the 'odd' raster lines of the video projection. As a result, the shots seem to dissolve and merge with one another. At only six points do two identical takes coincide, so that the grid lines are completed and a clear image emerges. At these same moments, the incomprehensible text mixture of the two monologues is interrupted by identical texts spoken synchronously and thus clearly intelligible. The artist has taken these particular texts from the literature of Edgar Allan Poe, Miguel de Cervantes, Jonathan Swift, Captain James Cook and the Marquis de Sade, i.e., from nineteenth-century Romantic and colonialist writings whose references to the sublime, the unconscious and the uncanny act as a kind of metaphor for the threatening power of the Other.

In the coded language both of the landscape sequences and of the historical and fictional texts, *Nu.tka.* tells the story of a place, a moment in history and an imperialist policy, as well as of individual psychological and emotional experiences related to them. This story, however, is only partially readable. The images and texts are superimposed, blend with one another, and seem to dissolve in the raster of the slow video projection. Only at a few points do image

and text come together to form clear parts that appear like hallucinations in the stream of the uncertain. At these moments, it is possible for one or another observer to recognize information and decipher meaning – the ideal observer, who can distinguish and interpret the specific codes. '… photographs always have a constellation of reference that hangs over them – a place, a period, a cultural setting – which someone familiar with the material can recognize. In a similar way, I hope my work will provoke certain associations in people familiar with the quoted cultural forms.'[10] But as soon as one starts to define landscapes and to understand fragments of texts, perhaps even recognizing their literary significance, the slow movement of the camera drifts apart, the images dissolve into one another and the texts become unclear. Expressed in these blurred areas between the lines and images is that which is not representable in the concrete idiom of the medium. Concealed behind the foreground story, present only in the form of absence, is the threatening unknown, that which is repressed. 'An absence is often the focus of my work. Even if I am resurrecting these obsolete forms of representation, I'm always indicating their inability to represent the real subject of the work. It's always something that is outside the system'.[11]

The exhibition *Moments in Time* (1999) opens up two perspectives on the relationship between narration and slowness. The first group of works, by James Coleman, Douglas Gordon and Bill Viola, deals with a form of slowness produced in the work itself by certain technical means. In these cases one could speak of a representation of slowness, in the very broadest sense. By extending a single moment, these works alter a given or staged narrative structure and partially dissolve it until it is unreadable.

In the second group of works, in particular in the projections by Bruce Nauman and Tacita Dean, slowness comes about not so much in the work itself, as in the observer's cognitive process of perception. The films *Art Make-up, # 1–4* (Nauman, 1967–68) and *Gellért* (Dean, 1998) were taken in real time. The duration of the event on the screen corresponds to the duration of their perception. Time is not manipulated in the film. Instead the film directly reproduces the time of the filmed action. Thus in the course of perception it is possible for viewers to be immersed successively in the action through their eyes. This also means that they must follow the whole sequence in order to experience its passage and possibly understand its meaning. In this second group of works, the term slowness refers to the duration of this successive form of perception.

In the four ten-minute silent colour films *Art Make-Up, # 1–4: White, Pink, Green, Black*, Nauman focuses the camera on the front of his naked torso, while carefully applying white, pink, green and black paint successively to his face and

body with his right hand. He begins with his arm, passes to his shoulder and armpit, then to his chest, and finally to his face, until his whole torso is evenly covered in paint. Fully absorbed in this action, Nauman's gaze is directed to an indeterminate point outside the frame. Although the observer can follow the movement of the artist's hand at every moment and can imagine the latter's psychological and emotional state of mind, the meaning of the action itself remains unclear. It could be interpreted (for example, in terms of Lacan's concept of narcissism, which emphasizes the self-destructive components of self-love and in which the Ego finds itself in an existential conflict, caught between abandonment to and aggression towards the ideal Ego) but it cannot be deciphered in terms of one 'logical' or clearly legible narrative.

Thus, while one follows the artist's hand in real time, trying to grasp the totality of the action through the single moment of the movement, a successive organization of individual moments of perception takes place. Bergson describes two versions of this process in *Time and Free Will*: '… when pushing my finger along a surface or a line provides me with a series of sensations of varying quality, then one of two things will happen: Either I will imagine these sensations only in a duration and they will then follow one another in such a way that at a given moment I cannot imagine several of them as simultaneous and yet clearly different; or else I will recognize in them a successive order, and then I have not only the capacity to perceive a succession of termini, but also to arrange these in series beside one another, once I have distinguished them …'[12]

Both these forms of perception presuppose a successive string of individual moments, that is to say, a perception which takes place not so much in the moment as in 'duration'.[13] Like the individual images in film, in the successive process of perception the moments of consciousness are strung in a row. In an 'intimate organization' they interpenetrate and form the consciousness of 'pure duration' in which 'our Ego […] abstains from making a distinction between the present and the prior states'.[14] Only when the individual moments interpenetrate, when our consciousness of the present and the past are not separate, do continuity and narration come about.

This consciousness of pure duration through the merging of present and past would seem to be visible in Tacita Dean's 16 mm film *Gellért.* This too was filmed in real time, as it were, though in a different way to Nauman's *Art Make-up.* The approximately six-minute colour film, shown as a loop, is a montage of several static shots taken over a period of one hour. They observe a group of women, calm and self-contained, moving slowly around the thermal baths of the Gellért Hotel in Budapest, as if detached from the temporality of the outside world. The images in the film are accompanied by the ambient sound of the bath: Snatches

of laughter, echoing voices, splashing water, create an atmosphere of calm and detachment. It is the detachment of those who are capable of freeing themselves from the general stream of time, creating within themselves an autonomous relationship to space and time. The movement of the bathers in *Gellért* is so reduced, their activity so focused on the here and now, that the difference between present and past seems to be obliterated. What was, what is, and what will be merge smoothly with one another, so that even the difference between the six minutes of the film and the 60 minutes in reality seems to disappear.

Although formally *Gellért* is based on both the shot and the montage, the essence of this film is determined by the shot. In his analysis of the function of both these formal elements with relation to time in film, Deleuze distinguishes between montage as that element which determines 'the relations of time or of forces in the succession of images', and shot as that which determines 'the form or rather force of time in the image'.[15] Whereas the course of time is construed and manipulated in montage, and can, therefore, only be represented indirectly, in the shot – especially in the static shot – it is immediate and direct. Montage may well have the possibility of selecting moments and thus 'of achieving time',[16] yet it is in the shot that time can unfold in its innate poetry. With reference to the, in his opinion, outstanding importance of the shot in the representation of time, Andrei Tarkovsky expressed the wish, in *On the cinematographic figure*, 'that the cinematographer succeeds in fixing time in its indices perceptible by the senses'.[17] It would seem that this wish has been granted in the long and motionless shots in *Gellért*.

In a space such as the Gellért, in which artificial light deceives us as to the passing of time, it is the acoustic elements in particular, alongside the movements of the bathers, through which time becomes perceptible to the senses. Thus in *Gellért* the movement of the persons through the space, and with it the passing of time, are discernible in the melody of the sounds of the water and the slight echo of laughter in the wide halls. The special atmosphere of this place, influenced as much by its architecture as its temporality, also finds expression in the diffuse ambient sound in *Gellért*. Dean attaches a special importance to the soundtracks of her films. These are usually made independently of the films and are mounted with great care in the last phase of production. In order to intensify the strongly evocative power of noises, voices and other acoustic elements, the artist often positions the soundtrack some minutes before or even after the appearance of the images. As a result, the loop contains a phase in which the soundtrack can be heard before the images are seen, or when they have already passed. The associative power of the sounds in *Gellért* is particularly evident at that moment when they occur at the same time as those 'black' moments in the film loop, when no images are yet visible. Even

before the first shots of the bath appear, the sounds have already inspired the first virtual images in our imagination. These are then superimposed on the images of the film, so that the recollection of the imagined image coincides with the image actually being perceived at the moment of observation.

In *L'Énergie spirituelle*[18] Bergson addresses the relationships between memory and perception, past and present. He discusses the necessity of that fundamental characteristic of the present described by Saint Augustine in his *Confessions*[19] – that it is always on the threshold between past and future, i.e., already transformed into the past at each new moment of its existence. Only if the present passes away at the very moment of its presence, can a new present come to be. Deleuze formulates this principle with reference to the image: 'If it was not already past at the same time as present, the present would never pass on'.[20] According to Deleuze, the present is the actual image, and the past inherent in the present is its virtual mirror image. He is referring here to Bergson's remarks on the déja-vu, which points to the existence in the present of a recollection that takes place at the same time as the present: 'Our actual existence, then, whilst it is unrolled in time, duplicates itself along with a virtual existence, a mirror image. Every moment of our life presents the two aspects, it is actual and virtual, perception on the one side and recollection on the other ...'[21] As the past is formed not *after* the present but *simultaneously* with it, therefore time must divide itself up into present and past in each of its individual moments. This division implies a schizophrenia of the moment, from which Deleuze derives the metaphor of the crystal image: a synthesis of the passing actual image of the present and the preserved virtual image of the past. Both are different and yet indistinguishable: 'The crystal always lives at the limit; it is itself the vanishing limit between the immediate past, which is already no longer, and the immediate future, which is not yet ... [it is a] mobile mirror which endlessly reflects perception in recollection'.[22] Thus, like a photograph, as described by Roland Barthes in *La Chambre claire*,[23] each image and each moment is the index of its own transience, a sign of death.

By combining two one-minute videos, *Mutter, Mutter* (1992) and *Ei-Dorado* (1993), projected one after the other in an endless loop, Rosemarie Trockel opposes the two forms of slowness which constitute the poles of this exhibition: the representation of slowness by technically extending the moment, and the emergence of a consciousness of duration in the very process of perception. In doing so, she contrasts the literal form of narration, in which a story is told in a classical narrative structure, with the coded form, in which what is represented serves to mediate another meaning not representable by what is actually visible.

Both videos were made in black and white and with a soundtrack. *Mutter, Mutter* tells the short story of a woman slowly descending a staircase into a kind of cellar or laundry room, picking up a carpet beater and hitting two large plastic spiders with it. The picture quality is so coarse that the objects in the room and the woman's actions are not clearly distinguishable. The action is accompanied by mediterranean guitar music, which is also reminiscent of popular melodies. *Ei-Dorado* seems abstract by comparison with *Mutter, Mutter*. On a moving white surface is a collection of eggs which have all been provided with a German name: Otto, Ulf, Gitta, Rosi, Doro, Moni ... The eggs move along with the surface on which they are lying. The sound of the video consists of a machine-like noise which is combined with the silent rendering of a Janis Joplin song. The surface becomes more and more agitated, until one after the other the eggs roll off. The next shot shows a heap of broken eggs, at which point the sound-collage turns into Janis Joplin's scream.

Whereas *Mutter, Mutter* tells a short story that is construed as an integral course of events and refers, by way of association, to a wider narrative context, *Ei-Dorado* functions more like a code, whose signs stand for something other than what they represent and have to be decoded before their meaning can unfold. Both videos, and their sound tracks, evoke a chain of initially different associations, which, however, at a none too distant point form a superordinate complex of meaning: fertility, femininity, movement, time, death etc. Not only the video's narratives but their temporal structures differ fundamentally. Initially *Mutter, Mutter* departs from a classical filmic space-time-continuum, in which time and its stylistic manipulation fulfil a function related to the content, as in the works of Viola and McQueen. *Ei-Dorado*, by contrast, is beyond all narrative clichés. Here the passing of time plays a role in the cognitive process of the successive perception of events.

As the two videos are shown continuously one after the other, our perception is constantly shifting from the one narrative and temporal form to the other. Narrative and abstraction, representation and coding, slowness of movement and duration of perception – the complexity of our cognitive apparatus on the one hand, and that of the various forms of representation on the other, are thus brought to our attention. In Rosemarie Trockel's videos, as in the other works in the exhibition, it is the change in conventional narrative and temporal structures in particular which interrupts the flow of our familiar perceptive mechanisms, allowing a free space to emerge. What happens when our cognitive expectations are not fulfilled? When the individual moments liberate themselves from the continuity of the movement? When meaning is transformed and information coded? It is this new space, evoked by the interruption of the familiar set of cognitive patterns, which links the eight works in the exhibition like a common

denominator – and perhaps also the invitation to the observer to become aware of its complexity.

1 Henri Bergson, *L'Évolution creatrice* (Paris, 1907).

2 Gilles Deleuze, *Cinema 1: The Movement-Image*, transl. Hugh Tomlinson and Barbara Habberjam (Minneapolis: University of Minnesota Press, 1986) [...]

3 Deleuze, *Cinema 1*, op. cit., 8.

4 Ibid., 1.

5 Ibid., 5.

6 Ibid., 8.

7 Jon Thompson, '"It's the way you tell'em". Narrative cliché in the Films of Steve McQueen', in exh. cat (Frankfurt am Main: Portikus, 1997).

8 Ibid., 6

9 Diana Thater in conversation with Stan Douglas, in *Stan Douglas* (London: Phaidon Press, 1998) 8.

10 Ibid., 24.

11 Ibid., 16.

12 Henri Bergson, *Essai sur les données immédiates de la conscience* (Paris 1889).

13 With the term 'duration' Bergson introduced a qualitative concept of time based on the individual's experience of time. As early as 1889, in his *Essai sur les données immédiates de la conscience*, Bergson distinguishes between the 'empty time' of classical physics and the 'experienced time' of our immediate consciousness. [...]

14 Deleuze, *Cinema 2*, op. cit., 77

15 Ibid., 42

16 Ibid. Deleuze here refers to Pasolini who in *Empirismo eretico* (Milan 1972) underlined the major importance, in his view, of montage as opposed to frame.

17 Andrei Tarkovsky, 'De la figure cinématographique', in *Positif*, no. 249 (December 1984).

18 Bergson, *L'Énergie spirituelle* (Paris, 1919).

19 *The Confessions of Saint Augustine*, trans. E.B. Pusey (London, 1907).

20 Deleuze, *Cinema 2*, op. cit., 79.

21 Bergson, *L'Énergie spirituelle*, op. cit., 136–9.

22 Gilles Deleuze, *Cinema 2*, op. cit., 81.

23 Roland Barthes, *La Chambre claire* (Paris, 1980; trans. *Camera Lucida*, New York, 1980)

Susanne Gaensheimer, 'Moments in Time: On narration and slowness in the works of James Coleman, Tacita Dean, Stan Douglas, Douglas Gordon, Steve McQueen, Bruce Nauman, Rosemarie Trockel and Bill Viola', trans. Pauline Cumbers, in *Moments in Time: On Narration and Slowness*, ed. Helmut Friedel (Munich: Städtische Galerie im Lenbachhaus/Kunstbau München/Ostfildern-Ruit: Hatje Cantz Verlag, 1999) 40–51.

IT DOESN'T FLOW
AS MUCH AS
FREEZE
INTO A SERIES OF
TABLEAU-LIKE
SCENES
LIKE A SINGLE
IMAGE
THE FILM
SIMULTANEOUSLY
SLOWS DOWN AND
EXTENDS TIME
DEMANDING THE
SAME OF OUR
ATTENTION
SPAN

Hannah Starkey, on Ang Lee's *The Ice Storm*, 2007

SERIALITY

Siegfried Kracauer
Photography//1927

The street, in the extended sense of the word, is not only the arena of fleeting impressions and chance encounters but a place where the flow of life is bound to assert itself. Again, one will have to think mainly of the city street with its ever-moving crowds. The kaleidoscopic sights mingle with unidentified shapes and fragmentary visual complexes and cancel each other out, thereby preventing the onlooker from following up any of the innumerable suggestions they offer. What appeals to him are not so much sharp-contoured individuals engaged in this or that definable pursuit as loose throngs of sketchy, completely indeterminate figures. Each has a story, yet the story is not given. Instead an incessant flow casts its spell over the *flâneur*, or even creates him. The *flâneur* is intoxicated with life in the street – life eternally dissolving the patterns which it is about to form. […]

Siegfried Kracauer, from 'Die Fotografie', *Frankfurter Zeitung*, no. 802/803 (Frankfurt am Main, October 1927); trans. Thomas Y. Levin, in *Critical Inquiry*, 29 (Chicago: University of Chicago, Spring 1993).

László Moholy-Nagy
Image Sequences/Series//1946

There is no more surprising, yet in its naturalness and organic sequence, simpler form than the photographic series. This is the logical culmination of photography – vision in motion. The series is no longer a 'picture', and the canons of pictorial aesthetics can only be applied to it *mutatis mutandis*. Here the single picture loses its separate identity and becomes a part of the assembly; it becomes a structural element of the related whole which is the thing itself. In this sequence of separate but inseparable parts, a photographic series – photographic comics, pamphlets, books – can be either a potent weapon or tender poetry.

But first must come the realization that the knowledge of photography is just as important as that of the alphabet.

The illiterate of the future will be the person ignorant of the use of the camera as well as of the pen.

László Moholy-Nagy, 'image sequences; series' (1946), in Moholy-Nagy, *Vision in Motion* (Chicago: Institute of Design, 1947) 208.

Pier Paolo Pasolini
Observations on the Long Take//1967

Consider the short, 16 mm film of Kennedy's death. Shot by a spectator in the crowd, it is a long take, the most typical long take imaginable.

The spectator-cameraman did not, in fact, choose his camera angle; he simply filmed from where he happened to be, framing what he, not the lens, saw. Thus the typical long take is subjective. In this, the only possible film of Kennedy's death, all other points of view are missing: that of Kennedy and Jacqueline, that of the assassin himself and his accomplices, that of those with a better vantage point, and that of the police escorts, etc.

Suppose we had footage shot from all those points of view; what would we have? A series of long takes that would reproduce that moment simultaneously from various viewpoints, as it appeared, that is, to a series of subjectivities. Subjectivity is thus the maximum conceivable limit of any audiovisual technique. It is impossible to perceive reality as it happens *if not from a single point of view*, and this point of view is always that of a perceiving subject. This subject is always incarnate, because even if, in a fiction film, we choose an ideal and therefore abstract and non-naturalistic point of view, it becomes realistic and ultimately naturalistic as soon as we place a camera and tape recorder there: the result will be seen and heard as if by a flesh-and-blood subject (that is, one with eyes and ears).

Reality seen and heard as it happens *is always in the present tense.* The long take, the schematic and primordial element of cinema, is thus in the present tense. Cinema therefore 'reproduces the present'. Live television is a paradigmatic reproduction of something happening in the present.

Suppose, then, that we have not only one short film of Kennedy's death, but a dozen such films, as many long takes as subjectively reproduce the President's death. When, for example, for purely documentary reasons (during a screening for a police investigation) we see all these subjective long takes in sequence, that is, when we splice them, even if not materially, what do we have? A type of montage, albeit extremely elementary. And what do we get from this montage? *A multiplication of 'presents'*, as if an action, instead of unwinding once before our eyes, were to unwind many times. This multiplication of 'presents' abolishes the present, empties it, each present postulating the relativity of all others, their unreliability, imprecision and ambiguity.[1]

For the police – who are least concerned with aesthetics and strongly interested in the documentary value of the short film projected as eyewitness

testimony to an event that must be precisely reconstructed – the first question to ask is: which of these films best represents the facts? There are so many unreliable eyes and ears (or cameras and tape recorders) which record an irreversible event, one which appears different to each of these natural organs or technical instruments (shot, countershot, establishing shot, medium shot, close-up, and all other possible camera positions). Each of these presentations of reality is extremely impoverished, aleatory, almost pitiful, if one realizes that it is *only one* among many.

It is clear that reality, in all its facets, is expressed in each: it speaks to those present (to be present is to take part, *because reality speaks only through itself*): it speaks its own language, which is the language of action: a gun shot, more gun shots, a body falls, a car stops, a woman screams, the crowd shouts … All these *non-symbolic signs* indicate that something happened: the death of a president, here and now, in the present. And that present, I repeat, is the tense of the various subjective long takes, shot from the various points of view where witnesses happened to be with their organs or instruments.

The language of action is thus the language of non-symbolic signs in the present tense; but in the present it makes no sense, or if it does, it does so only subjectively, in an incomplete, uncertain, mysterious way. *Kennedy, dying, expresses himself in his final action*: falling and dying, on the seat of a black presidential car, in the weak embrace of his American petit-bourgeois wife.

But this extreme language of action with which Kennedy is expressed to the spectators remains indecisive and meaningless in the present in which it was perceived by the senses and/or filmed. Like every moment of the language of action, *it requires something more.* It requires systematization with regard to both itself and the objective world; it must be related to other languages of action. In this case, Kennedy's final actions need to be related to the actions of those at that moment surrounding him, for example, to those of his assassin, or assassins.

As long as such actions remain unrelated, be it the language of Kennedy's last action or that of his assassins, they are fragmentary and incomplete languages, all but incomprehensible. What is needed to make them complete and comprehensible? The relationship which each of them, groping and stammering, seeks with the others must be established. Not through a simple multiplication of presents – as in the juxtaposition of various subjective views – but through their coordination. Unlike their juxtaposition, their coordination is not, in fact, limited to destroying and emptying the concept of the present (as in the hypothetical projection one after the other of the various films at FBI headquarters) *but to rendering the present past.*

Only completed acts may be coordinated among themselves and thus acquire meaning (as I will demonstrate later on).

For the moment let's suppose that among the detectives who have seen these hypothetical films spliced end-to-end there is one with an ingenious analytical mind. His ingenuity might show itself only in coordination. Intuiting the truth from an attentive analysis of the various pieces, he could gradually reconstruct it by choosing the truly significant moments of the various long takes, thereby finding their real order. One has, simply, a montage. In the wake of such work of choice and coordination, the various points of view would be dissolved and subjectivity would give way to objectivity; the pitiful eyes and ears (or cameras and recorders) which select and reproduce the fleeting and none too pleasant reality would be replaced by a narrator, who transforms present into past.

The substance of cinema is therefore an endless long take, as is reality to our senses for as long as we are able to see and feel (a long take that ends with the end of our lives); and this long take is nothing but the reproduction of the language of reality. In other words it is the reproduction of the present.

But as soon as montage intervenes, when we pass from cinema to film (they are very different, just as *langue* is different from *parole*), the present becomes past: a past that, for cinematographic and not aesthetic reasons, is always in the present mode (*that is, it is a historic present*).

I must now tell you my thoughts about death (and I leave my skeptical readers free to wonder what this has to do with cinema). I have said frequently, and always poorly, that reality has its own language – better still, it *is* a language – which, to be described, requires a general semiology, which at present we do not possess, even as a notion (semiologists always observe distinct and finite objects, that is, various existing languages, codified or not; they have not yet discovered that semiology is the descriptive science of reality).

This language – I've said, and always badly – coincides with human action. Man expresses himself above all through his action – not meant in a purely pragmatic way – because it is in this way that he modifies reality and leaves his spiritual imprint on it. But this action lacks unity, or meaning, *as long as it remains incomplete.* While Lenin was alive, the language of his actions was still in part indecipherable, because it remained *in potentia*, and thus modifiable by eventual future actions. In short, as long as he has a future, that is, something known, a man does not express himself. An honest man may at seventy commit a crime: such blameworthy action modifies all his past actions, and he thus presents himself as other than what he always was. So long as I'm not dead, no one will be able to guarantee he truly knows me, that is, be able to give meaning to my actions, which, as linguistic moments, are therefore indecipherable.

It is thus absolutely necessary to die, *because while living we lack meaning,* and the language of our lives (with which we express ourselves and to which we

attribute the greatest importance) is untranslatable: a chaos of possibilities, a search for relations among discontinuous meanings. *Death performs a lightning-quick montage on our lives*; that is, it chooses our truly significant moments (no longer changeable by other possible contrary or incoherent moments) and places them in sequence, convening our present, which is infinite, unstable and uncertain, and thus linguistically indescribable, into a clear, stable, certain, and thus linguistically describable past (precisely in the sphere of a general semiology). *It is thanks to death that our lives become expressive.*

Montage thus accomplishes for the material of film (constituted of fragments, the longest or the shortest, of as many long takes as there are subjectivities) what death accomplishes for life.

1 Bruce Conner's *Report* (1964) in fact illuminates, through its serial structuring of such footage, Pasolini's speculations. [translators]

Pier Paolo Pasolini, 'Osservazioni sul piano-sequenza' (1967), reprinted in Pasolini, *Empirismo eretico* (Milan: Garzanti Editore s.p.a., 1972; 2000) 237–41; trans. Norman Macafee and Craig Owens, 'Observations on the Long Take', *October*, no. 13 (Cambridge, Massachusetts: The MIT Press, Summer 1980) 3–6.

Wim Wenders
Time Sequences, Continuity of Movement//1971

Right at the beginning – and not much of that has survived – I thought making films meant setting the camera up somewhere, pointing it at some object, and then just letting it run. My favourite films were those made by the pioneer filmmakers at the turn of the century, who purely recorded and were surprised by what they had captured. The mere fact that you could make an image of something in motion and replay it fascinated them. A train pulling into a station, a lady in a hat taking a step backwards, billowing steam and a stationary train. That's the kind of thing the early filmmakers shot, cranking the camera by hand. They viewed it the next day, full of pride. What fascinated me about making films wasn't so much the possibility of altering or affecting or directing something, but simply watching it. Noticing or revealing things is actually much more precious to me than getting over some kind of message. There are films where you can't discover anything, where there's nothing to be discovered, because everything in them is completely unambiguous and obvious. Everything is presented exactly the way it's supposed to be understood. And then there are other films, where you're continually noticing little details, films that leave room for all kinds of possibilities. Those are mostly films where the images don't come complete with their interpretations.

Last year Robby Müller and I made a film called *Summer in the City*: it's shot in 16 mm black and white, it's two and a half hours long, and we shot it in six days. It had a screenplay, more or less, so that when we see the film now we're pretty sure what parts of it we were responsible for – mostly the framing and the dialogue – and what was left to chance. The way the film turned out, there's something almost private about it, the people who appeared in it were friends, it was all shot straight off, we only went for a second take when something went totally wrong. That first film could have been of any length: it was my graduation film at film school. It started off at three hours, but that seemed too long to me, so now it's two and a half. There's a shot in it of a cinema in Berlin and it's held for two minutes without anything happening, just because I happened to like the cinema; it was called the Urania. Or we drove the length of the Kudamm,, shooting out of the car window. In the film that lasts eight minutes, just as long as it took to shoot. We wouldn't have been able to use that shot of the cinema in *The Goalkeeper*: it would have been impossible,, a withdrawal into an attitude of pure contemplation. It would have left a hole that the rest of the film would have disappeared into. The eight-minute drive would

have had to be intercut with something else, and even then it couldn't have gone on for eight minutes. In *Summer in the City* we drove through a tunnel in Munich, and I filmed out of the side window of the car. We drove through this long tunnel and out the other side. For about a minute all you see on the screen is blackness, with the occasional headlight, and when I did the mixing, the man who sits at the back and puts on the tapes came up and said to me that there were a lot of things he liked about the film, but why on earth didn't I cut when we drove into the tunnel. And when I said: 'The tunnel was half a mile long, and we couldn't do it any quicker', he gave me a look and said: 'You can't do that.' I should take a look at his films sometime: he made 8 mm films, he'd been to Romania and he'd made this twenty-minute film that showed you everything there was to see in Romania. And he got very angry, though he'd been friendly to begin with. Yet it seemed to me that we'd done a lot of things earlier in the film that might easily have provoked him much more,, but none of it made him as angry as the fact that I hadn't switched off the camera when we'd entered the tunnel. When people think they've seen enough of something, but there's more, and no change of shot, then they react in a curiously livid way. They think there must be some justification for it, but it never occurs to them that the fact that you happen to like whatever is in the shot is sufficient justification. They imagine there has to be some other reason, and when they can't find it they get mad. It makes them madder than when a film actually insults them – which can happen too.

I think it's really important for films to be sequential. Anything that disturbs or breaks up these sequences annoys me. Films have got to respect these sequences of action – even highly stylized films, like the one we're making at the moment, *The Goalkeeper's Fear of the Penalty*. The continuity of movement and action must be true, there mustn't be any jolt in the time being portrayed. You see a lot of cuts like that now, especially in TV films, where they cut back and forth: close-up of someone speaking, cut to close-up of someone else listening, then back to the first person again – and you can just tell from his face that time has elapsed, time that you haven't been shown, because the whole thing's been 'tightened up'. I hate that, and it makes me angry whenever I see it happening. Doesn't matter what kind of film it is, I just think it should keep faith with the passage of time – even when it's not a 'realistic' film at all, but something quite artificial. There more than anywhere you have to observe certain rules, particularly visual rules. I hate abstract films where each image is somehow a separate thought, and where the sum of the images and thoughts is something quite arbitrary. Films are congruent time-sequences, not congruent ideas. Even a change of location is something I have difficulty with. In every scene, my biggest problem is always how to end it and go on to the next one. Ideally, I

would show the time in between as well. But sometimes you just have to leave it out,, it simply takes too long; so when someone leaves his house and turns up somewhere else, you leave out all the intervening time. Someone leaves the bar and goes back to his room, and for me it's terrible not to be able to show him going up the stairs. On the film I'm working on right now, it's the hardest thing. How do you cut this: he goes to bed at night, and then it's the following morning and he's having breakfast. Every time, I have to think: how do they manage that in films, how do they get from one day to the next? It's a problem even at the screenplay stage, cutting off an action that you know is actually continuing. In the end, the film just cuts somewhere. Every action – everything continues, and what you show is actually just a part of it. That's the hardest thing for me, how to choose what to show.

I spoke to a journalist the other day, someone who practically knew the novel by heart, and he quizzed me about specific passages in it, about how I'd managed to film them, and I got really scared. And yet all that's over and done with, really, how close the film is to the book, or if it's got anything to do with the book at all. Now someone's seen a print, and he said a particular scene seemed to him just exactly the way he remembered it in the book. And I couldn't even say whether it was in the book at all, or how it had been there, and I was just astounded that someone should come to me and say it was just like in the book. Actually, what interested me in the book wasn't so much the 'Handke' part of it as the writing: the way things were described, the way it moved from one sentence to the next. You suddenly felt completely hooked, because each sentence was so good on its own, the sequence of sentences suddenly seemed much more engrossing than the action and the question what, if anything, will happen next. I loved that about the book. How each sentence flows from the one before. That precision is what gave me the idea of making a film,, and of making it in a similar way too, using images in sequence, as Handke uses his sentences, images with the same truthfulness and precision. That's what made the film expensive to make, because achieving that sort of precision takes a great deal of trouble, making our images reminiscent of certain types of shot that you see a lot in American films, for instance, or using a particular kind of light that is difficult to produce. Because the images will 'click' only when you have that exact quality of light […]

Wim Wenders, 'Time Sequences, Continuity of Movement: *Summer in the City* and *The Goalkeeper's Fear of the Penalty*', *The Logic of Images* (London: Faber & Faber, 1991) 3–6.

Blake Stimson
The Pivot of the World: Photography and
Its Nation//2006

As a distinctive form, the essay draws its primary genealogical determinants initially from Montaigne and then from the Enlightenment philosophers. As a method of enquiry and exposition, it fleshes out its structure and shape through a process of groping towards conceptualization and articulation of its observations about the world rather than by trying to pin them down according to a pre-given method and set of established concepts or by presenting them as direct expressiveness that bypasses mediation through innovation. The essay, in other words, feels its way subjectively towards understanding about its object of investigation rather than through either the systematic analysis of science or the expressive enunciation of art. As such, the essay does not aim for rigour and incisive particularity in the manner of the thesis or study or dissertation, and it never approximates the depth and universality that artworks or poems or musical compositions often aspire to through the use of symbol or allegory. Instead, the essay works between fact and symbol, between comprehension and intuition, between objective understanding and subjective realization, in a manner that marks it as a third term, as an alternate way of experiencing and situating one's relation to the world. Fact pitted against symbol, and symbol against fact, it arises out of a keen awareness of the limits of both. The essay is itself a performance of subjectivity, but one that is neither nominal nor voluntaristic because it is developed only in and through its relation to the world it investigates, only as a process of coming into objectivity. It is in other words, analysis realizing itself as a subjective condition.[1]

Writing on this question [in 1958], at the same moment that the photographic projects studied here were being developed [*The Family of Man*; Robert Frank's *The Americans*; the work of Bernd and Hilla Becher], Adorno positioned the emergence of the essay at the split between art and science born of 'the objectification of the world in the course of progressive demythologization'.[2] The two poles of Adorno's critique generally were positivism (or the reduction of understanding to the concept) and aestheticism (or the reduction of understanding to appearance or impression), but he assumed the utmost importance for both. The truth was to be found in the mix, in the meeting of the two in the essay form. 'Aesthetic experience is not genuine experience', he wrote, 'unless it becomes philosophy'.[3] So too, he insisted, aesthetic experience is 'not accidental to philosophy'. Philosophy when it is done right measures itself by art just as much as art realizes itself in philosophy:

'What the philosophical concept will not abandon is the yearning that animates the non-conceptual side of art.'[4] Not attempting to be either a philosophical system itself or the revelation or raw innovation of art, the essay instead, according to Adorno, 'is radical in its non-radicalism', that is, radical 'in refraining from any reduction to principle', whether that principle is born of the disembodied empirical truths of science or the embodied expressive truths of art.[5] Instead, it occupies a middle ground immanent to both poles that allows it never to be reduced to either.

When the essay betrays that refusal of radicalism, betrays its own internal checks and balances, it attempts either to become science or to make conceptual understanding over into art. In this latter failure, the essay-become-art (or bad art) attempts a false reconciliation by becoming 'washed-out cultural babble' that refuses to 'honour the obligations of conceptual thought' and turns for its reconciliation to an 'aesthetic element' that 'consists merely of watered-down, second-hand reminiscences'. The essay gone bad – Heidegger was Adorno's principal example – is conceptual understanding trying to be aesthetic experience, science playing at being art: 'From the violence that image and concept thereby do to one another springs the jargon of authenticity, in which words vibrate with emotion while keeping quiet about what has moved them.'[6] The essay done right, in contrast, was a form of understanding groping towards articulation by working the split, by honouring the claims of both art and science without collapsing either into the other. In so doing, the essay becomes true only 'in its progress', only in and through its internal development from one word to the next, from one concept to the next, from the check of aesthetic experience played off against the balance of rational cognition: the elements of the essay, the concepts and affects given in words, sentences and paragraphs – or, for our purposes, in photographs – 'crystallize as a configuration through their motion'.[7]

As it emerged at the end of the nineteenth and the beginning of the twentieth centuries, the photographic essay defined itself, knowingly or not, around this formal criterion. 'What the pictures say', one historian has written insightfully about Walker Evans' classic essay American Photographs, for example, 'they say in and through the texture of relations which unfold – continuities, doublings, reversals, climaxes and resolutions'.[8] The idea that a series of pictures linked together could constitute an essay in all the richness of the form was widespread by 1937 when Evans' book was published. Henry Luce could comment that same year, for example, that what Life had learned was that a photographic series can 'picture the world as a seventeenth-century essayist'. Indeed, the best could 'give an impression', he argued, 'as personal and as homogeneous as any thousand words of Joseph Addison'.[9] The photographs collected together in essay form thus were assumed to be able to develop

together as a series of interrelated propositions or gestures in the manner that an argument or persona realizes itself in the world, in interactive performance, and thereby 'crystallize as a configuration through their motion'. The photographic essay, when done right, would take on a life of its own.

This sense of motion or unfolding of relations between images by linking photographs together in a series was first elaborated and systematized by Eadweard Muybridge and Étienne-Jules Marey and their followers in the 1870s, 1880s and 1890s. At this early moment in the development of the form, the motion given by the photographic series was still on the side of science, on the side of systematic understanding, still determined by a pregiven hypothesis and by the assumption that the emerging apparatus of serial photography would itself be simply and transparently neutral, that it would not endow its content with its own proprietary meaning. Following on these epistemological assumptions, the methodology of serial photography was initially developed in a corresponding manner, and the relations between photographs were defined mechanically and not yet allowed to develop on their own as a semi-independent (or interdependent) discursive medium. Seriality first gave to photography a new vigour as a pseudo-science (setting the stage for, among other things, pictorialism's rejoinder with various blurring techniques giving new vigour to photography's status as a pseudo-art) and served as linchpin in what Allan Sekula once called photography's 'philosophical shell game'. From the beginning, as he put it, photography has been peculiarly 'haunted by two chattering ghosts: that of bourgeois science and that of bourgeois art'. Its primary ideological function is to produce 'the apparent reconciliation of human creative energies with a scientifically guided process of mechanization' by ever-swapping one shell for the other, one chattering ghost for the other.[10]

While the door was open for the photographic essay to develop, the tension between conceptual and aesthetic understanding of serial form could not emerge without a poetic alternative to contradict photography's new role as pseudo-science. What Muybridge and his colleagues had achieved was a parsing of experience into analytical segments; what was needed in response was for those segments of experience to be sutured back together again into an affective unity or common thread of feeling or being. This was achieved in various ways, most prominently in theory by Henri Bergson and his many followers and most significantly in practice by film.

Serial photography has regularly been said to be like film or to be a precursor to film. The experience one gets in the movement from one image to the next to the next to the next, in a Muybridge series, for example, has routinely been understood to be cumulative, to develop as a synthetic experience of continuous

time. 'Each sequential element is perceived not next to the other', as one classic account of film form has it, one that has also been used to explain the workings of the photographic essay, 'but on top of each other. For the idea (or sensation) of movement arises from the process of superimposing on the retained impression of the object's first position, a newly visible further position.'[11] This routinely assumed conflation of the photographic essay with the prehistory of film is misleading and collapses one distinctive historical formation into another.[12] The similarities between the two forms are clear, but the idea and sensation of movement associated with film were, in fact, very different in kind from those offered by serial photography. We need only point out, for example, that the photographic essay is different from film precisely because it does *not* place each subsequent image on top of that which comes before it, that each image in the series, each instant in the representation, is preserved rather than being displaced by its follower.

We can put this difference most starkly with a simple comparison. A composition of still photographs in principle can be arranged into essay form in the manner outlined above – one that is 'radical in its non-radicalism', radical because it refrains from 'any reduction to principle' or 'system' or 'method', as Adorno put it – by entering into a dynamic relationship that gives its truth only in the process of the unfolding. Film, on the other hand, by its eighteen or twenty-four frames per second, its slow or fast motion, its freeze-frames, its material-temporal form, cannot – for film as a form is inescapably beholden to a rigid expository structure, to the succession of one frame after the next and the next and the next. In the words of one thoughtful scholar of the emergence of film form, it systematizes and structures 'life itself in all its multiplicity, diversity and contingency', and in so doing, that multiplicity, diversity and contingency are 'given the crucial ideological role of representing an outside', a 'free and indeterminable' relation to time that serves as the 'paradoxical basis of social stability in modernity'.[13]

The motion of film through the projector thus unavoidably takes on a function above and beyond that given by the movement of the essay: it gives rigid form to time and set temporality to form, and this addition endows film form (regardless of how plastically it is conceived, regardless of the degree to which other forms of time – narrative time, the time of the film crew or actors, the original temporality of the film itself – are challenged) with the radicalism that Adorno called system, principle and method. The film viewer is given a set, invariable chunk of time that is divided up and rewoven, first spatialized and then retemporalized, according to the filmmaker's or editor's system or method. What the viewer receives is a packaged composition of time, a pictorial, window-on-the-world expression of the experience of time.[14] Adorno makes the

same point by comparing the achievement of film to one of its literary contemporaries: 'The less dense reproduction of reality in naturalist literature left room for intentions: in the unbroken duplication achieved by the technical apparatus of film every intention, even that of truth, becomes a lie.'[15]

Film, in short, limits the performative unfolding made available in the photographic essay by its mechanization of the unfolding itself. Whether it wants to be or not, film makes itself over into a one-sided conversation – as we will see below – by collapsing the analytical, atemporal space opened up by the abstraction of serial photography back into a false synaesthetic naturalism of time.[16] What is lost in this suturing is the moment of science, the moment of opening up the space between subject and object, between hypothesis and empirical investigation, between theory and praxis, or the space that opens to the investigation of existing habits of perception. What is lost is the investigation into the hidden structures of movement through space and time, hidden factors available only to the analytical gaze of scientific method.

The key difference between serial photography and film can be understood by looking at what motivates the seriality in each. In the first attempts to use serial photography to capture motion and narrative sequence, the aim was not to reproduce life as experienced in time but instead to see what cannot be seen by the naked eye, to see what can be seen only when time is stopped. Muybridge's study of a horse gallop is the foundational case in point: the camera was brought in to give visual testimony to what the eye on its own could not see by disarticulating the sequence of events, by breaking the narrative apart into discrete moments, into discrete photographs. Such abstraction, of course, is the province of science and the partitioning of time made available by still photography that allowed the close, detailed analysis of sequencing from frame to frame. That mechanically amplified 'power of our sight', as applied to the depiction carried within any individual frame, would realize its most significant purpose in scientific management, or Taylorism. The stop-action and action-trace capacity of photography could break movement down into its constituent parts and flows, and chart those movements so that parts and paths through space and time could be re-narrated or re-choreographed by being put back together in better, more fluid and efficient systems of labour and organization, systems that were clearer and more focused in their sense of purpose.

This rationalization of vision in the systematic photographic series developed by Muybridge, Marey and others, and its later industrial applications, thus gave form to one side of a divide or debate over how the experience of time and space was to be best understood. That side argued for the mechanical, analytical understanding of movement, for breaking it apart into its constituent parts – its frames, as it were – and charting those individual, abstracted parts

like points along a curve. Each point, each frame, was thus available to analysis because it had been frozen by the camera and the collection of points mapped as an itinerary. There it could succumb to a calculus, an analytical derivation of the conflict of the various innate and environmental determinants that animated its movement through time. There it could succumb to a rationalization of the lived experience of time as it has been analysed endlessly by Foucault and his followers.

The other side of this divide, the side that can be broadly identified with film rather than photography, sought to counter what one commentator has called the 'spatialized duration', or the stopping of time so that the spatial coordinates and material conditions of one instant can be examined in depth.[17] In lieu of the series of frozen instants, this second side, the side given by film, sought to posit an alternate account of the experience of movement and duration that understood its meaning and vitality as a function not of the analyst's charting the coordinates of movement through space but instead of the vitalist's reanimating of those coordinates in time, of representing movement as flows and patterns of time by experiencing them as energy rather than as the effects of energy given in the transition from one frozen instant to another, one point in space to another.

The photographic essay was born of the promise of another kind of truth from that given by the individual photograph or image on its own, a truth available only in the interstices between pictures, in the movement from one picture to the next. At the moment when photography became film, however, a new question opened up that threatened to undermine its promise before it had even really emerged: How best to realize that movement? How best to develop the truth content of the exposition itself? Would it be with the spatialized time of the photographic series or with the retemporalized space of film as a form? The leading icon of the broad-based critical response to the photo-scientists like Muybridge and Marey, the photo-engineers like the Gilbreths, and the legion photo-essayists that would come was Bergson, and his inspiration carried far and wide in the literary and artistic culture of the first decades of the twentieth century.[18] So, too, this critique was evident in the work of many of Bergson's heirs: in Duchamp's famous pastiches of the chronophotographic and chrono-cyclegraphic methods (most notably in the work done during the period of his *Nude Descending a Staircase* series), for example, or in the work and writing of that other greatest visual symbolist of things-in-motion, Umberto Boccioni: 'Any accusations that we are merely being "cinematographic" make us laugh – they are like vulgar idiocies. We are not trying to split each individual image – we are looking for a symbol, or better, a single form, to replace these old concepts of division with new concepts of continuity'. Boccioni was clear about his debt to

Bergson on this pursuit of singular expressions of continuity and equally clear in his choice of quotations for his critique of the likes of Muybridge and Marey: 'Any dividing up of an object's motion is an arbitrary action, and equally arbitrary is the subdivision of matter. Henri Bergson said: "any division of matter into autonomous bodies with absolutely defined contours is an artificial division", and elsewhere: "Any movement viewed as a transition from one state of rest to another, is absolutely indivisible."'[19]

The problem was what Bergson called 'social life', or the abstraction of experience into socially and culturally determined analytical categories. That 'which is commonly called a *fact* is not reality as it appears to immediate intuition', he insisted, for example, in his brilliant *Matter and Memory*, 'but an adaptation of the real to the interests of practice and the exigencies of social life'.[20] Philosophy, like science itself and the scientific or pseudo-scientific photography of Muybridge and Marey, carves out discrete, socially defined concepts, facts and images from the continuous flow of experiential reality: 'Scientific thought, analysing this unbroken series of changes, and yielding to an irresistible need of symbolic presentment, arrests and solidifies into finished things the principal phases of this development. It erects the crude sounds heard into separate and complete words, then the remembered auditory images into entities independent of the idea they develop.'[21]

What philosophy (and representation generally) was to do under Bergson's lead thus was to 'get back to reality itself', that is, to retemporalize experience or put back into fluid motion that which had been broken apart into discrete parts or put back into time that which had been spatialized and therefore to redeem experience from the abstraction it has suffered in the hands of reason.[22] In so doing, the modern subject would benefit from a kind of redemption, a regrounding in the world: 'Subject and object would unite in an extended perception, the subjective side of perception being the contraction effected by memory, and the objective reality of matter fusing with the multitudinous and successive vibrations into which this perception can be internally broken up.' Truth, as he would have it, becomes the experience given to the perceiving subject in its most immediate, unarticulated form if one approaches that experience under the rule of one methodological principle: 'Questions relating to subject and object, to their distinction and their union, should be put in terms of time rather than of space.'[23] This temporalization was the theoretical underpinning of the false naturalism that would be given form by film.[24]

At issue dividing Marey and Muybridge's 'spatialized duration' from Bergson's *durée* or retemporalization of fragmented space was how experience was to be given to knowledge. What, in other words, was to be the experience of the representation of experience? Was time to be stopped, divided, distributed

and analysed in a laboratory setting to prepare for some future reconstitution of the whole out of its component parts? Or was it to be experienced anew as its own entity, reborn as a flow unto itself never visible as such, in a 'state of rest', or any time a single frame becomes discernible?[25] Was it, in other words, to be the stilled, spatialized domain of photography or the retemporalized domain of film? What was gained and what lost by the temporalizing of still photography, by introducing the 'idea (or sensation) of movement aris[ing] from the process of superimposing on the retained impression of the object's first position, a newly visible further position?'[26]

Serial photography was conceived from the beginning as an analytical project, and from the standpoint of the photographic essay, the filmic weaving together of eighteen or twenty-four individual photographs per second set that project back rather than advancing it. Marey was adamant on this point already in 1899: 'Cinema produces only what the eye can see in any case. It adds nothing to the power of sight, nor does it remove our illusions, and the real character of a scientific method is to supplant the insufficiency of our senses and correct their errors.'[27] Filmic time can be slowed and altered in any number of other ways, of course. But in so far as it continues to be film (and does not come to a stop, that is, to the condition of still photography), it gives in its form the principle and the experience of time. Time thus occupies the role of an unavoidable formal principle for film regardless of whether that temporality is somehow naturalistic or not, and in so doing it reproduces a specific illusion in the association of filmic time with lived time. The detail given in each frame of film is subordinated to the temporal hegemon of eighteen or twenty-four frames per second with each frame relentlessly giving way to the next and the next and the next in a singular neutralized temporality.[28]

The photographic essay is thus a form that holds onto the opening up of time, the 'spatialized duration' given by the experiments of Muybridge and Marey. It draws its meaning from the back-and-forth interrelation of discrete images that is eliminated when those images are sutured together into film. The photographic essay form also relies on – and draws its meaning and purpose from – a similar opening up of space into discrete and differentiated units. [...]

1 [footnote 32 in source] For more on this theme, see among other texts Jean Starobinski, *Montaigne in Motion* (1982), trans. Arthur Goldhammer (Chicago: University of Chicago Press, 1985).

2 [33] Theodor W. Adorno, 'The Essay as Form' (1958), in *Notes to Literature* (New York: Columbia University Press, 1991) 1: 6.

3 [34] Adorno, *Aesthetic Theory* (1970), trans. Robert Hullot-Kentor (Minneapolis: University of Minnesota Press, 1996) 131.

4 [35] Adorno, *Negative Dialectics* (1966), trans. E. B. Ashton (New York: Continuum, 1987) 15. [...]

5 [36] Ibid., 9.

6 [37] Ibid., 6–7.

7 [38] Ibid., 13. This is the foundation of dialectics as a whole. Witness the first page of the introduction to Hegel's *Logic*: 'The notion of logic has its genesis in the course of the exposition and cannot therefore be premised'. *Hegel's Logic: Being Part 1 of the Encyclopaedia of the Philosophical Sciences* (based on Hegel's 1830 text) trans. William Wallace (Oxford: The Clarendon Press, 1975) 43.

8 [39] Alan Trachtenberg, *Reading American Photographs: Images as History, Matthew Brady to Walker Evans* (New York: Hill and Wang) 259.

9 [40] Henry Luce, 'The Camera as Essayist', *Life* magazine (26 April 1937) 6–7.

10 [41] Allan Sekula, 'The Traffic in Photographs', *Art Journal*, 41, no. 1 (Spring 1981) 15; 22.

11 [42] This is Trachtenberg quoting Eisenstein to shore up his account. [...]

12 [43] This conflation is true of even the most learned and thoughtful accounts of early film. Leo Charney, for example, in an otherwise very interesting and productive account, reads Marey and Muybridge as only making visible the structure of film-as-representation: 'Muybridge and Marey ... anticipated the soon-to-emerge aesthetic of cinema in a simple and schematic manner: Both men used new technologies to re-present continuous motion as a chain of fragmentary moments ... both efforts made clear that in the constitution and reconstitution of movement, it is never possible to reconstitute the whole movement.' Leo Charney, 'In a Moment: Film and the Philosophy of Modernity', in Leo Charney and Vanessa R. Schwartz, eds, *Cinema and the Invention of Modern Life* (Berkeley and Los Angeles: University of California Press, 1995) 290. See also his *Empty Moments: Cinema, Modernity and Drift* (Durham, North Carolina: Duke University Press, 1998).

13 [44] Mary Ann Doane, *The Emergence of Cinematic Time: Modernity, Contingency, The Archive* (Cambridge, Massachusetts: Harvard University Press, 2002) 22; 230.

14 [45] This characteristic element of film is the subject of Deleuze's books on cinema and the turning point of his distinction between what he calls the classical 'movement-image' and the modern 'time-image' of cinema: 'The so-called classical cinema works above all through linkage of images, and subordinates cuts to this linkage ... Now, modern cinema can communicate with the old, and the distinction between the two can be very relative. However, it will be defined ideally by a reversal where the image is unlinked and the cut begins to have an importance in itself ... It is a whole new system of rhythm, and a serial or atonal cinema, a new conception of montage.' Each is its own image or 'system of rhythm' or ordering principle which comes to the beholder as a pre-given method, as a principle of time. Gilles Deleuze, *Cinema 2: The Time-Image* (Minneapolis: University of Minnesota Press, 1989) 213–14.

15 [46] Theodor W. Adorno, 'Intention and Reproduction', in *Minima Moralia: Reflections from a Damaged Life* (London: Verso, 1974) 142.

16 [47] Lisa Cartwright has this exactly right, I think, but looking at the problem from the other side. The 'greatest importance' of the film motion study, she writes, is 'its function as an intertext

between popular and professional representations of the body as the site of human life and subjectivity ... The film body of the motion study is thus a symptomatic site, a region invested with fantasies about what constituted "life" for scientists and the lay public in the early twentieth century ... and contributed to the generation of a broad cultural definition of the body as a characteristically dynamic entity – one uniquely suited to motion recording technologies like the cinema, but also one peculiarly unsuited to static photographic observation because of its changeability and interiority'. *Screening the Body: Tracing Medicine's Visual Culture* (Minneapolis: University of Minnesota Press, 1995) 12. What concerns us here is the loss resulting from that move to naturalism.

17 [48] Gilles Deleuze, *Cinema 1: The Movement-Image* (Minneapolis: University of Minnesota Press, 1986) 29.

18 [49] For more on this, see, for example, Mark Antliff, *Inventing Bergson: Cultural Politics and the Parisian Avant-Garde* (Princeton, New Jersey: Princeton University Press, 1993).

19 [50] Umberto Boccioni in 'Fondamento plastico' (1913) quoted by Marta Braun in *Picturing Time: The Work of Étienne-Jules Marey (1839–1904)* (Chicago: University of Chicago Press, 1992) 311. [...]

20 [51] Bergson, 'Introduction', op. cit., 238–9.

21 [52] Ibid., 154.

22 [53] Ibid.

23 [54] Ibid., 77.

24 [55] That naturalism is evident everywhere in Bergson's writings [...]

25 [56] Adorno was characteristically clear on issues subtending this debate: 'In the concept of *le temps durée*, of lived duration, Bergson tried theoretically to reconstruct the living experience of time, and thus its substantial element that had been sacrificed to the abstractions of philosophy and of causal-mechanical natural science. Even so, he did not convert to the dialectical concept any more than science did. More positivistically than he knew in his polemicizing, he absolutized the dynamic element out of disgust with the rising reification of consciousness; he on his part made of it a form of consciousness, so to speak, a particular and privileged mode of cognition. He reified it, if you will, into a line of business. In isolation, the time of subjective experience along with its content comes to be as accidental and mediated as its subject, and therefore, compared with chronometric time, is always "false" also. Sufficient to illustrate this is the triviality that, measured by clock time, subjective time experiences invite delusion.' *Negative Dialectics*, 333–4.

26 [57] The Bergsonian position continues to be a mainstay in aesthetic position taking by artists of all varieties. Witness, as just one example among countless, Bill Viola in the following interview: 'Q: Do you think that your work offers something that is intentionally excluded from mainstream popular culture?

'A: Yes, I think that one of the driving engines of not just filmmaking and media imagery today in the larger culture, but in so many facets of culture is ... time. You can look at conventional training in film as a study in the economics of time: How do you tell this story in a means that

is economical, that propels the story forward, that doesn't sit there, and when the sun goes down you don't turn the camera towards the window and watch it go down for half an hour? That's one of the reasons that Andy Warhol's films were so extraordinary, because he just turned the camera on the Empire State Building for eight hours. It sounds like a gimmicky thing, but if you ever watch that or one of his other films, it's incredibly palpable, and strange. I think that the whole notion, since the development of the mechanical clock in the fourteenth century, of time being portioned and cut up into identical units day and night, doesn't accurately describe our inner experience. Anyone who's ever been awake at three o'clock in the morning and goes through their daily life at three o'clock in the afternoon knows damn well that awake at three in the morning is not the same as three in the afternoon at your job. So that subjective sense of self, of space, of time, has been diminished in the great push that civilizations and societies have had to universalize and quantify experience through the scientific method.' Doug Harvey, 'Extremities: The Video Passions of Bill Viola', *LA Weekly* (24–30 January 2003) <http://www.laweekly.com/ink/03/10/features-harvey.php>.

27 [58] Étienne-Jules Marey, preface to Charles-Louis Eugène Trutat, *La photographic animée* (Paris: Gauthier-Villars, 1899) ix, quoted in Marta Braun, 'The Expanded Present: Photographing Movement', in Ann Thomas, *Beauty of Another Order: Photography in Science* (New Haven, Connecticut: Yale University Press/Ottowa: National Gallery of Canada, 1997) 175.

28 [59] In this regard, film's strong temporal structure, subordinating the details of its composition to its overall formal principle, can be said to be similar to the dominance of spatial structure given by Renaissance linear perspective. In the latter, in lieu of the beholder being addressed by and adapting herself to the singular expressive temporality of film, he is interpellated by a single dominant expressive spatiality. Like the strong time of film, linear perspective's rigid system of space attempts to render the experience of representation equivalent to the experience of experience itself. Its realism is rigorously mimetic rather than analytical, or, rather, its analysis conforms rigidly to, and thus is subordinated by, its mimesis.

Blake Stimson, Introduction, *The Pivot of the World: Photography and its Nation* (Cambridge, Massachusetts: The MIT Press, 2006) 32–43.

I WOULD SAY THAT

NO PICTURE COULD EXIST TODAY WITHOUT HAVING A TRACE
OF THE FILM STILL IN IT, AT LEAST NO PHOTOGRAPH

Jeff Wall, Interview/lecture, *Transcript*, vol. 2, no. 3, 1996

PHOTOGRAPHY AT THE CINEMA

Beaumont Newhall
Moving Pictures//1937

Moving pictures depend on photography for their existence. While it is true that the individual images which form the moving picture are made in a manner similar to that used for any other photograph, cinematography is so entirely different in its whole technique and point of view that it forms a special field in itself. We can no more than indicate here the barest outlines of a complex and powerful medium.

The problem of the cinematographer is almost the exact opposite of that which faces the still photographer. The latter makes a single critical exposure; the former must take a whole series of exposures. The effect of motion is obtained by projecting photographs of various phases of action upon a screen in rapid succession. Sequences not in themselves of special importance are combined with other sequences to form a dramatic and dynamic whole. Whereas the still photographer attempts to tell his story within the confines of a single picture, the moving picture photographer can tell it from a great many points of view, showing now a general view (long shot) now a detail (close-up). Because he can get these details separately, he does not need to attempt them in a distant view.

The moving picture is one of the purest forms of photography. It is almost impossible to retouch the images because there are thousands. Control of the composition by enlargement and cropping is out of the question. The cinematographer must compose all his pictures directly within a frame of unchanging size. To help him, a series of interchangeable lenses of varying focal length are usually mounted on the camera, so that from one viewpoint long shots, medium shots, and close-ups can be made.

To examine individual stills is to see only parts of a whole, the words of a sentence, the notes of a bar of music. Enlargements from actual cinema film often have remarkable force; this may be due to the fact that from so vast a choice of pictures, the most effective arrangement can be chosen. The laws of chance, which are so successfully exploited by the miniature camera technique, seem to apply here in an extreme degree. At present, enlargements from an actual strip are technically unsatisfactory, because of the loss of detail, but it is quite possible that within a few years great improvement will be made. Already some of the most striking news photographs are enlargements from a news film.

The influence of cinematography on still photography is deeply felt. The present popularity of the miniature camera is due to the moving pictures.

Another striking example of their influence is the emphasis placed on layout in thousands of publications. Photographs are arranged in sequence to give an impression of action by continuity of space, or the effect of one picture is heightened by the close juxtaposition of another. Photographs of portions of objects (close-ups) were most uncommon before the moving picture. The modern use of panchromatic material giving dark skies was fostered by Hollywood.

Aesthetically, the moving picture and the still photograph are so independent that they cannot be compared. A fascinating and powerful ideology underlies the moving picture; this ideology is based on the fact that the moving picture has precisely that dimension which the still cannot have – time. The moving picture creates its own time; the still photograph stops time and holds it for us.

Herein lies, perhaps, the greatest power of the camera. What has been recorded is gone forever. Whenever a moving picture is projected, past time moves again. The actors, the statesmen, the working-men may be dead, yet their living semblance moves before us on the screen. Though the stones of Chartres cathedral are still with us, no photograph taken today can ever show the crispness of detail which eighty years of weather have dulled. The faces that look out from daguerreotypes and calotypes have vanished. Our ways of looking change; the photograph not only documents a subject but records the vision of a person and a period.

Beaumont Newhall, 'Moving Pictures', in *Photography: A Short Critical History* (New York: The Musem of Modern Art, 1937) 88–90.

Steve Reich
Wavelength by Michael Snow//1968

Wavelength – as in length of sound or light wave; wave as in the sea.

Begins with a girl having bookcase moved into loft room. Synch sound.
Documentary level. Sounds of the street and traffic. People leave – the room by
itself. What does a room feel when no one is there? Does the tree fall in the
forest if no one sees it? The camera (no one?) sees it. Two girls enter (one
coming back? from where?) and turn on a transistor radio – *Strawberry Fields* –
traffic, and they turn it off before tune is over and they leave. And then the sound
(synch) goes off and we get a new sound (no sound?) of the 60 cycle hum of the
amplifier slowly beating against an oscillator tone which then, slowly, very
slowly, begins to rise, creating faster and faster beats and finally intervals and in
short we're in the realm of pure sound, and then the images change colour, and
there are filters used all on the same shot out of the windows and different film
stock, and so we've moved out of documentary reality into the reality of film
itself – not film about something, and so we've moved into the filmmaker's head.
There are suggestions of strobe effect of the image, 'you could strobe' but he
doesn't have to, you complete it in your head. A fast moving red light blur from
right to left; was it a special film trick or a tail light from a car out of the window
(is it night time?). More and more variations of exposure, film stock, focus and
filters, all on the one shot (perhaps sometimes, a little closer than others) of
those four windows with the space between, with pictures on the wall, a desk
and a yellow chair. Completely taken up with the filmic variations possible on
one image and – a man enters just as the rising oscillator tone just reaches the
octave above the 60 cycle tonic hum and synch sound mixed in on top of the
oscillator; the man falls to the floor in a heap. We all laugh – it is a long movie.
Comic relief and right on the octave to boot. But then the synch sound stops after
he's on the floor and we're back with the oscillator and the 60 cycle hum and the
four windows with the space in between, with the pictures on the wall and the
desk and yellow chair, and the oscillator didn't stop at the octave (why should
it?) but is rising slowly, very, very slowly, in closer to the windows – or is it
between the windows? And there are more filters and film stocks and variations
on the same image that does, yes, get still closer and, slowly, closer, and are we
going to zoom out of the window and 'into the world' or, and it looks like we are,
aiming at the space between the windows where pictures are on the wall and
then after the fourth or fifth octave has been passed by the oscillator and we're

back in 'documentary reality' again (keeping all the balls in the air) and she makes a telephone call. 'Richard, will you come over? There's a man on my floor and he's dead.' Then out of synch sound and back to the rising oscillator. A little play with superimposing the image (on a different film stock) of the girl over herself making the phone call; one could make a movie of that, but he doesn't have to, you complete it in your head. Then back to the oscillator, the filters, the slowly zooming in image now more and more just between the two windows zooming slowly, very slowly, onto the pictures on the wall between the two windows; and what about the dead man? Now it's getting closer to the picture with the four thumb tacks, one in each corner, the rectangular picture of – could it be the sea? It's slowly getting still closer and, slowly, at last, it is a picture of THE SEA, a picture of the sea, and it fills the whole screen. A picture of a picture of the sea in black and white; what about the dead man? We could go further into the picture of the sea, but he doesn't have to; you complete it in your head.

This text, not originally intended for publication, was mailed to me in 1968 by a great composer, Steve Reich, whom I hadn't met at the time. It was written, he later told me, immediately after he had seen the film because he wanted to put on paper what he had just experienced. (Michael Snow, 1995.)

Steve Reich, 'Wavelength by Michael Snow' (1968), in *The Michael Snow Project. Presence and Absence. The Films of Michael Snow 1956–1991* (Toronto: Art Gallery of Ontario, 1995) 91–3.

Peter Wollen
Fire and Ice//1984

The aesthetic discussion of photography is dominated by the concept of time. Photographs appear as devices for stopping time and preserving fragments of the past, like flies in amber. Nowhere, of course, is this trend more evident than when still photography is compared with film. The natural, familiar metaphor is that photography is like a point, film like a line. Zeno's paradox: the illusion of movement.

The lover of photography is fascinated both by the instant and by the past. The moment captured in the image is of near-zero duration and located in an ever-receding 'then'. At the same time, the spectator's 'now', the moment of looking at the image, has no fixed duration. It can be extended as long as fascination lasts and endlessly reiterated as long as curiosity returns. This contrasts sharply with film, where the sequence of images is presented to the spectator with a predetermined duration and, in general, is only available at a fixed programme time. It is this difference in the time-base of the two forms that explains, for example, Roland Barthes' antipathy towards the cinema and absorption in the still photograph. Barthes' aesthetic is governed by a prejudice against linear time and especially against narrative, the privileged form of linear time as he saw it, which he regarded with typically high-modernist scorn and disdain. His major work on literature, *S/Z*, is a prolonged deceleration and freeze-framing, so to speak, of Balzac's (very) short story, marked throughout by a bias against the hermeneutic and proaeretic codes (the two constituent codes of narrative) which function in 'irreversible time'.

When Barthes wrote about film he wrote about film stills; when he wrote about theatre he preferred the idea of *tableaux vivants* to that of dramatic development. Photography appeared as a spatial rather than temporal art, vertical rather than horizontal (simultaneity of features rather than consecutiveness) and one which allowed the spectator time to veer away on a train of thought, circle back, traverse and criss-cross the image. Time, for Barthes, should be the prerogative of the reader/spectator: a free rewriting time rather than an imposed reading time.

I don't want, here and now, to launch into a defence of narrative; that can keep for another day. But I do want to suggest that the relationship of photography to time is more complex than is usually allowed. Especially, it is impossible to extract our concept of time completely from the grasp of narrative. This is all the more true when we discuss photography as a form of art rather

than as a scientific or instructional instrument.

First, I am going to talk about 'aspect' rather than 'tense'. (Here I must acknowledge my dependence on and debt to Bernard Comrie's book on 'Aspect', the standard work on the subject). Aspect, on one level, is concerned with duration but this, in itself, is inadequate to explain its functioning. We need semantic categories which distinguish different types of situation, in relation to change (or potential for change) and perspective as well as duration. Comrie distinguishes between states, processes and events. Events themselves can be broken down between durative and punctual events. Alongside these categories aspect also involves the concepts of the iterative, the habitual and the characteristic. It is the interlocking of these underlying semantic categories which determines the various aspectual forms taken by verbs in different languages (*grosso modo*).

It is useful to approach photography in the light of these categories. Is the signified of a photographic image to be seen as a state, a process or an event? That is to say, is it stable, unchanging, or, if it is a changing, dynamic situation, is it seen from outside as conceptually complete, or from inside, as ongoing? (In terms of aspect, stative or perfective/imperfective non-stative?) The fact that images may themselves appear as punctual, virtually without duration, does not mean that the situations that they represent lack any quality of duration or other qualities related to time.

Some light is thrown on these questions by the verb-forms used in captions. (A word of warning: English, unlike French, distinguishes between perfective and imperfective forms, progressive and non-progressive, in the present tense as well as the past. The observations which follow are based on English-language captions). News photographs tend to be captioned with the non-progressive present, in this case, a narrative present, since the reference is to past time. Art photographs are usually captioned with noun-phrases, lacking verb-forms altogether. So also are documentary photographs, though here we do find some use of the progressive present. This imperfective form is used more than usual, for example, in Susan Meiselas' book of photographs, *Nicaragua*. Finally, the imperfective is used throughout in the captions of Muybridge's series photographs, in participle form.

Evidently these choices of verb-form correspond to different intuitions about the subjects or signifieds of the various types of photograph. News photographs are perceived as signifying events. Art photographs and most documentary photographs signify states. Some documentary photographs and Muybridge's series in particular are seen as signifying processes. From what we know about minimal narratives, we might say that an ideal minimal story-form might consist of a documentary photograph, then a news photograph, then an art

photograph (process, event, state). In fact, the classic early film minimal narrative, Lumière's *L'Arrosseur arrosé*, does follow this pattern: a man is watering the garden (process), a child comes and stamps on the hose (event), the man is soaked and the garden empty (state). What this implies of course is that the semantic structure of still and moving images may be the same or, at least, similar, in which case it would not be movement but sequencing (editing, découpage) which made the main difference by determining duration differently.

Still photographs, then, cannot be seen as narratives in themselves, but as elements of narrative. Different types of still photograph correspond to different types of narrative element. If this conjecture is right, then a documentary photograph would imply the question: 'Is anything going to happen to end or to interrupt this?' A news photograph would imply: 'What was it like just before and what's the result going to be?' An art photograph would imply: 'How did it come to be like this or has it always been the same?' Thus different genres of photography imply different perspectives within durative situations and sequences of situations.

While I was thinking about photography and film, prior to writing, I began playing with the idea that film is like fire, photography is like ice. Film is all light and shadow, incessant motion, transience, flicker, a source of Bachelardian reverie like the flames in the grate. Photography is motionless and frozen, it has the cryogenic power to preserve objects through time without decay. Fire will melt ice, but then the melted ice will put out the fire (like in *Superman III*). Playful, indeed futile, metaphors, yet like all such games anchored in something real.

The time of photographs themselves is one of stasis. They endure. Hence there is a fit between the photographic image which signifies a state and its own signified, whereas we sense something paradoxical about the photograph which signifies an event, like a frozen tongue of fire. In a film, on the contrary, it is the still image (Warhol, Straub-Huillet) which seems paradoxical in the opposite sense: the moving picture of the motionless subject.

Hence the integral relationship between the still photograph and the pose. The subject freezes for the instantaneous exposure to produce a frozen image, state results in state. In *La Chambre claire*, Barthes keeps returning to the mental image of death which shadows the photographs that fascinate him. In fact these particular photographs all show posed subjects. When he treats unposed photographs (Wessing's photograph of Nicaragua, Klein's of May Day in Moscow) Barthes sees not death, even when they show death, but tableaux of history, 'historemes' (to coin a word on the model of his own 'biographemes'). Images, in fact, submitted to the Law.

I can't help wondering whether Barthes ever saw James Van Der Zee's *Harlem Book of the Dead*, with its photographs of the dead posed for the camera

FILM IS ALL LIGHT AND SHADOW,

INCESSANT MOTION, TRANSIENCE, FLICKER, A SOURCE OF BACHELARDIAN REVERIE LIKE THE FLAMES IN THE GRATE.

PHOTOGRAPHY IS MOTIONLESS AND FROZEN,

IT HAS THE CRYOGENIC POWER TO PRESERVE OBJECTS THROUGH TIME WITHOUT DECAY. FIRE WILL MELT ICE, BUT THEN THE MELTED ICE WILL PUT OUT THE FIRE.

Peter Wollen, 'Fire and Ice', 1984

in funeral parlours: a triple registration of stasis – body, pose, image. The strange thing about these photographs is that, at first glance, there is an eerie similarity between mourners and corpses, each as formal and immobile as the other. Indeed, the interviewers whose questioning of Van Der Zee makes up the written text of the book, ask him why the eyes of the bodies aren't opened, since this would make them look more life-like, virtually indistinguishable from the mourners even to the smallest detail.

This view of death, of course, stresses death as a state rather than an event. Yet we know from news photographs that death can be photographed as an event: the Capa photograph of the Spanish Civil War soldier is the *locus classicus*, taken as he is felled. There is a sense, though, in which Barthes was right. This photograph has become a 'historeme', a 'pregnant moment' after Diderot or Greuze, or like the habitual narrative present in Russian, where, according to Comrie, 'a recurrent sequence of events is narrated as if it were a single sequence, i.e. one instance stands for the whole pattern'. In my book of Capa photographs, it is captioned simply *Spain, 1936*.

The fate of Capa's photograph focuses attention on another important aspect of the way images function in time: their currency, their circulation and recycling. From the moment they are published, images are contextualized and, frequently, if they become famous, they go through a whole history of republication and recontextualization. Far more is involved than the simple doubling of the encounter of photographer with object and spectator with image. There is a very pertinent example of this in the case of Capa's photograph. It is clearly the model for the pivotal image of death in Chris Marker's film photo-roman *La Jetée* – the same toppling body with outstretched arm.

Marker's film is interesting for a lot of reasons. First of all, it is the exemplar of a fascinating combination of film and still: the film made entirely of stills. (In just one image there is an eye-movement, the converse of a freeze frame in a moving picture.) The effect is to demonstrate that movement is not a necessary feature of film; in fact, the impression of movement can be created by the jump-cutting of still images. Moreover, *La Jetée* shows that still photographs, strung together in a chain, can carry a narrative as efficiently as moving pictures, given a shared dependence on a soundtrack.

It is not only a question of narrative, however, but also of fiction. The still photographs carry a fictional diegetic time, set in the future and in the present as past-of-the-future, as well as an in-between near-future from which vantage-point the story is told. Clearly there is no intrinsic 'tense' of the still image, any 'past' in contrast with a filmic 'present', as has often been averred. Still photography, like film (and like some languages), lacks any structure of tense, though it can order and demarcate time.

Aspect, however, is still with us. In the 'past' of memories to which the hero returns (through an experiment in time-travel) the images are all imperfective, moments within ongoing states or processes seen as they occur. But the object of the time-travel is to recover one fixated memory-image, which, it turns out at the climax of the film, is that of the hero's own death. This image, the one based on Capa's *Spain, 1936*, is perfective: it is seen from the outside as a complete action, delimited in time with a beginning and an end. Although *La Jetée* uses a whole sequence of photographs, the single 'Capa' image in itself carries the condensed implication of a whole action, starting, happening and finishing at one virtual point in time: a 'punctual situation', in Comrie's terms. And, at this very point, the subject is split into an observer of himself, in accordance with the aspectual change of perspective.

My own fascination with pictorial narrative is not a recalcitrant fascination, like that of Barthes. Unlike him, I am not always longing for a way of bringing the flow to a stop. It is more a fascination with the way in which the spectator is thrown in and out of the narrative, fixed and unfixed. Traditionally, this is explained in terms of identification, distanciation, and other dramatic devices. Perhaps it is also connected with aspect, a dimension of the semantics of time common to both the still and the moving picture and used in both to place the spectator within or without a narrative.

Peter Wollen, 'Fire and Ice', in *Photographies*, no. 4 (Paris, April 1984) 118–20.

Constance Penley
The Imaginary of the Photograph in Film Theory//1984

Film theory keeps on citing photography as the cinema's historical origin, both technologically and aesthetically. After all, it seems natural to begin a theory of film with a discussion of the properties of the photographic image, and André Bazin's 'The Ontology of the Photographic Image' is only the most famous example. But what, in fact, does the 'filmic' have to do with the 'photographic'?

The privileging of the photographic image and the overly hasty assertion of film's technological and aesthetic origin in photography is summed up in the popular subscription to a belief that the photographer Eadweard Muybridge was 'the father of the motion picture'. But a remarkable film-essay made in 1975 by Thorn Anderson, *Eadweard Muybridge: Zoopraxographer*, argues that Muybridge's photographic experiments had little or nothing to do with the development of 'motion pictures'. In fact, his aesthetic concerns were exactly the opposite: to stop motion, and to abstract the still image out of a flow of movement. Moreover, Muybridge's aesthetic was concerned less with the photographic than with the pictorial, and hence refers to the conventions of painting and drawing. Studying the naked human figure in order to depict it in painting or drawing was not acceptable in the American academies of art during Muybridge's time, but under the guise of the scientific investigation through photography of the body in motion, he was able to carry out studies of the nude forbidden to contemporaries like Thomas Eakins. Rather, then, than embodying some pre-filmic impulse, Muybridge's interests might better be understood with respect to the history of the nude in painting. Andersen's questioning of this mythological prehistory of the cinema stands as one particularly effective critique of the automatic assumption that film evolved from photography and that, consequently, film aesthetics can be derived from those of photography. Another way of questioning this assumed genealogy would be to reconsider what film theorists have in fact meant by 'photography' and the 'photographic' in the eagerness and rapidity with which they have derived film from it. The fact that theorists as diverse as André Bazin, Siegfried Kracauer, Walter Benjamin, Edgar Morin and Roland Barthes have all, on the one hand, variously selected the 'basic properties of the photograph', and have, on the other, constructed, in quite different ways, the relation of film to photography, makes one wonder if the 'photographic' really has the easily defined ontological status that a number of these theorists claim that it possesses.

In no other work of film theory does the photograph hold a more central

place than in Siegfried Kracauer's *Nature of Film: The Redemption of Physical Reality*.[1] For Kracauer, film 'grows out of photography'. It is 'intrinsically photographic', in spite of any other 'technical' properties that it may possess, while the truly 'cinematic' film is the one that remains truest to its photographic nature. In Kracauer's account, there is no need to provide a worked-out 'ontology of the photographic image' because, for him, it is self-evident that photography faithfully reproduces nature. Because of the realism inherent in its medium, photographic art does no more and no less than record a state of physical reality. And, since he argues that 'the nature of photography survives in that of film', film aesthetics, too, is obliged to adopt realism as its a priori criterion. For example, Kracauer disclaims any need for a discussion of editing, because he is concerned with 'cinematic techniques' only to the degree to which they 'bear on the nature of film as defined by its basic properties (i.e., photographic) and their various implications', He believes that editing makes no more than a minor contribution to the cinematic (photographic) quality of film, and warns against its being used in a way that would subvert the quintessential filmic function of presenting physical reality,

However, Kracauer's discussion of the 'realism' of specific films and film techniques effectively attributes an importance to editing that he has been at pains to deny. For Kracauer, even the musical can be realistic if the shots are composed and ordered in such a way as to give an illusion of reality. He admits that close-ups, for example, often look very unreal; however, a careful attention to their placement in the film can ensure their having a realistic effect: 'If they form part of an otherwise realistic film they are likely to affect us as the outgrowth of the same realism which animates the rest of the picture.' Repeatedly in his writing, the filmic image loses its photographic self-sufficiency, for, despite his theoretical claims, the signifying possibilities he lays out for the filmic image cannot be contained within those of photographic realism.

If we look closely at the metaphysics of film that Kracauer offers as his final chapter, the already precarious notion of the photographic begins to fall apart completely. Throughout *Nature of Film* photography has represented the possibility of a concrete apprehension of the world; photography, he says, allows us to 'shake hands with reality', a reality that is, furthermore, 'disinfected' of consciousness, intentionality or ideology. But in the final chapter, the concreteness of the photographic image is replaced by its 'ephemerality' because, we are told, reality is *behind* surface phenomena or ordinary sense experience. Kracauer claims that, although the photographic image is non-ideological, film, because of its base in photographic realism, is *predestined* to take up an important theme: 'the actual rapprochement between the peoples of this world', the fact that there is a universal human essence that transcends

nationality, religion, race and class. If the concrete in this new scheme of things becomes merely the veil of the ideal, where does Kracauer's notion of photographic realism leave us? Given the lack of any discussion of its ontological status, it is clear that the 'photographic' is little more than a retrospective construction of his liberal and humanistic metaphysics. That system depends upon the idea of a direct contact with the real; the category of the 'photographic' then is not something objectively given but a highly engineered concept used to satisfy the demands of a metaphysical system.

We know that André Bazin, on the other hand, outlined in some detail the ontological status of the photographic image.[2] Perhaps realizing how untenable it was to construct a realism around photographic 'fidelity', Bazin, in 'The Ontology of the Photographic Image' privileges instead the causal relation of world to photograph. 'The irrational power of the photograph to bear away our faith' lies not in its likeness to the object photographed, but in our knowledge that photographs are mechanically produced, without any human mediation: 'This production by automatic means has radically affected our psychology of the image.' Though differing from Kracauer in his emphasis on causality rather than analogy, Bazin still concludes that the 'realism of the cinema follows directly from its photographic nature'. But what happens to this *idea* of the 'photographic' in actual critical practice? Bazin, too, is obliged to say that simply recording an impression of an object does not make it art, 'something else is needed'. More honestly than Kracauer he acknowledges the 'essential paradox of photographic art, that sometimes reality has to be "conjured"'. This paradox is most striking if we contrast his discussion of photographic realism in 'The Ontology of the Photographic Image' to his 1948 essay on neorealism, 'An Aesthetic of Reality', in which he defines 'realist' as 'all narrative means tending to bring an added measure of reality to the screen'. Although Bazin is finally *unable* to identify photographic meaning with filmic meaning, he is loath to renounce the photograph as his point of reference for film, as here for example, in 'In Defence of Rossellini': '[Film] is ontological in the sense that the reality it restores to us is still a whole – just as a black and white photograph is not an image of reality broken down and put back together again *'without the colour'* but, rather, a true imprint of reality.' Bazin's desire to retain the idea of the photographic in film theory can perhaps be explained by examining his statement that 'neorealism, too, is an ontology'. Again, as with Kracauer's liberal humanism, neorealism needs as its founding term the possibility of a direct contact with reality in order to be able to show the truth of daily life and ordinary experience. Bazin's notion of the photographic image as 'the very identity of the model', or as 'the object itself' perfectly fills this need.

There is, however, a very different way that the photograph has been taken

up in film theory and one which contradicts the realists' attempt to make the photograph the ideal model of film. For the realists tried to anchor filmic meaning in the realism of the photograph, whereas Walter Benjamin, Edgar Morin and Roland Barthes have, variously, used the idea of photography's 'special' relation to the real as a way of delivering filmic meaning from its grounding in a notion of an immediately present and conscious reality.

For Walter Benjamin, the filmic effect is linked to photographic realism.[3] But his idea of the respective 'reality' that photography and film present is very different from that of Kracauer or Bazin. Here it is the fidelity of the photographic image that enables photography and film to isolate and analyse things which had 'hitherto floated unnoticed in the broad stream of perception'. The photographic image can reveal to us not the common sense data of the world, as Kracauer would have it, but its slips and omissions, such as those described by Freud in *The Psychopathology of Everyday Life*. It is film, however, even more so than photography, which reveals most strikingly the full range of quotidian parapraxes; the film camera can both move and record movement, running the gamut of perceptual detail. Film, Benjamin says, 'introduces us to unconscious optics as does psychoanalysis to uncouscious impulses'.

For Edgar Morin, too, the common source of what he calls '*photogénie*' in both film and photography lies in the realism of the photographic image, although, as he says, the 'photogenic of the cinematograph cannot be reduced to that of photography'.[4] Morin's approach to the realism of the photographic image is an anthropological one. His argument, that photography and film can give us a double of the world, involves a discussion of the archaic, animistic role which doubles, reflections and shadows play in our psychical life. Morin goes so far as to say that, in magic and myth as well as art, the theme of the double is the only universally human one. In addition, because the photographic image so closely resembles our mental images, like those of dream and fantasy, all of the affects accompanying these images are transferred onto the photographic image, thus giving it its great affective power, its ability to make us believe in its reality. Because of its capacity to show movement, film resembles the images of dream and fantasy even more closely. Morin consistently returns to the idea that the realism of the photographic image common to film and photography makes it the representational form which is most clearly associated with the imaginary.

In Roland Barthes' attempt to isolate what he calls the 'troisième sens' [third meaning] of film, he seems at first to be duplicating the typical realist reduction of film to photography, for he asks us to look for specifically filmic meaning in a still image, a frame enlargement from a film.[5] How can the filmic be found in a still? Barthes resolves what seems to be a contradiction in terms by demonstrating that our habitual idea of the 'filmic' is, effectively, either the

photographic (the analogical message of cultural information and symbols) or the novelistic (filmic meaning channeled strictly into a linear narrative meaning). Barthes, then, uses a photograph to try to isolate the filmic by progressively stripping the still of everything that is of the order of communication or anecdote, that is, everything that is not specific to film. We are left with a signifier without a signified, which poses the question of the signifier itself. Barthes does not give a definition of filmic specificity, this signifying trace which exceeds both representation and language (*signifiance*), because it is equally not reducible to a metalanguage (at most one could write a haiku about it). Film is not in this instance reduced to photography because the still has nothing in common with the self-containment of the photograph. It is no more than a *fragment* which contains the trace of the film experienced as an animated flow; it is here, however, that we can find the 'filmic'.

When Benjamin, Barthes and Morin return to the photographic 'base' of film, they do so as a way of acknowledging the unimpeachable 'realism' of the photographic image, but only in order to suggest the following: that the 'realism' that photography claims as its privileged realm cannot be conceived as an immediately graspable physical presence or the recorded data of common sense. Rather, the 'realism' of the photographic image is exactly one which opens out onto a different register of epistemological relations, one in which the idea of the unconscious must be taken into account.

1 Siegfried Kracauer, *Nature of Film: The Redemption of Physical Reality* [translated writings on film, 1921–61] (London: Denis Dobson, 1961).

2 André Bazin, *What is Cinema?*, vols 1 and 2, trans. Hugh Gray (Berkeley and Los Angeles: University of California Press, 1967).

3 Walter Benjamin, 'The Work of Art in the Age of Mechanical Reproduction' (1935), in *Illuminations* (New York: Schocken Books, 1973).

4 Edgar Morin, *Le Cinéma ou l'homme imaginaire: essai d'anthropologie* (Paris: Éditions de Minuit, 1956).

5 Roland Barthes, 'The Third Meaning: Research notes on some Eisenstein stills', in *Image, Music, Text*, trans. Stephen Heath (New York: Hill & Wang, 1977).

Constance Penley 'The Imaginary of the Photograph in Film Theory', in *Photographies*, no. 4 (Paris, April 1984) 122–3.

Raymond Bellour
The Pensive Spectator//1984

On one side, there is movement, the present, presence; on the other, immobility, the past, a certain absence. On one side, the consent of illusion; on the other, a quest for hallucination. Here, a fleeting image, one that seizes us in its flight; there, a completely still image that cannot be fully grasped. On this side, time doubles life; on that, time returns to us brushed by death. Such is the line traced by Barthes between cinema and photography.

The spectator of the cinema is idle, yet hurried. He/she follows a thread that at times seems to move too slowly, but that suddenly goes too fast once one tries to halt it. 'Do I add to the images in movies? I don't think so; I don't have time: in front of the screen, I am not free to shut my eyes; otherwise, opening them again I would not discover the same image ...'[1] On the other hand, before a photograph, you always close your eyes, more or less: the time it takes (theoretically infinite, above all repeatable) to produce the 'supplement' necessary for the spectator to enter into the image.

What happens when the spectator of film is confronted with a photograph? The photo becomes first one object among many; like all other elements of a film, the photograph is caught up in the film's unfolding. Yet the presence of a photo on the screen gives rise to a very particular trouble. Without ceasing to advance its own rhythm, the film seems to freeze, to suspend itself, inspiring in the spectator a recoil from the image that goes hand in hand with a growing fascination. This curious effect attests to the immense power of photography to hold its own in a situation in which it is not truly itself. The cinema reproduces everything, even the fascination the photograph exercises over us. But in the process, something happens to cinema.

Consider, for example, *Letter from an Unknown Woman* (Max Ophuls, 1948, with Louis Jourdan and Joan Fontaine). Here the power of cinema is at its height. Built on a flashback structure (the pretext is a letter the hero receives in the opening sequence), the film gives us past events in the present tense. The flashback is constantly begun again: we see the hero several times reading the letter from the unknown woman (in reality, the forgotten woman), whose voice-off heard reading the letter ties together most of the scenes. About midway through the film, the hero learns that this woman he has forsaken after one night of love has borne a child he unquestionably fathered. He scrutinizes in close-up, through a magnifying glass, the photographs attached to the letter: three photos, displayed for the spectator. The first, oval-framed, shows a child

about one year old, full face, eyes wide open. In the next, the child has grown taller, and poses with his mother in a hot-air balloon. Finally, the child appears once again, now nearly an adolescent.

What purpose do these photographs serve? A narrative one, to be sure. In the very next sequence, we pick up on the heroine and her son in the middle of everyday life. The photos act as a hinge between the two major parts of the story; they express the passing of time. Yet, these photographs also seem to resist time. It isn't only that they symbolize it, as one might believe. They in fact open up another time: a past of the past, a second, different time. Thus, they freeze for one instant the time of the film, and uprooting us from the film's unfolding, situate us in relation to it.

For this there are three reasons. First, the sudden stillness of the image. This has nothing to do with the stillness of those shots where inanimate objects await the arrival of a human being. Rather, it works against the movement of the film, which depends on figures moving. Second, these images look at us, the first one especially, from the depths of a long-lost childhood (the photographic time par excellence), with the kind of direct look at the camera almost never seen then in the cinema. Finally, the hero himself confirms the fascination of the photograph in its ability to rivet the gaze. One is tempted to say that, as a character, he adds to the image, even if the film discourages this. What the photos bear witness to upsets him; he is, at the very thought of what they suggest, petrified. I who identify with him am, like him, petrified. But not in the same way. A division erupts in the filmic illusion: at the same time that I am borne along by the narrative, with the part the photo plays, I am put into direct contact with the photograph. This doesn't mean the film permits me to add to the image itself, as I would with a photograph; in any case, it doesnt afford enough time to do so. But contact with the photo allows me in retrospect the precious leisure to 'add to' the film. And it does this in an unexpected way: by subtraction. The photo subtracts me from the fiction of the cinema, even if it forms a part of the film, even if it adds to it. Creating a distance, another time, the photograph permits me to reflect on cinema. Permits me, that is, to reflect that I am at the cinema. In short, the presence of the photo permits me to invest more freely in what I am seeing. It helps me to close my eyes, yet keep them wide open.

The single photo of *Shadow of a Doubt* (Hitchcock, 1943) creates something of the same effect. This time, the dialogue propagates it like a shock wave. In this film, the photo is at the heart of the symbolic system: it concentrates within it the film's energy, its meaning; it takes us back to the beginning, to the trauma that (everything in the film strongly suggests) has transformed a precocious child into a psychopath. But we reflect here as well (again, in that curious position evoked above), like Uncle Charlie holding between his fingers this

frame embedded many times over within the frame: we reflect on the childhood that, for a second, has looked at us.

The effect of the voice is so strong in its relation to the photograph that a film can often practically forego the image itself. In *Fanny* (Marcel Pagnol, 1932), Marius, returning from the country, tells his old fiancée how, after a long absence, it became impossible for him to conjure up her image. He attempts to describe, as something almost intolerable, the 'darkness' that would conceal her face. He decides to write to Fanny and ask her for a photo. Caught between this black screen and the photo that replaces it, the lovers' scene veers off for a moment and makes us shudder slightly: this is cinema seized by photography.

Films that take the photo as their subject (or at least as the linch-pin of their *dispositif*) can't help but parade the effect of those instances where the photograph's material potency radiates in a fleeting moment. Take Antonioni's *Blow-up* (1966), film *princeps*. Or the little-known Rossellini film *La Machina ammazzacativi (The Machine to Kill Bad People,* 1948). Or Fritz Lang's *Beyond a Reasonable Doubt* (1956). Or the ending of Truffaut's *L'Amour en fuite* (*Love on the Run,* 1979). In these films, on the one hand, the spectator is literally swept up in the narrativization of the photograph. Once past the first shock, the spectator plunges eagerly into the traps laid by the photograph (especially the photo-as-proof, the index, etc., even if it retains its symbolic value as fetish). Far from arresting the film's temporal flow, the photo becomes its very instrument: it precipitates, then regulates the suspense. Witness Hathaway's *Call Northside 777* (1948). As soon as the journalist (James Stewart) has figured out that the press photo he's using for his investigation will probably delay obtaining the sought-after evidence (a newspaper headline date), the implacable suspense of the classical film is set in motion – and nothing stops it. Except possibly, in the course of the photographic process itself (the photograph gets blown up 100 then 200 per cent), those all too brief moments when the materiality of the photograph leaps to the eye.

Yet on the other hand, as soon as the narrative role of the photo has been sufficiently established, one has the impression of following a double fiction. This requires strong directors, those who are up to the perversity of the challenge: Lang, Rossellini. In *Beyond a Reasonable Doubt,* under the guise of a debate on the death penalty (there's always the risk of condemning an innocent person), some photographs are staged as convicting evidence so that the hero can accuse himself without danger of being condemned for the crime of which he is in reality guilty. At the very moment they are to be introduced in the trial, the photos are destroyed in a car accident. Both before and after the accident, they haunt the film, creating a sort of two-way mirror. The photo, shimmering in memory, plays with the truth of cinema.

For his part, Rossellini develops a fabulous parable. Under the spell of a cartoon-like devil, a village photographer discovers that he kills the subjects represented in his photos each time he rephotographs them. The subject literally dies from a freeze-frame, immobilized in the pose he/she struck in the photograph. This operation is repeated, crescendo, until the spell is broken-and the film ends. More so even than in Lang's film (preoccupied, as it is, with the deceptive truth of appearances), the cinema is here conceived in relation to photography. At that point where the photo stops time and kills what it sees, the film produces the illusion of life and carries us away in its movement. But this succession of little murders of fiction also illuminates the film's mechanism from within. Think of any film in which the cinema represents itself: such films don't produce this same disquieting strangeness. When film looks at itself, it never sees itself as it does in the photograph.

At the other extreme, the photograph becomes the material support of the film, either in its totality, or in fragments powerful enough to produce an effect all by themselves, as in the beautiful enlargement sequence in *Blade Runner* (1982). In such films, a reversal occurs: immobility becomes the principal (which accounts for the irony, and the force, of the famous shot in Chris Marker's *La Jetée* (1963): the eye that opens, the only vibration in a completely frozen world). This is why camera movement is often used to supplement the stillness of the image. But this reversal is in any case much more limited than it would seem, for it isn't movement that defines most profoundly the cinema (Peter Wollen was right to remind us of this recently).[2] Rather, it is time: the concatenation, the unfolding of images in time, a time the spectator cannot control. Music and voice-over harmonize particularly well in films composed of photographs. It isnt simply that the two audio tracks animate such films; it's rather that their respective manifestations (*défilements*) share the character of temporal movement, and that these movements reinforce each other.

What's the difference then in those films in which the substance of the photograph becomes the fiction of the cinema? Quite simply this: their relative stillness tempers the 'hysteria' of the film. Such is the secret of their seduction (for whomever is sensitive to it). Though drawn more deeply into the flow of the film, the spectator is simultaneously able to reflect on it with a maximum of intensity. In this slight swerve in the film's course, the viewer is also able to reflect on cinema.

The presence of the photograph, diverse, diffuse, ambiguous, thus has the effect of uncoupling the spectator from the image, even if only slightly, even if only by virtue of the extra fascination it holds. It pulls the spectator out of this imprecise, yet pregnant force: the ordinary imaginary of the cinema. Photographs are not the only instruments of this uncoupling. In the narrative

cinema (leaving aside the question of so-called experimental cinema), what is called 'mise-en-scène' can also yield, through its own means, effects of suspension, freezing, reflexivity, effects which enable the spectator to reflect on what he/she is seeing. It is no doubt this that allows us to recognize the true auteurs, and the great films. The photograph transformed into cinema isn't always the most powerful of these means. Nor is it especially the most frequently employed, even if its repeated occurrence in film is striking. But it is, in retrospect, the most visible. And the only one that lingers in memory when the film is over thanks to the great, unique materiality of the still image.

Here we touch on the intriguing point that, in terms of a theory of the image, might best permit us to formulate the relation between cinema and photography. As soon as you stop the film, you begin to find the time to add to the image. You start to reflect differently on film, on cinema. You are led towards the photogram – which is itself a step further in the direction of the photograph. In the frozen film (or photogram), the presence of the photograph bursts forth, while other means exploited by mise-en-scène to work against time tend to vanish. The photo thus becomes a stop within a stop, a freeze-frame within a freeze-frame; between it and the film from which it emerges, two kinds of time blend together, always and inextricable, but without becoming confused. In this, the photograph enjoys a privilege over all other effects that make the spectator of cinema, this hurried spectator, a pensive one as well.

1 Roland Barthes, *Camera Lucida*, trans. Richard Howard (New York: Hill & Wang, 1981) 55.

2 Peter Wollen, 'Fire and Ice', in *Photographies*, no. 4 (Paris, March 1984); reprinted in this volume, 108–13.

Raymond Bellour, 'Le Spectateur pensif', in *Photogénies*, no. 5 (Paris: Centre National de la Photographie, 1984); trans. Lynne Kirby, 'The Pensive Spectator', *Wide Angle*, vol. 9, no. 1 (Baltimore: The Johns Hopkins University Press, 1987) 6–10.

Christian Metz
Photography and Fetish//1985

To begin I will briefly recall some basic differences between film and photography. Although these may be well known, they must be, as far as possible, precisely defined, since they have a determinant influence on the respective status of both forms of expression in relation to the fetish and fetishism.

First difference: the spatio-temporal size of the *lexis*, according to that term's definition as proposed by the Danish semiotician Louis Hjelmslev. The lexis is the socialized unit of reading, of reception: in sculpture, the statue; in music, the 'piece'. Obviously the photographic lexis, a silent rectangle of paper, is much smaller than the cinematic lexis. Even when the film is only two minutes long, these two minutes are *enlarged*, so to speak, by sounds, movements, and so forth, to say nothing of the average surface of the screen and of the very fact of projection. In addition, the photographic lexis has no fixed duration (= temporal size): it depends, rather, on the spectator, who is the master of the look, whereas the timing of the cinematic lexis is determined in advance by the filmmaker. Thus on the one side, 'a free rewriting time'; on the other, 'an imposed reading time', as Peter Wollen has pointed out.[1] Thanks to these two features (smallness, possibility of a lingering look), photography is better fit, or more likely, to work as a fetish.

Another important difference pertains to the social use, or more exactly (as film and photography both have many uses) to their principal legitimated use. Film is considered as collective entertainment or as art, according to the work and to the social group. This is probably due to the fact that its production is less accessible to 'ordinary' people than that of photography. Equally, it is in most eases fictional, and our culture still has a strong tendency to confound art with fiction. Photography enjoys a high degree of social recognition in another domain: that of the presumed real, of life, mostly private and family life, birthplace of the Freudian fetish. This recognition is ambiguous. Up to a point, it does correspond to a real distribution of social practices: people do take photographs of their children, and when they want their feature film, they do go to the movies or watch TV. But on the other side, it happens that photographs are considered by society as works of art, presented in exhibitions or in albums accompanied by learned commentary. And the family is frequently celebrated, or self-celebrated, in private, with super-8 films or other nonprofessional productions, which *are* still cinema. Nevertheless, the kinship between film and collectivity, photography and privacy, remains alive and strong as a social myth,

half true like all myths; it influences each of us, and most of all the stamp, the look of photography and cinema themselves. It is easy to observe – and the researches of the sociologist Pierre Bourdieu,[2] among others, confirm it – that photography very often primarily means souvenir, keepsake. It has replaced the portrait, thanks to the historical transition from the period when long exposure times were needed for true portraits. While the social reception of film is oriented mainly toward a show-businesslike or imaginary referent, the real referent is felt to be dominant in photography.

There is something strange in this discrepancy, as both modes of expression are fundamentally *indexical*, in Charles Sanders Peirce's terms. (A recent, remarkable book on photography by Philippe Dubois is devoted to the elaboration of this idea and its implications.)[3] Peirce called indexical the process of signification (*semeiosis*) in which the signifier is bound to the referent not by a social convention (= 'symbol'), not necessarily by some similarity (= 'icon'), but by an actual contiguity or connection in the world: the lightning is the index of the storm. In this sense, film and photography are close to each other, both are *prints* of real objects, prints left on a special surface by a combination of light and chemical action. This indexicality, of course, leaves room for iconic aspects, as the chemical image often looks like the object (Peirce considered photography as an index *and* an icon). It leaves much room for symbolic aspects as well, such as the more or less codified patterns of treatment of the image (framing, lighting, and so forth) and of choice or organization of its contents. What is indexical is the mode of production itself, the principle of the *taking*. And at this point, after all, a film is only a series of photographs. But it is more precisely a series with supplementary components as well, so that the unfolding as such tends to become more important than the link of each image with its referent. This property is very often exploited by the narrative, the initially indexical power of the cinema turning frequently into a realist guarantee for the unreal. Photography, on the other hand, remains closer to the pure index, stubbornly pointing to the print of what was, but no longer *is*.

A third kind of difference concerns the physical nature of the respective signifiers. Lacan used to say that the only materialism he knew was the materialism of the signifier. Whether the only one or not, in all signifying practices the material definition is essential to their social and psychoanalytic inscription. In this respect – speaking in terms of set theory – film 'includes' photography: cinema results from an addition of perceptive features to those of photography. In the visual sphere, the important addition is, of course, movement and the plurality of images, of shots. The latter is distinct from the former: even if each image is still, switching from one to the next creates a *second movement*, an ideal one, made out of successive and different

immobilities. Movement and plurality both imply *time*, as opposed to the timelessness of photography which is comparable to the timelessness of the unconscious and of memory. In the auditory sphere – totally absent in photography – cinema adds phonic sound (spoken words), non-phonic sound (sound effects, noises, and so forth), and musical sound. One of the properties of sounds is their expansion, their development in time (in space they only irradiate), whereas images construct themselves in space. Thus film disposes of five more orders of perception (two visual and three auditory) than does photography, all of the five challenging the powers of silence and immobility which belong to and define all photography, immersing film in a stream of temporality where nothing can be *kept*, nothing stopped. The emergence of a fetish is thus made more difficult.

Cinema is the product of two distinct technological inventions: photography, and the mastering of stroboscopy, of the ø-effect. Each of these can be exploited separately: photography makes no use of stroboscopy, and animated cartoons are based on stroboscopy without photography.

The importance of immobility and silence to photographic *authority*, the non-filmic nature of this authority, leads me to some remarks on the relationship of photography with death. Immobility and silence are not only two objective aspects of death, they are also its main symbols, they *figure* it. Photography's deeply rooted kinship with death has been noted by many different authors, including Dubois, who speaks of photography as a 'thanatography', and, of course, Roland Barthes, whose *Camera Lucida*[4] bears witness to this relationship most poignantly. It is not only the book itself but also its position of enunciation which illustrates this kinship, since the work was written just after (and because of) the death of the mother, and just before the death of the writer.

Photography is linked with death in many *different* ways. The most immediate and explicit is the social practice of keeping photographs in memory of loved beings who are no longer alive. But there is another real death which each of us undergoes every day, as each day we draw nearer our own death. Even when the person photographed is still living, that moment when she or he *was* has forever vanished. Strictly speaking, the person *who has been photographed* – not the total person, who is an effect of time – is dead: 'dead for having been seen', as Dubois says in another context.[5] Photography is the mirror, more faithful than any actual mirror, in which we witness, at every age, our own ageing. The actual mirror accompanies us through time, thoughtfully and treacherously; it changes with us, so that we appear not to change.

Photography has a third character in common with death: the snapshot, like death, is an instantaneous abduction of the object out of the world into another

world, into another kind of time – unlike cinema, which replaces the object, after the act of appropriation, in an unfolding time similar to that of life. The photographic *take* is immediate and definitive, like death and like the constitution of the fetish in the unconscious, fixed by a glance in childhood, unchanged and always active later. Photography is a cut inside the referent, it cuts off a piece of it, a fragment, a part object, for a long immobile travel of no return. Dubois remarks that with each photograph, a tiny piece of time brutally and forever escapes its ordinary fate, and thus is protected against its own loss. I will add that in life, and to some extent in film, one piece of time is indefinitely pushed backwards by the next: this is what we call 'forgetting'. The fetish, too, means both loss (symbolic castration) and protection against loss. Peter Wollen states this in an apt simile: photography preserves fragments of the past 'like flies in amber'.[6] Not by chance, the photographic art (or acting, who knows?) has been frequently compared with shooting, and the camera with a gun.

Against what I am saying, it could of course be objected that film as well is able to perpetuate the memory of dead persons, or of dead moments of their lives. Socially, the family film, the super-8, and so forth, to which I previously alluded, are often used for such a purpose. But this pseudo-similarity between film and photography leads me back, in a paradoxical way, to the selective kinship of photography (not film) with death,, and to a fourth aspect of this link. The two modes of perpetuation are very different in their effects, and nearly opposed. Film gives back to the dead a semblance of life, a fragile semblance but one immediately strengthened by the wishful thinking of the viewer. Photography, on the contrary, by virtue of the objective suggestions of its signifier (stillness, again) maintains the memory of the dead *as being dead.*

Tenderness towards loved beings who have left us forever is a deeply ambiguous, split feeling, which Freud has remarkably analysed in his famous study, 'Mourning and Melancholia'.[7] The work of mourning is at the same time an attempt (not successful in all cases: see the suicides, the breakdowns) to survive. The object-libido, attached to the loved person, wishes to accompany her or him in death, and sometimes does. Yet the narcissistic, conservation instinct (ego-libido) claims the right to live. The compromise which normally concludes this inner struggle consists in transforming the very nature of the feeling for the object, in learning progressively to love this object as *dead,* instead of continuing to desire a living presence and ignoring the verdict of reality, hence prolonging the intensity of suffering.

Sociologists and anthropologists arrive by other means at similar conceptions. The funeral rites which exist in all societies have a double, dialectically articulated signification: a remembering of the dead, but a remembering as well *that they are dead*, and that life continues for others. Photography, much better

than film, fits into this complex psycho-social operation, since it suppresses from its own appearance the primary marks of 'livingness', yet nevertheless conserves the convincing print of the object: a past presence.

All this does not concern only the photographs of loved ones. There are obviously many other kinds of photographs: landscapes, artistic compositions, and so forth. But the kind on which I have insisted seems to me to be exemplary of the whole domain. In all photographs, we have this same act of cutting off a piece of space and time, of keeping it unchanged while the world around continues to change, of making a compromise between conservation and death. The frequent use of photography for private commemorations thus results in part (there are economic and social factors, too) from the intrinsic characteristics of photography itself. In contrast, film is less a succession of photographs than, to a large extent, a destruction of the photograph, or more exactly of the photograph's power and action.

At this point, the problem of the space off-frame in film and in photography has to be raised. The fetish is related to death through the terms of castration and fear, to the off-frame in terms of the look, glance, or gaze. In his well-known article on fetishism,[8] Freud considers that the child, when discovering for the first time the mother's body, is terrified by the very possibility that human beings can be 'deprived' of the penis, a possibility which implies (imaginarily) a castration. The child tries to maintain its prior conviction that all human beings have the penis, but in opposition to this, what has been seen continues to work strongly and to generate anxiety. The compromise, more or less spectacular according to the person, consists in making the seen retrospectively unseen by a disavowal of the perception, and in *stopping the look*, once and for all, on an object, the fetish – generally a piece of clothing or underclothing – which was, with respect to the moment of the primal glance, near, just prior to, the place of the terrifying absence. From our perspective, what does this mean, if not that this place is positioned off-frame, that the look is framed close by the absence? Furthermore, we can state that the fetish is taken up in two chains of meaning: metonymically, it alludes to the contiguous place of the lack, as I have just stated; and metaphorically, according to Freud's conception, it is an equivalent of the penis, as the primordial displacement of the look aimed at replacing an absence by a presence – an object, a small object, a part object. It is remarkable that the fetish – even in the common meaning of the word, the fetish in everyday life, a re-displaced derivative of the fetish proper, the object which brings luck, the mascot, the amulet, a fountain pen, cigarette, lipstick, a teddy bear, or pet – it is remarkable that it always combines a double and contradictory function: on the side of metaphor, an inciting and encouraging one (it is a pocket

phallus); and, on the side of metonymy, an apotropaic one, that is, the averting of danger (thus involuntarily attesting a belief in it), the warding off of bad luck or of the ordinary, permanent anxiety which sleeps (or suddenly wakes up) inside each of us. In the clinical, nosographic, 'abnormal' forms of fetishism – or in the social institution of the striptease, which pertains to a collective nosography and which is, at the same time, a progressive process of framing/deframing – pieces of clothing or various other objects are absolutely necessary for the restoration of sexual power. Without them nothing can happen.

Let us return to the problem of off-frame space. The difference which separated film and photography in this respect has been partially but acutely analysed by Pascal Bonitzer.[9] The filmic off-frame space is *étoffé*, let us say 'substantial', whereas the photographic off-frame space is 'subtle'. In film there is a plurality of successive frames, of camera movements, and character movements, so that a person or an object which is off-frame in a given moment may appear inside the frame the moment after, then disappear, again, and so on, according to the principle (I purposely exaggerate) of the *turnstile*. The off-frame is taken into the evolutions and scansions of the temporal flow: it is off-frame, but not off-film. Furthermore, the very existence of a soundtrack allows a character who has deserted the visual scene to continue to mark her or his presence in the auditory scene (if I can risk this quasi-oxymoron: 'auditory' and 'scene'). If the filmic off-frame is substantial, it is because we generally know, or are able to guess more or less precisely, what is going on in it. The character who is off-frame in a photograph, however, will never come into the frame, will never be heard – again a death, another form of death. The spectator has no empirical knowledge of the contents of the off-frame, but at the same time cannot help imagining some off-frame, hallucinating it, dreaming the shape of this emptiness. It is a projective off-frame (that of the cinema is more introjective), an immaterial, 'subtle' one, with no remaining print. 'Excluded', to use Dubois' term, excluded once and for all. Yet nevertheless present, striking, properly fascinating (or hypnotic) – insisting on its status as *excluded* by the force of its absence *inside* the rectangle of paper, which reminds us of the feeling of lack in the Freudian theory of the fetish. For Barthes, the only part of a photograph which entails the feeling of an off-frame space is what he calls the *punctum*, the point of sudden and strong emotion, of small trauma; it can be a tiny detail. This *punctum* depends more on the reader than on the photograph itself, and the corresponding off-frame it calls up is also generally subjective; it is the 'metonymic expansion of the *punctum*'.[10]

Using these strikingly convergent analyses which I have freely summed up, I would say that the off-frame effect in photography results from a singular and definitive cutting off which figures castration and is figured by the 'click' of the

shutter. It marks the place of an irreversible absence, a place from which the look has been averted forever. The photograph itself, the 'in-frame', the abducted part-space, the place of presence and fullness – although undermined and haunted by the feeling of its exterior, of its borderlines, which are the past, the left, the lost: the far away even if very close by, as in Walter Benjamin's conception of the 'aura'[11] – the photograph, inexhaustible reserve of strength and anxiety, shares, as we see, many properties of the fetish (as object), if not directly of fetishism (as activity). The familiar photographs that many people always carry with them obviously belong to the order of fetishes in the ordinary sense of the word.

Film is much more difficult to characterize as a fetish. It is too big, it lasts too long, and it addresses too many sensorial channels at the same time to offer a credible unconscious equivalent of a lacking part-object. It does *contain* many potential part-objects (the different shots, the sounds, and so forth), but each of them disappears quickly after a moment of presence, whereas a fetish has be to kept, mastered, held, like the photograph in the pocket. Film is, however, an extraordinary activator of fetishism. It endlessly mimes the primal displacement of the look between the seen absence and the presence nearby. Thanks to the principle of a *moving cutting off*, thanks to the changes of framing between shots (or within a shot: tracking, panning, characters moving into or out of the frame, and so forth), cinema literally *plays* with the terror and the pleasure of fetishism, with its combination of desire and fear. This combination is particularly visible, for instance, in the horror film, which is built upon progressive reframings that lead us through desire and fear, nearer and nearer the terrifying place. More generally, the play of framings and the play with framings, in all sorts of films, work like a striptease of the space itself (and a striptease proper in erotic sequences, when they are constructed with some subtlety). The moving camera caresses the space, and the whole of cinematic fetishism consists in the constant and teasing displacement of the cutting line which separates the seen from the unseen. But this game has no end. Things are too unstable, and there are too many of them on the screen. It is not simple – although still possible, of course, depending on the character of each spectator – to stop and isolate one of these objects, to make it able to work as a fetish. Most of all, a film cannot be *touched*, cannot be carried and handled: although the actual reels can, the projected film cannot.

I will deal more briefly with the last difference – and the problem of belief-disbelief – since I have already spoken of it. As pointed out by Octave Mannoni,[12] Freud considered fetishism the prototype of the cleavage of belief: 'I know very well, *but* …'. In this sense, film and photography are basically similar. The spectator does not confound the signifier with the referent, she or he knows

what a *representation* is, but nevertheless has a strange feeling of reality (a denial of the signifier). This is a classical theme of film theory.

But the very nature of *what* we believe in is not the same in film and photography. If I consider the two extreme points of the scale – there are, of course, intermediate cases: still shots in films, large and film-like photographs, for example – I would say that film is able to call up our belief for long and complex dispositions of actions and characters (in narrative cinema) or of images and sounds (in experimental cinema), to disseminate belief; whereas photography is able to fix it, to concentrate it, to spend it all at the same time on a single object. Its poverty constitutes its force – I speak of a poverty of means, not of significance. The photographic effect is not produced from diversity, from itinerancy or inner migrations, from multiple juxtapositions or arrangements. It is the effect, rather, of a laser or lightning, a sudden and violent illumination on a limited and petrified surface: again the fetish and death. Where film lets us believe in more things, photography lets us believe more in one thing.

In conclusion, I should like to add some remarks on the use of psychoanalysis in the study of film, photography, theatre, literature, and so on. First, there are presentations, like this one, which are less 'psychoanalytic' than it might seem. The notion of 'fetish', and the word, were not invented by Freud; he took them from language, life, the history of cultures, anthropology. He proposed an *interpretation* of fetishism. This interpretation, in my opinion, is not fully satisfactory. It is obvious that it applies primarily to the early evolution of the young *boy.* (Incidentally, psychoanalysts often state that the recorded clinical cases of fetishism are for the most part male.) The fear of castration and its further consequence, its 'fate', are necessarily different, at least partially, in children whose body is similar to the mother's. The Lacanian notion of the *phallus*, a symbolic organ distinct from the penis, the real organ, represents a step forward in theory; yet it is still the case that within the description of the human subject that psychoanalysis gives us, the male features are often dominant, mixed with (and as) general features. But apart from such distortions or silences, which are linked to a general history, other aspects of Freud's thinking, and various easily accessible observations which confirm it, remain fully valid. These include: the analysis of the fetishistic nature of male desire; in both sexes the 'willing suspension of disbelief' (to use the well-known Anglo-Saxon notion), a suspension which is determinant in all representative arts, in everyday life (mostly in order to solve problems by half-solutions), and in the handling of ordinary fetishes; the fetishistic pleasure of framing-deframing.

It is impossible to *use* a theory, to 'apply' it. That which is so called involves, in fact, two aspects more distinct than one might at first believe: the intrinsic degree of perfection of the theory itself, and its power of suggestion, of

activation, of enlightenment *in another field* studied by other researchers. I feel that psychoanalysis has this power in the fields of the humanities and social sciences because it is an acute and profound discovery. It has helped *me* – the personal coefficient of each researcher always enters into the account, despite the ritual declarations of the impersonality of science – to explore one of the many possible paths through the complex problem of the relationship between cinema and photography. I have, in other words, used the theory of fetishism as a fetish.

Psychoanalysis, as Raymond Bellour has often underscored, is contemporary in our western history with the technological arts (such as cinema) and with the reign of the patriarchal, nuclear, bourgeois family. Our period has invented neurosis (at least in its current form), *and* the remedy for it (it has often been so for all kinds of diseases). It is possible to consider psychoanalysis as the founding myth of our emotional modernity. In his famous study of the Oedipus myth, Levi-Strauss has suggested that the Freudian interpretation of this myth (the central one in psychoanalysis, as everybody knows) could be nothing but the last variant of the myth itself.[13] This was not an attempt to blame: myths are always true, even if indirectly and by hidden ways, for the good reason that they are invented by the natives themselves, searching for a parable of their own fate.

After this long digression, I turn back to my topic and purpose, only to state that they could be summed up in one sentence: film is more capable of playing on fetishism, photography more capable of itself becoming a fetish.

An earlier version of this text was first delivered at a conference on the theory of film and photography at the University of California, Santa Barbara, in May 1984.

1 Peter Wollen, 'Fire and Ice', in *Photographies*, no. 4 (1984); reprinted in this volume, 108–13.

2 Pierre Bourdieu, *Un Art moyen: Essai sur les usages sociaux de la photographie* (Paris: Éditions de Minuit, 1965).

3 Philippe Dubois, *L'Acte photographique* (Paris and Brussels: Nathan & Labor, 1983).

4 Roland Barthes, *La Chambre claire* (1981), trans. Richard Howard, *Camera Lucida* (New York: Hill & Wang, 1981).

5 Dubois, *L'Acte photographique*, op. cit., 89.

6 Wollen, 'Fire and Ice', op. cit.

7 Sigmund Freud, 'Mourning and Melancholia' (1917), in *The Standard Edition of the Complete Psychological Works of Sigmund Freud*, trans. James Strachey (London: The Hogarth Press and the Institute of Psychoanalysis, 1953–74), vol. 14.

8 Freud, 'Fetishism' (1927), *Standard Edition*, op. cit., vol. 21.

9 Pascal Bonitzer, 'Le hors-champ subtil', *Cahiers du cinéma*, 311 (Paris, May 1980).

10 Barthes, *Camera Lucida*, op. cit., 45.

11 Walter Benjamin, 'A Short History of Photography', trans. Phil Patton, in *Classic Essays on*

Photography, ed. Alan Trachtenberg (New Haven, Connecticut: Leete's Island Books, 1980).

12 Octave Mannoni, 'Je sais bien mais quand même ...', *Clefs pour l'imaginaire, ou, L'autre scène* (Paris: Éditions du Seuil, 1969).

13 Claude Lévi-Strauss, chapter II, 'La Structure des mythes', in *Anthropologie structurale* (1958), trans. *Structural Anthropology* (New York: Basic Books, 1963).

Christian Metz 'Photography and Fetish', *October*, no. 34 (Cambridge, Massachusetts: The MIT Press, Fall 1985); reprinted in Carol Squiers, ed., *The Critical Image* (London: Lawrence and Wishart, 1991) 155–64.

Laura Mulvey
Stillness in the Moving Image: Ways of Visualizing Time and Its Passing//2003

My opening proposition – that electronic and digital technologies have recently had a significant impact on celluloid-based cinema – is obvious to the point of banality. My hope here is, first of all, to bring out some of the implications for film criticism and film history that might lie behind the obviousness. My hope is also to concentrate particularly on how new technologies have given a new visibility to stillness as a property of celluloid. I say 'celluloid' advisedly, as my interest, in the first instance, has been on the interaction between the old, mechanical technology associated with cinema and the new, electronic or digital: that is, how the images produced by a cinema that was *not* conscious of the implications of a future new technology might be affected, even enhanced, by refraction through the new. I have been trying to imagine a dialectical relationship here, where the old and the new react with each other to create innovative ways of thinking about the language of cinema and its significance at the present moment of time/history.

I started writing about the cinema and thinking about it theoretically in the early 1970s, so a juxtaposition between 'old' and 'new' must also refer to my own attitudes and approaches. Using new technology as a 'new horizon' to look back at the cinema of the past has pushed me also to return to, and to attempt to reconfigure, the main theoretical structures that have influenced my thought. This process has been like an experiment, trying out, in changed conditions, the theories that I have been applying to film for so long. There are three points of departure. First, spectatorship. Radical changes in the material, physical ways in which the cinema is consumed necessarily demand that theories of spectatorship should be reconfigured. Second, the indexical sign. The fact that the digital can mimic, as well as doctor, analogue images gives a new significance to the indexical sign. And finally, narrative. Theoretical analysis that assumes that narrative is essentially linear, dependent on cause and effect and on closure, shifts with nonlinear viewing. All these inflections depend, above all, on the viewer's new command over viewing technology and, most of all, the freedom given by the technology over the pace and order of a film. As narrative coherence fragments, as the indexical moment suddenly finds visibility in the slowed or stilled image, so spectatorship finds new forms.

When I first started writing about cinema, films had always been seen in darkened rooms, projected at twenty-four (or thereabouts) frames a second. Only professionals, directors and editors had easy access to the flatbed editing

tables that broke down the speed needed to create the illusion of natural movement. Then, I was preoccupied by Hollywood's ability to construct the female star as ultimate spectacle, the emblem and guarantee of its fascination and power. Now, I am more interested in the way that those moments of spectacle were also moments of narrative halt, near stillness, that figure the halt and stillness inherent in the structure of celluloid itself. Then, I was concerned with the way Hollywood eroticized the pleasure of looking, inscribing a sanitized voyeurism into its style and narrative conventions. Now, I am more interested in the ways in which the presence of time itself can be discovered behind the mask of storytelling.

The paradox: new technologies are able to reveal the beauty of the cinema, but through a displacement that breaks the bond of specificity so important to my generation of filmmakers and theorists. Furthermore, particularly through access to the cinema's essential stillness, new technologies allow the spectator time to stop, look and think. This process opens up the possibility of a link that takes the kind of theoretical reflection developed for an analysis of the still photograph to a new relevance for the moving image. I want to try to lead to these theoretical implications through a short summary of some aspects of the fraught, but also productive, relationship between still and moving images in the cinema.

First, the problem. Does the property of indexicality, so easily and consciously attributed to the still, tend to get lost in the moving image? And then, if stillness does appear in the moving image, does the cinema's indexicality find a new kind of visibility? These questions involve a return to familiar ground for photographic theory and to some of the most well-known sites of its discussion and elaboration. But these reflections might now have new relevance for cinematic theory.

Roland Barthes, unsurprisingly, provides a point of departure. *Camera Lucida* establishes key attributes of the still photograph's relation to time. Most particularly, Barthes suggests that as the photographic image embalms a moment of time, it also embalms an image of life halted, which eventually, with the actual passing of time, will become an image of life after death. In numerous passages, he associates the photographic image with death. But he denies that this presence can appear in cinema. Not only does the cinema have no *punctum*, but it both loses and disguises its relation to the temporality characteristic of the still photograph because of its movement:

> In the cinema, whose raw material is photographic, the image does not, however, have this completeness (which is fortunate for the cinema). Why? Because the photograph, taken in flux, is impelled, ceaselessly drawn towards other views; in the cinema, no doubt, there is always a photographic referent, but this referent

shifts, it does not make a claim in favour of its reality, it does not protest its former existence; it does not cling to me: it is not a *spectre*.[1]

Furthermore, 'The cinema participates in the domestication of Photography – at least the fictional cinema, precisely the one said to be the seventh art; a film can be mad by artifice, can present the cultural signs of madness, it is never mad by nature (by iconic status); it is always the very opposite of an hallucination; it is simply an illusion; its vision is oneiric, not ecmnesic.'[2]

There are two factors here: first, the movement inherent to the cinematographic technology as the celluloid travels through the machine, enhanced by the camera's own ability to move; second, the conceptual and ideological properties of storytelling. Between the two exists the 'objective alliance' that links cinema's mechanical forward movement, the illusion of movement and the movement of narrative. This obsession with movement has dominated cinema from its origins (although avant-garde movements have continually rebelled against it), and it is beginning to blur as celluloid is displaced onto technologies that allow access to an illusion of its inherent stillness.

Raymond Bellour paraphrases Barthes' distinction between the photograph and the cinema: 'On one side, there is movement, the present, presence; on the other, immobility, the past, a certain absence. On one side, the consent of illusion; on the other, a quest for hallucination. Here, a fleeting image, one that seizes us in its flight; there, a completely still image that cannot be fully grasped. On this side, time doubles life; on that, time returns to us brushed by death.'[3]

The question of fiction is central here and leads directly to the film fiction's 'double temporality.' Creating a contradiction or a fundamental duality, conflicting temporalities lie at the heart of narrative cinema:

1 There is the moment of registration, the moment when the image in front of the lens was inscribed by light onto photosensitive material passing behind the lens. This inscription gives the cinematic sign its indexical aspect, which, in turn, draws attention to the sign's temporal attribute giving it, in common with the still photograph, its characteristic 'there-and-then-ness.'

2 Just as the still frame is absorbed into the illusion of movement of narrative, so does 'then-ness,' the presence of the moment of registration associated with the aesthetics of still photography, have to lose itself in the temporality of the narrative and its fictional world. There is a presence, a 'here-and-now-ness,' that the cinema asserts through its 'objective alliance' with storytelling that downplays, even represses, the aesthetic attributes it may share with the photograph.

Christian Metz also points out that the immobility and silence of the still photograph, with its connotation of death, disappears in the moving image. To repeat: narrative asserts its own temporality.

But Bellour goes on to point out that even if the spectator is unable to halt time in the cinema, films can, and indeed often do, refer to stillness by direct reference to photography within a given story:

> What happens when the spectator of film is confronted with a photograph? ... [T]he presence of a photo on the screen gives rise to a very particular trouble. Without ceasing to advance its own rhythm, the film seems to freeze, to suspend itself, inspiring in the spectator a recoil from the image that goes hand in hand with a growing fascination [...]
>
> The photo subtracts me from the fiction of the cinema even as it forms a part of the film, even if it adds to it. Creating a distance, another time, the photograph permits me to reflect on cinema. Permits me, that is, to reflect that I am at the cinema.[4] [...]
>
> As soon as you stop the film, you begin to find time to add to the image. You start to reflect differently on film, on cinema. You are led toward the photogram – which is itself a step further in the direction of the photograph. In the frozen film (or photogram), the presence of the photograph bursts forth, while other means exploited by the *mise-en-scène* to work against time tend to vanish. The photo thus becomes a stop within a stop, a freeze-frame within a freeze-frame; between it and the film from which it emerges, two kinds of time blend together, always and inextricable, but without becoming confused. In this, the photograph enjoys a privilege over all other effects that make the spectator of cinema, this hurried spectator, a pensive one as well.[5]

Here, Bellour makes an important connection between the halting of narrative: the eruption of the still and a shift in the nature of spectatorship. With the arrival of new technologies giving the spectator control of the viewing process, this kind of radical break can be experienced by anyone with the simple touch of a button. The still image both makes the moment of registration comparatively visible and creates a new space of time for the 'pensive' spectator to reflect and experience the kind of reverie that Barthes had associated only with the photograph.

For a cinematic story to be credible in its own terms, it asserts the power of its own story time over the simple photographic time when its images were registered. Now, by stilling or slowing movie images, the time of the film's original moment of registration suddenly bursts through its artificial, narrative surface. Another moment of time, behind the fictional time of the story, emerges

through this fragmentation and excavation of a sequence or film fragment. Even in a Hollywood movie, beyond the story is the indexical imprint of the pro-filmic scene: the set, the stars, the extras take on the immediacy and presence of a document, and the fascination of time fossilized can overwhelm and halt the fascination of narrative progression. The newness of story time gives way to the then-ness of the movie's own moment in history.

The fragmentation of narrative has its own critical history that pre-dates new technology. It was the critical practice of textual analysis that first systematically fragmented narrative film. Textual analysis generated a tension between the coherent narrative 'whole' and the desire, as it were, to capture the cinema in the process of its own coming into being. The segment received privileged attention; a fragment was extracted from the overall narrative structure of a film's horizontal and linear drive of narrative.

But in the celluloid era, textual analysis was extremely difficult to put into practice, and only the very fortunate had access (generally limited) to 16 or 35 mm flatbed editing tables. Annette Michelson has described the 'heady delights of the editing table': 'the sense of control, of repetition, acceleration, deceleration, arrest in freeze-frame, release, and reversal of movement is inseparable from the thrill of power.'[6]

Returns

Both spectatorship, my longstanding theoretical point of engagement with cinema, and textual analysis, a key method of critical practice for my generation, have been radically transformed by new forms of film consumption. My concept of the voyeuristic spectator depended in the first instance on certain material conditions of cinema exhibition: darkness, the projector beam lighting up the screen, the procession of images that imposed their own rhythm on the spectator's attention. And, of course, the particular structure of spectacle the Hollywood studios refined so perfectly. In counter-distinction, I later tried to evolve an alternative spectator, who was driven by curiosity and the desire to decipher the screen. The curious spectator was, perhaps, an intellectual, informed by feminism and the avant-garde. The idea of curiosity as a drive to see, but also to know, however, still marked a utopian space in the cinema that might answer to the human mind's longstanding interest in puzzles and riddles. This spectator may be the ancestor of the one formed by new modes of consumption that open up the pleasures of the hidden cinema to anyone who cares to experiment with the equipment available.

I have, in the first instance, attempted to adapt Bellour's concept of the pensive spectator to evoke the thoughtful reflection on the film image now possible by seeing into the screen's images, stretching them into new

dimensions of time and space. The pleasure in the fragment leads to the pleasure in the still itself. Here, the pensive spectator can confront the film's original moment of registration, revealed once the narrative's ornament has been stripped away. With the hybrid relation between the celluloid original and its new electronic carrier, there is time to reflect on time itself and on the presence of the past and on the then-ness of the photographic process. On the other hand, however, this spectator is also 'fetishistic'. The slowing down and stilling process opens up new areas of fascination, especially with the human figure. Certain privileged moments can become fetishized moments for endless and obsessive repetition, while looks or gestures can suddenly acquire a further dimension of fascination once freed from their subordination to narrative. This new, freely accessible stillness, extracted from the moving image, is a product of the paradoxical relation between celluloid and new technology. It is primarily the historic cinema of celluloid that can blossom into new significance and beauty when its original stillness, its material existence in the photogram, is revealed in this way. The cinema has always been a medium of revelation and, once again, there is a paradox here. The magic of cinema has been identified, through its history, with its ability to simulate movement. In very early film demonstrations, this element of revelation could be built into the staging of the show. The projection might start with a stilled image, a projected photograph. Suddenly, the image would come to life and the magic of cinema would infuse the screen. Now, perhaps, the magical moment, perversely and paradoxically, comes with a reversal of direction: a new fascination comes into being when the moving image is stilled. The new, from this perspective, allows a fresh and unfamiliar insight into the old. Just as the early theorists of film celebrated the way that the camera could reveal more of the world than was perceptible to the naked eye, now the pensive spectator can discover more in the celluloid image than could be seen at twenty-four frames per second.

1 Roland Barthes, *Camera Lucida* (New York: Hill & Wang, 1981) 89.

2 Ibid., 117.

3 Raymond Bellour, 'The Pensive Spectator' (1984), in *Wide Angle*, vol. 9, no. 1 (1987) 6; essay reprinted in this volume, 119–23.

4 Ibid., 6–7.

5 Ibid., 10.

6 Annette Michelson, 'The kinetic icon in the work of mourning: Prolegomena to the analysis of a textual system', *October*, no. 52 (Spring 1990) 22.

Laura Mulvey 'Stillness in the Moving Image: Ways of Visualizing Time and Its Passing', in *Saving the Image: Art After Film* (Manchester: Manchester Metropolitan University, 2003) 78–89.

I remember an image from my native land, Chiloé. In front of my house, wind would move the trees. At a certain point the wind would blow with such regularity that one had the impression the trees were frozen in place, bent over in the same direction. The fishermen moving through the scene stopped short themselves, but in a posture opposite to that of the trees. Complemented by the extravagant positions of the fishermen and the trees, that moment of immobility gave the impression that movement and its opposite were not contradictory. When the wind recovered its irregular rhythms, the immobile image vanished in homage to movement and everything became normal again. But it always could happen that the wind would blow constantly and the landscape would return to immobility, only to spring back into motion some few seconds later. This oscillation gradually gave a new feeling to the scene: when everything moved about one only saw immobility, and vice-versa. I told myself this was a good way to photograph the wind.

Raúl Ruiz, 'The Photographic Unconscious', 1995

Richard Prince
Why I Go to the Movies Alone//1983

When he got back to work it was about nine p.m.

He works for a magazine in a department called 'Tear Sheets'. He rips up magazines and tears out pages so if anybody wants a particular page they can call down for a couple of copies.

Tonight there were some advertisements, ones he was just beginning to see, with pictures of cars, new cars, with their headlights on, in a scene that looked to be photographed right around dusk. The scenes had suns going down in the background. It looked like they used a photo-projection of a sunset and the projection made the principle parts of the picture look flat and cut out.

That time of day has always been nice for him. The artificial light from the car's headlights and the natural light disappearing behind the horizon, and the way it gets mixed; he's always thought the look set up a kind of pseudo-reality that seemed to suggest something less than true.

Just in the past few weeks he's seen a lot of these pictures, Saab, Volkswagen, Ford, Pontiac. They all have them out. He tears them quickly, with one tear at the bind. He likes to do this. It makes him feel good.

There's nothing there that seems to be him, and no matter how he calls them his, it's not like he's the author of whatever their design is supposed to be. They have a range he says, a lot of possibilities. Nothing specific except the number of times they appear. He likes the fact that it's not just one company putting them out. The way they show up gives the images a curious, almost believable fiction. Their symbols make him feel reassured. And the way they're put together and their over-emphasis, dares to be believed. It's almost as if the presumptuousness of these pictures has no shame.

Anyway it was Saab, Volkswagen, Ford and Pontiac.

He stopped tearing at twelve. He went to Howard Johnson's, the one at forty-ninth street and Broadway and took a seat in a booth next to the window.

The view from the seat looks out upon the carnival façade of the Pussycat Theater, which is really a complex of businesses, two movie houses, a peep show arcade, burlesque, live dancing and encounters and a Flame Steak Restaurant.

In front of the complex, up and down the sidewalk, is the usual fare. Hookers, con-artists, barkers, three card monti. There's as much open, predictable action there as any place in Times Square.

He likes to sit and watch the scene and all the movement and hustle. He

especially likes it because of the silence that goes along with his location. The silence he thinks makes the obnoxiousness smart and stylish, and whatever the outrage, the inability to hear it makes it reasonable.

This position he assumes is for no specific purpose, and it seems to be becoming one of his more shoddier affairs with what's outside.

'It's like my looking in that particular place has become customary because the looking there is no longer accompanied by what I have always liked to think of as me. Sometimes I feel when I'm sitting there that my own desires have nothing to do with what comes from me personally because what I'll eventually put out, will in a sense, have already been out.'

'It's one way to think about it. A better way perhaps is the fact that what I see there is somewhat fragmented and additionalized onto something more real, and this, in effect, makes my focus ordained and weigh significantly more than the spiritual displacement the view sometimes suggests. After all, artificial intelligence, like fiction, whether displaced or fabricated, makes reference to the particular, to the sensory detail ... and it is these "details" that are terrifyingly beautiful.'

'Anyway, maybe it's just wishful thinking. The thing of it is, it's always out there and never across from me in the booth.'

The Pussycat Theater, three card monti, the Flame Steak Restaurant. [...]

Richard Prince, *Why I Go to the Movies Alone*, Tanam Press, New York, 1983; second printing, Barbara Gladstone Gallery, New York, 1993, 55–7.

Catherine David
Photography and Cinema//1989

The present task is to articulate two types of approach to the issue of the relationship between photography and cinema: the first is historical, in order to see how these relations began and how they have evolved in the course of the century, and the second is more structural and will attempt to view the relations between cinema and photography in terms of their differences. When certain people speak of these differences, they will tell you that cinema is photography plus movement, plus real time. It is not my intention to prove otherwise, but it seems to me that the relations between photography and cinema go far beyond these dynamic, structural problems. Instead of choosing one of these two approaches, it may be more subtle to try to view them together, because it seems that at certain moments in the history of this relationship they are indissociable.

As far as the historical relationship of these two media is concerned, one must realize that things progressed very quickly after photography was invented in 1826, and cinema in 1895. From the very beginning, one notes that if cinema, that is photography plus movement, is taken into account alongside photography, a whole series of much more subtle relations exist, some of which were pinned down by the French theorist Alain Jobert, who is also an editor of film montages and is interested in the role of photography in cinema. He published an article in *Photographies*, titled *About cinema in photography*, in which he investigated relations between these two media that have been less discussed than stillness and motion – these are fundamental and constitutive elements, but not the only ones. He noted that 'if one only analyses the trajectory of the photographers from their recording of movement to moving photographs, one runs the risk of confusing this cinema of [photographic] origins with the origins of cinema, and of determining one single criterion. However, in such photographic origins one can find the trace of two very different procedures, which do not necessarily exclude each other. On the one hand, one sees that most photographers seem voluntarily to adhere to the pre-existing laws of the plasticity of painting, sculpture, theatre sets. It is as if the real were already strictly divided into discreet units, as if each subject imposed a certain mode of choice, scope, cutting and editing (pictorialism, monumentality, the picturesque). On the other hand, for a few photographers, it is the view which imposes its own subjective logic on the cliché and the succession of images; a logic which gives rise to original forms which are often strongly narrative, such as the series, the sequence, or reportage.' He illustrates

this remark with two series of documentary works, one by Felice Beato and one by John Thompson, both of which consist of photographs of life. Whereas Thompson respects a certain picturesque register with respect to landscape, transmits China as he expected to see it, and has it enter into the framework of classical painting, Beato has a much more ambiguous view, which one could almost characterize as perverse, since he is interested in the wars of the time and tries, by taking a succession of pictures, to create, if not a film, at least a sense of movement, a story, the beginning of narration. One later realizes that certain pictures by Beato use fakery to convey implied meanings: he didn't hesitate to move bodies and thus to transform the real. When we speak today of faked images, we think of photographers in the late twentieth century reporting on the war in Asia, who changed the position of the scenery so as to make a certain angle of vision more prominent, more decisive.

These observations by Jobert undermine the discourse about the stillness of photography and the motion of cinema, which is all too neat and organized. We should recall these kinds of observation, which inform us of the most interesting relations that photography and cinema maintain today. Another perception is that it is more legitimate to make a history of viewpoints than a history of forms, in terms of certain bodies of work in both photography and film.

I will discuss some complex and ambiguous relations between photography and the cinema in their heroic early periods. Paul Virilio describes the relations between photography and cinema at the end of the twentieth century as relations on a logical level; he calls it the era of logic, to be more precise. It is a privileged moment of collaboration between art and artists. In the early twentieth-century avant-garde movements, one can see works of photography and cinema being made side by side, often by the same people. It is quite clear that these parallel practices in the 1920s tend to separate from one another later on, that photographers who are also film producers are relatively few, and that this fact leads to works that are very specialized, but I will return to this later. In the 1920s, which are the high point of the relations between photography and cinema, photographic artists produce films and vice versa, and they have common stakes. The discourse of the Russian avant-gardes is full of implicit meaning; that is, photography and cinema are assimilated on the level of ambitions, namely the desire to make art for the masses which is directly accessible, and to have an artform which maintains a privileged relationship to the real. There is also the desire to produce work under industrial conditions.

Cinema is the paradigmatic form of modern art, as Jeff Wall has said. One of the great privileges of cinema of this century is that of being an artform which is confronted with and defined by its conditions of production, that is, by its relations to the institution, but especially by a logic of industrial production.

Cinema has never been made with scraps; one realized very quickly that it was expensive and that it implied a certain kind of management of art in society. In the 1920s there were privileged relations between photographers and film producers. Dziga Vertov, Aleksandr Rodchenko, Sergei Eisenstein, László Moholy-Nagy – the collaboration of these photographers is documented in the legendary *Film und Foto* exhibition (Stuttgart, 1929), which assembled the elite of creative photographers but also an astonishing section of films. The catalogue of this section did not include the list of films, this had been lost, but it was published in a new edition in Stuttgart in 1979. It's surprising to see its diversity: there are films such as Carl Dreyer's *Jeanne d'Arc* (1928), G.W. Pabst's *Secrets of a Soul* (1926), Walter Ruttmann's *Berlin, Symphony of a Great City* (1927), Sergei Eisenstein's *Ten Days That Shook the World* (1927), Robert Wiene's *The Cabinet of Dr Caligari* (1920), Charlie Chaplin's *The Circus* (1928), Fernand Léger's *Ballet mécanique* (1924) and Man Ray's *L'Étoile de mer* (1928). Despite certain later interpretations which have viewed this event as the manifestation of a pure and rigorous tendency, one sees that as far as the films were concerned, the choice was completely eclectic. Relations between photography and cinema were exemplary in the work of Moholy-Nagy at that time, but were just as important in the images of Carl Dreyer. And one cannot say that these two artists can be compared to one another with respect to their forms and intention.

Today, it would no longer be possible to put on this particular exhibition, due to the arrival of video and synthesized images, and also due to the impossibility of putting together an ideal list of photographs and films. One would only be able to single out secondary phenomena, such as the estimable work of the photographer Raymond Depardon, or the cinema and photography of the filmmaker Wim Wenders. The relations documented in the *Film und Foto* exhibition and which become established in the 1930s clearly far transcend the strictly formal opposition of stillness and motion. Already we see aesthetic contamination, such as in Robert Siodmak's film *Menschen am Sonntag* (*Sunday Men*, 1929), in which has been integrated what can be referred to as the German photographic style that was to define the 1930s; that is, certain angles of vision and positions of the body in relation to the scenery. A kind of photographic aesthetics has been transmitted to this film.

On the other hand, in these same years, if we compare or, better, consider side by side (it's a question of making a synthesis between the visions and the intentions) Moholy-Nagy's oeuvre of photographs and films, we see that he was almost the only film producer to use photography in film, in the way he cuts and edits; the way in which the images succeed one another in a jerky fashion. He showed very little interest in continuous passages except in a film he produced about gypsies. More so than in the film on Marseille (*Marseille, Vieux Port,*

1929), interest is shown in human beings, and that is another variation on what I said above about 'photography that makes cinema'. Moholy-Nagy was also - and this is interesting in relation to contemporary work - an artist who was going to start with photography and cinema in order to make astonishing, hybrid, fabricated productions (which he called 'simultaneous polycinema') such as his 1925 scenario-sketch for the film-work he intended to make on Berlin, titled *Dynamic of the Big City*, a complex, photo-type montage which corresponds neither to existing models of photomontage nor of cinema.

After these privileged years, relations became strained for political and economic reasons. With the rise of fascism, communities dissolved, artists went in different directions and the life of independent cinema, which is not in the domain of big industry, became difficult due to economic problems. Film producers who did not accept their role of being 'just' documentarians were isolated. These economic difficulties halted this organic type of film which was produced by artists from different backgrounds and with modest means.

Another fascinating sequence of these relations takes place in the 1950s at the time of neo-realism and of its inventor (in the sense of archaeological excavation) André Bazin, who defined and interpreted it. Photographic aesthetics again became visible in films; the cases of direct influence are quite rare, but the implied meaning, the domination of photographic aesthetics in cinema is remarkable. To Bazin, in his precise, commited and definitive mode of description, the aesthetics and ethics of cinema were essentially the ethics and aesthetics of photography. This is a notion which still has repercussions today. Bazin's famous article entitled *Ontology of the Photographic Image* (1945) would have its greatest echo in the 1950s when the first films by Rossellini arrived in France. He defended the aesthetics of photography and its implications for the cinema, which can be called a kind of realism. One can affirm today that realism is not a kind of verism, nor is it a kind of naturalism, naturalism being a fraudulent means of making that which is represented seem to be real by absorbing the heterogeneity of beings and things in passing. Photographic aesthetics constitute cinema; cinema is above all photography, a photographic act of the recording and the representation of the real. These aesthetics have the ambition of guaranteeing us a certain kind of relationship to the real.

It is difficult to go from then to the present time. Today, the relationship between photography and cinema poses itself in a context of the crisis of images. I understand this to be a phenomenon which one sometimes overestimates, that of the unfurling of images, the proliferation, the haemorrhaging of images which we are experiencing more and more, especially by means of advertising, by means of television; these are images which take

part essentially and almost exclusively in entertainment and in advertising. The problem of this crisis of images, of this permanent, continual flux is that the price is that of invisibility; as soon as you are in an image in a permanent way and without articulation, you risk finding yourself face to face with images which lose their meaning and become practically invisible. And that leads us back to the more specific problem of certain contemporary artists. The relations between cinema and photography are registered in this context of the crisis of contemporary images, in this context of an irrealization, of a growing abstraction of a certain kind of image.

Parallel to this growing phenomenon, one can consider the fact that we are being invaded more and more by images without risks, without any asperity, which are completely replaceable, just like merchandise. One can consider, and it is here that the problem becomes serious, that to a certain extent, the cinema is dying from within of a kind of cancer, of the anaesthesia of images which it caused to convey and about which a certain French critic wrote recently that 'the only thing left for us to do is to free the cinema from the image'. It is interesting that he did not say 'free the cinema from photography' but he is talking about this saturated image, this advertising image, this fashionable image, this interchangeable image.

It is very obvious that this problem, even if it preoccupies us today, is nothing new and that this fight against the invasion of the image which is not photography, but rather a kind of permanent image in which we live in contemporary society, this attempt at a reaction can be found in the cinema of Jean-Luc Godard, not completely in his earlier work, but in any case for about ten years. If one considers the first risk, that of the soft, generalized image with no particular character and lacking qualities, the second risk is of a different kind. It is not so much a political and cultural risk, it is the risk, to be more precise, of the confrontation with synthesized images, which obviously present us with images that no longer have any analogous relationship to the real, but have one which is purely digital. You can use a certain kind of calculation and programming of machines in order to create an image of whatever object, which has a very problematical relationship to that which one has always called the real.

Faced with these two types of risks, which do not have the same stakes, a certain kind of cinema is floundering about at present and along parallel lines; a certain kind of photography is doing the same. Both are trying in a certain way – some by means of slowing down, of making weightless, others by means of hysterical acceleration – to meditate and to preserve what remains for us beyond the publicity image and the synthesized image.

When I speak of this preoccupation of contemporary film producers and

photographers with the remainder, what is left of a relationship to the real, I refer to the photographic image; images that mediate certain subjects. I was surprised when I was preparing this lecture, because I had chosen artists some of whom had made new works in the meantime: I was then confronted with works that I had not expected, in any case, not so precisely, and I was surprised to see that, for the most part, they approached the subjects of the face and the body. Almost all the works had the face or the human body as their subject. On the other hand, when viewing contemporary productions, I was surprised by the revival, the reconciliation, with what one usually calls the documentary, and this interest in a form of cinema which has a very privileged relationship to the real is obviously not independent of the causes, dangers and risks which I mentioned earlier. Now I would like to introduce some pictures, first from contemporary photographic works.

First, Jeff Wall. What is fascinating about these pictures is the fact that one could define them, before saying that they are photographs, by saying that they are very complex and heterogeneous pictures. I think that the manner in which they can be articulated is cinematic, that is to say, they are obviously pictures according to cinematic criteria. They are from, that is, *with* the cinema as a basic frame of reference, but they are also images which are only thinkable and realizable after the invention and the experience of cinema: the invention of the cinema as a point of no return, a historical moment; and the experience of the cinema, the fact that you and I have been confronted with this kind of picture. I am presenting them to you as entire images without making use of close-ups. I almost had the impression that in these procedures of approach and also in the explanation — without making too rigid parallels - watching Jeff Wall gradually approach certain details, gestures and objects, that he was using the close-up as one would in the cinema. In other words, with respect to these pictures, he had the ambiguous and highly controversial relationship that certain film enthusiasts have to the hologram, namely, an approach that plays in time illegitimately. A hologram as such does not exist: a violent operation is necessary which implies that one stops the film and, as it were, cuts it into small pieces. In the same way, I have the impression that Jeff Wall carried out the operations of cinema, which are normally horizontal in movement and in time, in a vertical way, by working within the various strata of the picture. I am not saying that this is not legitimate, I am saying that this is one type of approach, one type of view which, it seems to me, can hardly be envisaged without the cinema and its legacy.

When Wall says that these pictures arrest and make dense that which cinema lets pass by or obscures, I think that he is really making a choice, he is taking a stand. I would like to tell him that in contemporary cinema, which

seems to be close to his work with respect to the level of ambition - I am thinking especially of Wim Wenders' work, but also of that of the duo Straub-Huillet - I find that these filmmakers' relationship to time and the manner in which they try to fix and distort it is similar to Wall's. There are obvious relations between Wall's work and that of Wenders. I would simply say that the latter makes very photographic cinema. Even when he has a scenario, he greatly favours the accidental, that which is likely to happen in front of the camera, and he has a very contemplative relationship, he expects things to happen a bit like a photographer who waits to trap a privileged moment. Whereas Wall, on the other hand, tries to increase the density of all this, and to make the film meaningful with all the ambiguities which this kind of procedure could imply. The other filmmakers I mentioned are Straub-Huillet because it seems to me that by wanting to work in real time according to a fixed plan, in other words, to film without moving the camera, they have chosen a very ambiguous transaction. This ambiguity of the relationship to time to the subject, is obviously not comprehensible without a relationship to photography, except that this relationship can be very evident, very formal, or secondary.

My last comment on these pictures is that they rely on a condensation of all the phenomena, all the transactions which are at stake in the interior of a film in order to give all the immobility, the weight, the density of a kind of photographic image back to the cinema. In Wall's work, there is an attempt to saturate the image as much as possible by making it polysemous almost to the point of bursting. I chose these pictures because, to my way of thinking, they are very different as far as their conception and result are concerned; they are exemplary of a certain kind of very complex, almost indecipherable picture.

The interest of these images goes beyond the artist's own discourse; the images continue to resonate with their density, complexity and high degree of ambiguity. I will conclude by saying that an image, for example, like *The Arrest* (1989), even if you are unfamiliar with its iconographical reference to compositions from Baroque era painting such as Caravaggio's *Flagellation of Christ* (1607) and, at the same time, to our immediate social reality (it depicts an Indian labourer from Vancouver; in France or Germany the subject would probably be Algerian or Turkish) such an image is saturated with meaning, and that is very interesting with respect to cinema and Wall's attempt at giving more significance to the cinematographic.

Here are some photographs by Suzanne Lafont in black and white. One is tempted to say that, with respect to their means, they are much more classical than Wall's pictures, yet nevertheless they are pictures which are produced just as much by the cinema, if in a different register. What one also sees in the pictures presented at the Staatsgalerie is a certain kind of relationship to the

silent film and its economy, its interest in faces, an almost distorted relationship in so far as it comes well after the silent film. It is a step which comes after many others, and it is conscious of the passage of time.

I chose these pictures so that they would echo two extracts which I am now going to show you on video and which pose another kind of problem since, if one is honest, what I am going to show you can almost not be acknowledged, since it is a film that has been transferred to a cassette. The first extract is the sequence before the credit lines of the black and white film *Persona* (1966) by Ingmar Bergman. The second sequence is the latest video by Jean-Luc Godard, *The Power of the Word* (1988).

I am not trying to establish a connection between these two kinds of film aesthetics; I wanted to show them to you at the end because they seem to bear witness to two kinds of relations between cinema and photography. A major element of the relationship between cinema and photography is missing in this projection, which is Chris Marker's incredible film *La Jetée* (1962). It is a film which is made up entirely of fixed images except for an instant when an eye opens. It would be a completely different topic to present it. If one wants to express slight differences in the topic by the chronological gap which exists between the two works, one realizes that Bergman's film is crossed with photography and Godard's video is contaminated with the contemporary image, that borderless image without content which I evoked before. The only difference is that when I speak of contamination, it is similar to the situation of certain patients; it is a contamination which is finally positive to the extent in which it is carried out on a body which reacts and which produces its metastases, its own images.

For people who are intrigued by Godard's images, they are obviously images which have been mixed and which are very complex: Godard films videos and cinema with the same skill; he does not introduce video sequences in film, it is video with all the most entertaining means. In their heterogeneity and in the same movement of resistance, these two attitudes also resemble the image which goes through a particular attention to photography, an organic attention for Bergman which is privileged and which goes through the heritage of Carl Dreyer and of the silent film. For Godard, it is an attention to the real, to its transcription by all possible means. In the pre-credit lines of Bergman, one can consider it to be an entity within the film, like a silent film. Except for the moments at the end, when the child starts to draw the face of the woman, one can consider that most of the sequences have the status of photographs, traumatic photographs. I understand that to be what one generally understands to be trauma, namely, that which suspends language, which blocks communication. This sequence, which is almost entirely photographic and

which is active in the entire remainder of the film, these images before the opening title have the same violent status as the image of the big shot who sacrifices himself during the Vietnam war.

Catherine David, 'Photography and Cinema', trans. Joy Fischer, in *Die Photographie in der Zeitgenössischen Kunst. Eine Veranstaltung der Akademie Schloss Solitude. 6./7. Dezember 1989* (Ostfildern-Ruit: Edition Cantz, 1990) 117–24. Revised 2006.

Régis Durand
Melancholic Mutations in Cindy Sherman's
Film Stills//1996

Looking at the *Film Stills* almost two decades after they were made (the series was started in 1977), one is struck by their continuing vitality, their imaginary power and capacity to raise critical problems. Of course, our way of looking at these early pieces is changed by what we know of Sherman's subsequent production (from 1980), as well as by the abundant critical commentary that has accompanied it. I would venture, however, that the opposite perspective is more fruitful, that we can go further than the customary critical debates by reading the later pieces in the light of the *Film Stills*. Not that there is anything old hat about the question of individual identity versus cultural and media stereotypes, of 'woman as image' or of the obsessions and loathings of the age, but it seems to me that our way of seeing and talking about these images has become tinted with a pathos that obscures their inherent comedy. Of course, this comical dimension is infused with a deep seriousness and melancholy, as comedy so often is. The attempt to do it justice does not mean we have to underplay the other aspects of Sherman's work, and in particular the importance of its contribution to thought about femininity in relation to the 'theatre of the mass-media'.[1] But is it really necessary to labour the theme of 'the language of the body inhabited by filmic drama'?[2] Must we really content ourselves with the same old pat analyses of role-playing and of the projections that these works purportedly elicit from the spectator? No. These notions of 'filmic drama' and 'role-playing' need to be properly re-examined.

The Zelig complex
Readers no doubt remember the eponymous hero of Woody Allen's famous film *Zelig* (1983): a man who suffers from a powerful mimetic compulsion that makes him crop up willy-nilly in all kinds of periods and situations, in all parts of the globe, like some incongruous yet strangely plausible parasite. When asked to explain his weird and irrepressible chameleonizing, Zelig replies that it is surely the consequence of never having read *Moby Dick*. I believe this answer needs to be taken seriously. Not to have read this novel – the Great American Novel – is, to borrow Melville's terms in the book's preface, to be condemned to floating around without the salutary ballast of a masterpiece, to suffering from an uncontrollable and guilt-inducing lightness; it is tantamount to saying that one has never experienced the archetypal Quest narrative, the imaginary saga that makes all our half-baked individual wanderings pale into triviality. Not to

have read *Moby Dick* is to run the risk of not being stabilized by the cohesive power of myth. More ironically, this admission also puts its finger on a general imposture which is itself something of a joke: how many people say, and end up believing, that they have read this book, when the band of those who have completed the voyage is apparently very small indeed.

I have no idea whether Cindy Sherman has ready *Moby Dick*, but her approach clearly evinces both the lack of a stable imaginary referent and a deep irony that comes out in the combination of comedy and gravitas in the work. Though Zelig's facial expressions have a Keaton-style lugubriousness, his appearances play across a series of comic registers, from the repetitive gags of early silent movies to the more subtle vein of the schlemiel. If he is a tragic character, his tragedy lies in the inability to inhabit one time, the specific time of the subject.

Image fictions

In a similar way, albeit by means of very different procedures, the actress of Cindy Sherman's *Film Stills*, i.e., herself, never shows her true face and is therefore totally out of time. This time is not the simulated narrative time of *Zelig*, but that of real years (close on two decades). Thare is something disturbing about this practice of taking oneself as one's own model while eluding the affects of passing time. For it is precisely this passage of time that film and photography can register more pitilessly than any other artistic medium, and this power has much to do with their fascination and their fragility. However great the gap between their real selves and the nature and attributes of their role, it is something no movie actor can escape. Nor can artists who use self-representation: indeed, the work of a Michel Journiac or an Urs Lüthi actually emphasizes this factor.

With Sherman, then, we have a photographic artist whose works come across as pseudo-stills from a shoot in which she is the sole support for roles that seem to come from movie-history, photographs in which it is impossible to identify or *identify with* the actress. These works weave a dense fabric of expectations and frustrations. They confirm neither the truth of the self-portrait (not even in travestied form) nor the law of ageing that governs cinematic and photographic images. Sherman seems to be producing image fictions, something that looks like images to do with cinema but has none of their substance, by which I mean their particularly complex and rigorous relation to time – for example, their ability to condense 'kernels of time', or, to borrow Daniel Sibony's phrase, to act as 'time-objects [...] extracts from time which, if you use them correctly, are ready to open up'.[3] Note also the equivocal nature of the genre invoked by the title: a film still is not an image from the film, a photogram, nor is it a snap taken during the shoot; it is the photograph of the reconstitution of

a given scene that is re-enacted in front of the photographer for documentary and publicity purposes.

This brings to mind Julian Gracq's remark that the painter differs from the writer in as much as he 'makes gold with lead, without really having to transform it. Or, rather than gold, a strange paper money whose value is purely fiduciary and which circulates with all the virtues of precious metal, while no one has the right to examine the reserves'.[4] Sherman's works are also a case of pure fiduciary circulation: the referent is inaccessible. We have no way of knowing if it is always the same person, or if that person is the artist. All we have is rumour. Everything about these images bespeaks imposture and, besides, the figure of this 'extra' is almost totally absent from Sherman's later works.

This ironic instability, which is fiduciary in terms of the circulation of value, but unreliable when it comes to the identity of the 'collateral', now appears as a way of avoiding the ageing of the image (and, for the referent-cum-actress, ageing *by* the image). Even this avoidance is itself variable, for an unbendingly absolute denial would reduce the strategy to pure symptom (in the early photographs, we do 'recognize' the general appearance of someone whom we identify as Cindy Sherman; the face and body are not yet deformed by prostheses). Moreover, some of the works contain secondary references. In certain *Film Stills* we can spot a system of allusions that will strike chords with moviegoers. Here the act of cultural idertification replaces the attempt to identify the actress. We think we recognize this or that character played by Sophia Loren or Marilyn Monroe, some film by Antonioni or a film noir from the 1940s. The images act as triggers for the mass of memories and knowledge we bring to them.

Minimal expression

But this imaginary world potentialized by the images is in itself deceptive. A passion for movies is another form of defence against time, or life. Allusions too are no more than circulation, pure movement, devoid of even the smallest fiduciary guarantee. Added to which is the fact that film noir, which is often (and, as it happens, erroneously) taken as the main reference of the *Film Stills*, is itself a world of imposture, deceit and doubles where women are like paintings (*Laura*, Preminger, 1944; *The Dark Corner*, Hathaway, 1946), and where characters undergo instantaneous transformations. Film noir is full of charlatans (*Nightmare Alley*, Gouldring, 1947) and disguise (*Stage Fright*, Hitchcock, 1950). Its actors can be roughly divided up into two categories: those who remain 'themselves', and are recognizable and predictable whatever their role or the quality of their acting, and those who are so ductile that they seem like avatars of some being that has no true face, no true body (Bette Davis, Joan Crawford and Laurence Olivier are all examples of this).[5]

A further factor is that the protagonists of the *Film Stills* are usually shown outside, in a long shot or medium close-up, so that it is almost impossible to pick up any significant details. Sometimes, it is true, one senses (or projects) a vague feeling of expectation or anxiety. This is particularly true of the photographs featuring a road which, like the station that appears in other shots, is a classic vector of film narration. Generally, though, it is hard to deduce any particular narrative or psychological situation from what we see. We can imagine and construct one, and that is probably one of the functions of these images.[6]

But their main impact derives from the minimalism of the actress' expression and identity: she seems to blend in with the situation like a chameleon, as if she were the pure emanation of her surroundings. Unlike many other self-representations of the 1960s and 1970s, what we see is not an artist acting but a much more general system, made almost anonymous by the absence of precise references. It is the system of a certain type of film that moulds the player to its image.

Towards dissolution

The evolution of Sherman's work since the *Film Stills* simultaneously contradicts and confirms this interpretation. It seems to contradict it, in that over the years the focus gradually homes in on the actress, her expressions, costumes and accessories, all the way to the close-up. More importantly, though, it confirms it by revealing the deceptiveness of the close-ups and the apparent 'psychologization' of the roles. The new focus on details adds nothing to our knowledge of the actress: all we see is the artifice of her make-up and prostheses. The other 'referents' are equally elusive. The backgrounds are often obtained with slides and the new use or colour does not make the images any more 'realistic'. All we have to go on are a few allusions to the history of painting or, more hazily, to American stereotypes (the student, the housewife, etc.). Essentially, these images evoke states – not so much feelings or moods, which imply the presence of a perceiving subject, but corporeal or material states, halfway between abstraction and pseudo-realist allegory: the repugnant, the ugly, the trivial, the grotesque, and so on. In these works the actress' face and body are increasingly indistinct. At times they are totally absent, replaced by a puppet or evoked by a fragment (is this her hand or leg – a fragile link with the previous works?). Having taken over the body, the power of mimesis is now forcing this totally labile entity to dissolve. And when this mimetic power finally seems to flag, what appears is not the 'real' object (the body and face of Cindy Sherman), for this has existed only as the unending sequence of its transformations. What appears is disorder, the imprint left by a body on a seat, a few abandoned accessories, the trace of what has always and only been passing through.

1 See Abigail Solomon-Godeau, 'Suitable for Framing: the Critical Recasting of Cindy Sherman', *Parkett*, 29. Opinions remain divided on the question of Cindy Sherman's feminism. For a fine clarification of the issue of 'hysteria' in her work, sec Elizabeth Bronfen, 'The Other Self of the Imagination: C. Sherman's Hysterical Performance', *Cindy Sherman, Photographic Work 1975–95* (Schirmer Mosel, 1995).

2 I quote from Guy Bellavance's generally excellent essay, 'Déssaisissement et réappropriation – de l'émergence du photographique dans l'art americain', *Parachute*, Winter 1982–83.

3 Daniel Sibony, 'Que faites-vou de vos instants?' *Evénements I, Psychopathologie du quotidian*, (Paris: Éditions du Seuil, 1995).

4 Julian Gracq, *En lisant, en scrivant*, (Paris: Corti, 1988). On the connection between photography and cinema and ageing, see Alain Bergala, 'Une erotique du filmage', *Trafic*, 11, Summer 1994.

5 This aspect of film noir is analysed by Patrick Brion in his fine book, *Le Film noir* (Paris: Nathan, 1991).

6 The turning point is clearly around 1979/80, as is shown by a comparison of *Untitled* # 40 (1979) and *Untitled* # 55 (1980). The former is a black and white, long shot of a woman on a roadside, turning away from the camera. The cinematic echo is obvious (Italian neo-realism and Aldrich's *White Heat*, 1948). The latter, a colour medium close-up cut off at mid-height, shows a woman crossing the road, pushing a bicycle, The woman is seen face-on. While the backdrop is the same, our attention in the latter focuses on the woman's gaze, which is directed leftwards out of the frame and invites us to make an interpretation.

Régis Durand, 'Cindy Sherman: le caméléonisme mélancolique des *Film Stills*/Cindy Sherman: The Melancholy Chameleonism of the *Film Stills*' (in French and English, trans. Charles Penwarden), *Art Press* (Paris: February 1996) 50–55.

Jeff Wall and Mike Figgis
An Email Exchange//2005

Mike Figgis Dear Jeff, I'm just leaving LA. I've been shooting a small film, trying out some radical (for me, that is) new approaches to filming – I will get into that later. Thought it was time to kick this off. My first thought is this. I started to read an interview between you and Arielle Pelenc [*Jeff Wall*, 1996] and what struck me was that I have no idea what you are both talking about. The references are all to do with other art, art from the past, etc. After a short while I felt very shut out, almost denied my own interpretation of what I saw. Is it important to you that I understand the context of your work within the confines of art history? I'm fascinated by the relationship between art and critics and audience. This is something I'm trying to deal with in cinema as well. Best, Mike

Jeff Wall Dear Mike, I'm sorry you had that impression of the conversation. One tends to talk to the person one's talking to and not think about how it will sound to others. It is not important at all to me that you or anyone else should have this or that knowledge of anything written or recorded about my pictures or anyone else's. It's about experiencing the pictures, not understanding them. People now tend to think their experience of art is based in understanding the art, whereas in the past people in general understood the art and were maybe more freely able to absorb it intuitively. They understood it because it hadn't yet separated itself off from the mainstream of culture the way modern art had to do. So I guess it is not surprising that, since that separation has occurred, people try to bridge it through understanding the oddness of the various new art forms. Cinema seems more or less still in the mainstream, as if it never had a 'secession' of modern or modernist artists against that mainstream. So people don't tend to be so emphatic about understanding films, they tend to enjoy them and evaluate them: great, good, not so good, two thumbs up, etc. Although that can be perfunctory and dull, it may be a better form of response. Experience and evaluation – judgment – are richer responses than gestures of understanding or interpretation.

Figgis I'm back in London now. Forgive my somewhat crude opening move. To put it another way – you, the artist, create an image and then submit to a critical gaze and then discuss it in detail – how it fits into an historical art context. Sometimes I feel that critics use language as a demonstration of their own knowledge and it tends towards elitism. I first became aware of your work in a bookstore in Amsterdam some years ago. I immediately bought the book and

have been a fan ever since. I now have a number of your books and am very interested in what you've written about cinematic imagery in your work. Have you thought about making a film? Would this be of any interest to you? I imagine not – film seems to demand a literal linear progression because of its use of a set period of time, whereas what you are doing seems to be about a moment of time that is full of ambiguity. Most films start well, with moments like this, set pieces which are designed to fire imagination, and then the rest of the film is usually downhill.

Wall Thirty years ago I thought I would make films; I thought that film was *the* artform. I spent a couple of years, 1974–75 I think, preparing myself somehow to do that. During my years in London (1970–73), when I was ostensibly a student of art history at the Courtauld Institute, I spent a great deal of time looking at film with the still vague intention of getting involved. I went to the film clubs, the Institute of Contemporary Arts, the National Film Theatre, and everywhere I could see the things I wanted to see – which were experimental and art films, from Peter Gidal and Michael Snow, to Jean-Marie Straub, Fassbinder, Robert Kramer, or Godard and Eustache. When I got back to Vancouver I was convinced I had to find a way to make films. I thought I had to do something that related to structural film but which also depicted events, or had a narrative element, some kind of fusion of Michael Snow's *La Region Centrale* (1971) and Jean Eustache's *The Mother and the Whore* (1973). And done in Vancouver! When I returned here, I worked on some video projects with my friend Dennis Wheeler, then some scenarios with him, and then on my own. Dennis tragically got ill with leukemia at that time, and passed away soon after. I wonder what would have happened if he'd been lucky and we'd gone on working together. Slowly, I began to believe that cinema was essentially rooted in its storytelling nature, and that, therefore, I had to take that on in earnest. In the interview with Arielle Pelenc you mentioned earlier, I discussed one aspect of this decision. I said I'd lost conviction in the kind of anti-cinema exemplified by Godard, felt that its structures and results just weren't as compelling artistically as those achieved by apparently more 'conservative' filmmakers, like Bergman, Eustache, Buñuel or Fassbinder, who didn't explicitly call the form of a film into question but internalized some of that critical, negative energy within the narrative form itself, making it stronger, more original, more intense. I tried to go in that direction, by attempting to write scenarios for those kinds of films, with the hope of somehow finding the means to make them. I did think even then that video could work, even though at that time we used these heavy reel-to-reel 'portapacks'. I thought that if Jean Eustache could make the films he made with what looked like just a bit of money, so could I. But as I worked on those scripts,

I realized that I wasn't the person for that kind of thing, and I felt that there was no possibility that I could raise the money I'd need. That, in retrospect, proves I have no aptitude for filmmaking because I think filmmakers always believe they can get the money! Still, I learned a lot about image making in that process, and I know that when I finally reconciled myself to the fact that I was some kind of ordinary visual artist, probably a photographer, I was able to make use of what I'd learned and struggled with in film.

Figgis I agree with what you say about Buñuel and Bergman following a more psychologically complex narrative rather than going the route taken by Godard, but for me Godard throws up more interesting ideas about cinema, particularly in his use of sound. Also his ironic humour is something I can relate to whereas Bergman seems to get more and more pompous as he gets older, which makes it harder for me to love some of his films. Buñuel is altogether a different kettle of fish. Do you like David Lynch? Very few filmmakers get through to me the way [the artists] Ed Kienholz and George Segal do.

Wall I don't want to make a polarity between the two kinds of films because I think Godard did create really interesting structures, exemplary modes and forms. I notice, though, that many of his films are not aging well. Maybe it's because of the ironic treatment of the people he's depicting, the insistent detachment from them, the way they're treated as signs, as emblems of ideas. Ideas, particularly the kind of arch-political ideas Godard has, come and go, and what remains is the feeling created by the depiction of the beings and objects present in front of the camera at the time. The more formally conventional cinema is maybe more conventional because those conventional forms have accepted a different (I won't say better) notion of the things and creatures being depicted.

Figgis It seems to me that in order for photography to be taken seriously it has to be seen to be the result of a long and hard process of creativity – reading about your work process was fascinating to me. Is it important for you to arrive at a result that is the culmination of such an intense period of work? To put it another way, could a 'snap' be as satisfying an image as, say, *The Flooded Grave* (1998–2000)? I have these feelings about my own work. Thomas Ruff's book of nudes had porno images downloaded from the internet, which he then made aesthetically acceptable on a computer – my first reaction was that they really weren't his own images, he should have taken the pictures himself. But I don't feel the same about Gerhard Richter, even though his images often look like digital computer-enhanced photographs. This is because I imagine Richter worked longer and in a more involved way by painting them. But it gets

confusing when computers are involved. I picked up on, and appreciated, something related to this that you once wrote: 'If you could tell (that it was a computer montage) the picture would be a failure'. I was really interested in the fact that you do everything 'in-house'. This must be very satisfying. I am trying to do the same with cinema and it throws light on some interesting differences between us, differences that are indications of the worlds of cinema and visual art. I have become very bored with conventional cinema and its insistence on 'reality'. You mention in your email that cinema is still in the 'mainstream'. It is, and one of the reasons for this is the way it has been designated the 'story' medium. It has very limited technical demands – 35 mm imagery, clear sound, etc – and as time passes a stronger and stronger economic relationship with the music industry and the US corporate multinational companies. In order to break away from this tradition of clean imagery I have found it necessary to go through a period of more impressionistic, disposable filmmaking. Right now I use DVCam and quite a lot of cheap consumer equipment. What this does allow is the ability to be in-house, to make a film (usually a very expensive process) without outside influence. I imagine you work closely with one or two assistants.

Wall Are you dissatisfied with the form of the narrative film, or with the economic constraints? You've been very successful making what I consider really personal films apparently within that context, like *Internal Affairs* (1989) and *Leaving Las Vegas* (1994). *Internal Affairs* is a film I have always liked. I connect it to the style and feel of some of my favourite films of the 1970s, like *Straight Time* (1978). Ulu Grosbard is a really interesting, under-appreciated director. I tend to think of filmmakers as gigantic people, capable of mammoth achievements, and so the making of a 'movie' in the conventional sense, which has serious artistic qualities always strikes me as an almost superhuman accomplishment. But I guess that scale of cinema is not what it appears to be when looked at from the outside. I get the feeling that, for you, it's a heavy obligation, too heavy to be moulded into an authentic artistic expression anymore. Do you think 'lightweight', impressionistic filmmaking is a real alternative to the mainstream cinema, one that audiences could appreciate – or is it something you want to do, no matter what the audience?

Figgis Within the mainstream of cinema, form and economics go hand in hand. When I first went to LA, to make my second film, *Internal Affairs*, I really did have the sense that it would be possible to work in a studio system and still make films that had artistic merit. It worked because I was not under scrutiny at that time, I was under the radar and no-one was watching. Studios are for the most part very sloppy organizations run by committees. A friend of mine,

Agnieszka Holland, has worked in both Hollywood and Communist Poland and she says there is a strong similarity between the two. After *Internal Affairs* there was not a single film of mine that didn't have some kind of major restraint on it. *Leaving Las Vegas* was made outside of the system, using 16 mm and financed in France. I had final cut and total control of the film. Studio filmmaking is slow and wasteful and most of the energy is diverted into non-artistic functions. It's hard to maintain the right kind of energy. There is also the sense of a deep boredom in cinema audiences and cinemas themselves are not exactly places of inspiration. The marketing of sugar-based food and drink doesn't help. On my last trip to LA I noticed most of the billboards were for adult-kid films like *Two White Chicks*, *Anchorman*, etc. So with all of that in mind I would say that, yes, lightweight impressionistic filmmaking is the way to go for the moment – until we can redefine and reclaim cinema.

Wall Now I'm older I notice I don't go to the cinema very much any more. Partly because the youth films are not for us, but also because I find myself restless with the experience of the duration itself, of the unrolling of time. I notice I feel oppressed and even trapped by that, by the replaying of a recording, essentially. I feel much the same about listening to recorded music. Recorded music always seems to intrude on the place I'm in and dominate it. The unorganized, random soundscape of everyday life is so much more interesting, beautiful and even serene, than any music can be.

Figgis I agree. I am a big fan of bad speakers though, transistor radios playing quietly within a bigger soundscape, someone singing quietly hanging out the washing. I remember Bill Forsyth saying something in an interview I did with him '… the way rain drops fall on leaves in an irregular way' (and he demonstrated with his hands – bing … bing … bing) '… I like to watch this kind of movement.' I did a video installation last year in Valencia and had all the screens on random cycles so that nothing ever repeated and different coincidences were constantly taking place. I try to resist the temptation to control because computers invite us to do just that. With *Timecode* (1999) I tried to combine some new technology with some very traditional ideas – paper and ink for the planning, wristwatches for the timing. Now I screen the film and do 'live' mixes using the separate soundtracks as source and always changing the music with each performance so that the meaning of the film changes and it is no longer a 'recording'. I think you put your finger onto something very important there, this cultural obsession with recording things, because we have the technology to do so.

Wall When I was concerned with cinema in the 1970s, I remember liking very much going to places like the London Filmmakers' Co-op. It wasn't a cinema in the standard sense. The films might be very short or very long, any length, so there was no set interval for the replaying of the recording. You could also walk in and out more easily. That suggested a kind of 'smoker's cinema' (to paraphrase Brecht), where the audience was more detached, mobile and intermittent than they are in the normal cinema. They aren't there to see a play, but to contemplate some instance of motion pictures, formed in some other way. It is more like going to an art gallery and encountering this or that work, each different in scale, medium, etc. That whole scene seemed to fade away after a while, I guess because the films couldn't make money and also because the young film artist moved in different directions. But the new lightweight film you're talking about might be part of a reconsideration of that experimental art-cinema of the 1970s.

Figgis I saw my first art films at the Arts Lab in London [1966–69] and then places like the 'Milky Way' in Amsterdam. I've been trying to establish the idea of a peripatetic cinema – all you need now is a fairly small digital projector and a DVD machine and the cinema can be anywhere.

Wall This brings me back to your earlier observation about my trying to do all my technical work 'in house', in my own studio. When I began working in colour on a large scale, again in the 1970s, I was obliged to get the prints made in commercial labs because I couldn't obtain the equipment I needed; I couldn't afford it or the place to house it. But I wanted to do that, and that was an aim that I've almost managed to realize, struggling towards it for nearly thirty years. Artists need to have as much authority and control over their work as they can. The essential model, for me, is still the painter, the artisan who has all the tools and materials needed right at hand, and who knows how to make the object he or she is making from start to finish. With photography this is almost possible. You could say that the photographer purchases unexposed film the way a painter purchases new canvas or paper; chemicals for development are analogous to paints. The camera and the enlarger are new technologies and not parallel to anything but, using those machines, the photographer can expose that film and produce a final print all in one in-house activity. Any extension of that, into collaboration with other technical people, or into having aspects of the work done outside the studio, could be thought of as just circumstantial events that don't disturb the basic structure. I always thought working in labs was just a temporary situation. If we photographers extended the work process outside the studio, we could feel confident that we could bring it back there when necessary. Even though, now, many would never even consider doing that, the

thing we call 'photography' still retains that potential – the capacity to be done at the highest artistic levels on a very modest technical scale.

Figgis Yes, I agree. I've been working with digital stills cameras over the past three years, and hold the same philosophy as with the cinema ideas. You take a different kind of photograph if you know it remains a private experience until the moment that you are ready to expose it to others. I recall in the past having very strange conversations with technicians in labs ... we'd be talking colour and sometimes the image would be quite strange, but never referred to.

Wall The artisanal nature of the practice is an enormously significant kind of freedom, artistic freedom and personal freedom. Many artists have abandoned it because it seemed too conventional and they needed to explore the space opened up by the idea of technical collaboration and everything related to that (all this defined by Duchamp and Warhol). That is as it may be, but in some sense we always know we can still keep working in the absence of those extended capacities. Film in the large sense of it, always assumed it wasn't an artisanal activity, but an industrial one. That was the enthusiasm of the earlier filmmakers and theorists, I think. It was the mark of film's difference from all the other, previous arts. That's true enough, except it blurs over the sense in which artistic freedom is connected with the scale of the work process. Industrial film is large, like opera used to be; now the costs of putting on a large opera seem miniscule in comparison to the cost of making even a middling movie. Your idea of lightweight filmmaking seems to be an approach to the older artisanal form of art. This idea has been around for quite a while, as I said, and it's worked well, for the most part, as long as you have no ambition to reach a huge audience. I like to think that serious art is not at all exclusive, but it is not for everyone; it's for anyone.

Figgis When directing films I would often hear the cry, 'We're all making the same film' from a producer or studio head. One such boss once asked me if I'd seen the trailer they'd cut for my film. I said I hadn't and he said, 'Take a look, it'll give you an idea of the film you're supposed to be making.' There's a huge pressure in the film industry to try to make something that everyone will like, i.e. a hit. But it's such a relief when you realize that this isn't really possible. I may steal your quote: 'it is not for everyone; it's for anyone'.

Wall John Waters put it this way once: he said to me, 'You artists have it great. You make your art and if it's unpopular, that's perfect. You make a film, you have to show it at the mall and then change what the people at the mall don't like!' There's been this tremendous incursion of video and film projection in art

galleries over the past fifteen years. Exhibitions often now look like a kind of film festival with dozens of little dark cinemas, side by side, each showing their one projection, the sound clashing endlessly. I like to think that motion pictures as an art form, as what we can generically call 'cinema', are something fundamentally different from the more conventional visual arts – painting, sculpture, photography. It's a peculiar circumstance that finds all this cinema presented as if it were visual art as such. But the main reason for this is that people who want to make non-conventional motion pictures can only find support from the art institutions and the art market. The film industry, public or private, has no interest in this kind of film. Even though I don't like these projections taking the place of art works, I like the fact that people who want to make film can see that the artisanal scale of visual art stands as a viable model for them, and therefore, as it has been for a long time now, for 'another cinema'. I guess the conflicted thing here is that a lot of the film-art people aren't quite convinced about the idea that, if it's art, it isn't going to be for a big audience. It will have some sort of audience, but one more like the public for the fine arts as such. A lot of the film-video-art people still have this sneaking hope for a huge public, and that's really an illusion.

Figgis I have very mixed feelings about gallery projections and art films. I see things and usually feel that it's not very well made and that the artist is getting away with murder. Usually the acting (or performance as it is called) is dire and self-conscious, the images are held for too long with no acknowledgement of the fact that everyone watches TV and movies and therefore will be used to a far quicker editing style which, like it or not, has affected the way we expect film images to progress on the screen. And, although I'm no fan of the Hollywood product, the technical aspects are of a very high level. The tricky thing about Hollywood is this – they pay really well and it's very difficult not to delude oneself by saying 'Just one more film and then I'm out of here'.

Wall The fact that the shot is held for too long is one of the main markers that it is cinema in the realm of visual art. It has become formulaic. It tends to mean 'this is not the kind of cinema we normally call cinema, this is another way of looking at the world.' That's interesting and valid in principle, except that by now it is another very well-worn way of looking at the world. It's interesting that there are by now so many new conventional ways of being different. Dogme, for example. The aesthetic strictures they set down were in themselves nothing new, just cinema verité. But I noticed, at least in the three or four Dogme films I have seen, that this 'verité' effect always seemed to involve a lot of hand-held camera. That seems very unreflected-upon, since it seems that all the other

criteria of Dogme could be satisfied while holding the camera very still (even if tripods aren't allowed). Maybe a different verité-Dogme-lightweight cinema should combine the immediacy that you are looking for with the severity of long, static shots, the way the art-video people do it? There's something tragic and sinister about the 'one more film' …

Figgis What it seems to come down to is that filmmakers are determined to leave their 'mark' on the film. So Lars von Trier insists on retaining the right to wobble, (the right to punish the audience?) but in fact it constantly reminds us that we're watching a Dogme film. For me this is all too self-conscious. I've invented a rig for digital cameras which allows hand held work without wobble. Aside from that I'm a huge fan of the tripod and the locked off frame. We probably don't have enough time to get into this but what intrigues me right now is the contract we have with an audience; the suspension of disbelief contract. I feel it is something that needs to be constantly reaffirmed and can never be taken for granted. It seems to me that this is an area you are also interested in. For me it is the reason constantly to examine form and structure so that I can maintain some tension with the audience. Another thing that really separates filmmakers from 'artists' is this – you will create either one, or a small series of works. I will try and make as many copies as possible on DVD or tape so my film will never be special, unique. But surely the future is going to be all about this multi-editioning and shouldn't art try not to be so iconic? Hasn't our culture really moved away from the principles that created this uniqueness?

Wall But that accepts that the cinema, in its industrial form, is the measure of all the arts. That seems old fashioned, the kind of thing they talked about in the 1930s and 40s, that cinema, the 'seventh art', would be the model for everyone. But I'm arguing for the at least equal validity of artisanal methods and approaches, and at least the equal and simultaneous validity of different models. The fact that some kinds of works can do perfectly well as innumerable copies doesn't affect the fact that others can do just as well as a unique thing. With a painting, the uniqueness is inherent in the nature of the medium anyway. So the question is really posed to photographers because we are the only ones in the artisanal field who have the feasible possibility of making works in large editions. It isn't really feasible in the older graphic media, like etching or lithography, because the printing plates or stones aren't capable of reproduction past a fairly limited point. So, in a way the question never really comes up seriously for people who paint, draw or make those kinds of prints. That seems to mean that they will never really be absorbed into any sense of mass-produced art, except through external, mechanical reproduction of their work. Since they

cannot give us the mass of copies we might request from them, we'll just have to let them continue on their way with their single works or small editions. But I don't see that as out of date, since it is happening now and for inescapable reasons; so it has to be part of 'now' and presumably, of the future. The question is posed most meaningfully to the photographers. Even though it is again not very easy to make very large numbers of copies from a photographic negative. That would be really slow work, since each print would have to be done individually, by hand, and, even if you have all your settings just right, there will still be variations from print to print. Even letting that pass, and accepting that photography can actually give us the large editions, there are obstacles. For me, the main obstacle is that, in so far as a photograph is made with an artistic aim akin to a painting or a drawing, there is no inherent reason to make any particular number of prints from a negative. If your aim is to make a picture by means of photography, then one picture is enough. The God of Photography is content when a negative is transformed into a positive. The act of photography is complete. Making a second print, then, might be only the response to an external stimulus of some kind, one that actually has nothing essential to do with photography. So, since uniqueness seems to have a strong status in this way of looking at it, there isn't any powerful reason to abandon it.

Figgis I was at a film conference in Portugal and a man raised an interesting point. He was in his sixties. He said that when he first started seeing good films by Buñuel and Bergman (and Godard, of course) he would go to the cinema knowing that perhaps he would never again have an opportunity to see this film. I quite like this notion of uniqueness. Something that lives in the memory and modifies internally as we age, by the organic process of memory. When I see a strong film I have no desire to see it again.

Jeff Wall and Mike Figgis, 'An email exchange between Jeff Wall and Mike Figgis', *Contemporary*, no. 65 (London, 2005).

Gregory Crewdson
Interview with Anna Holtzman//2006

Anna Holtzman What was the genesis of the series *Beneath the Roses* (2003–5)?

Gregory Crewdson You know, I'm never conscious of some exact parameter in terms of whether a project is going to be concerned with this or that – I see the whole process of making pictures as more organic. That being said, these pictures are really about these moments of beauty and wonder and mystery and everyday life. And through the pictures I try to find moments of some sort of psychological tension … All these things remain inconclusive though – they remain a kind of riddle or question mark.

Holtzman The photos in this series are taken in small towns in Massachusetts and Vermont. How do you choose your locations?

Crewdson Well, I've been making pictures in and around this one area for many years, starting in my mid-twenties when I was a graduate student at Yale in the photo department. I kept coming back to this one area, this one geography, and I can't quite say why, although obviously I'm drawn to the iconography of the place. But I think that more importantly it's just become a place where I can work. My productions are very large scale and I think it helps that I've slowly but surely been building up a working relationship with this place. But in a way, the pictures could be made anywhere. You know, I look for the places that feel like anywhere or nowhere. [...]

Holtzman How do you find your crew? Are they generally people who come from the film world?

Crewdson Yes, practically everyone who works on my productions comes out of the film world and I have a basic group that I work with on everything. It's a core group that includes my director of photography, my cameraman, my line producer and my assistant.

Holtzman So you're not the person pushing the button of the camera?

Crewdson No, I don't. I use an 8 x 10 camera, which is a very cumbersome machine, and the camera never moves once it's set, so there's no changing the

point of view. (That's partially because we combine different elements from different negatives in post-production.) Once the shot is framed, I don't want to be behind the camera. It's too much of a division between myself and my subject. I much prefer to be right along next to it.

Holtzman What's your interaction like with your models? Do you even consider them models, or are they more like actors?

Crewdson Well, it's funny, because I never quite know what to call them – they're not actors, and they're not models. Maybe they're subjects ... objects? [*laughs.*] I actually like to have almost no contact with them. First of all, it makes me uncomfortable to be around them too much. And then the other thing is that there's no improvisation in the work, so by the time they come out on set, I know exactly where they're going to be. I like them to come out at the very last moment.

Holtzman Are the subjects given a back-story or an emotion to have in mind?

Crewdson Again, as little as possible. You know, I don't usually actually know what's happening in the pictures myself. So usually I'll just say something like: 'I want a little less', or, 'Empty it out a little bit more.' You know, 'Just stand right here, look this way.' Stuff like that. You know the thing about photographs, unlike a film, is that it's just a frozen moment. And a lot of my pictures are really about an in-between moment. So that's why I think I want as little [emotion to be determined] as possible.

Holtzman How does your work relate to the current zeitgeist of suburban alienation in film and photography?

Crewdson I'll leave that for others to comment on. When I'm making my pictures, I only really truly think about the photograph at hand. And the whole process, despite the [magnitude of the] production, is very organic. You know, it starts off as a very isolated activity, weeks of me just driving around finding the perfect location. And then, out of that an image comes out of my mind. That image is very illusive, and you sort of wait for it to happen, and you wait and wait, and you drive around more ... And so, by the time it all comes together, if it comes together correctly, ultimately it's just this very private, strange, elusive, removed thing. It's like catching a spirit, in a way. So I'm really not concerned with anything outside of all that. However, I think it's important to say that an artist's pictures also carry their own meaning once they're out in the world. [...]

Holtzman You describe your image-making process as organic and somewhat mysterious. When you're in the editing phase, do you ever go back and try to analyse your psychological and aesthetic motives?

Crewdson No, you know what, it really becomes like a maths problem at that stage – it's like a technical issue. Because, to me, the aesthetic moment that's the most meaningful is that moment when I'm out there [shooting], where everything aligns and we have this perfect stillness, and everything just feels absolutely beautiful, and it's sort of like I'm a witness to that. Then afterwards, it's months of post-production, where we're putting different negatives together, and doing everything in post-production we can to … not recreate that moment, but make it its own thing. So by the end of it, you almost can't see the content, in a way. And I don't want to be too conscious of the process.

Holtzman What's your relationship to the motion picture world?

Crewdson It's a funny thing, I've always had a great love for movies and in fact, as a student at SUNY, Purchase, I had an odd triple major on photography and film theory and American literature. So film always motivated my pictures from the beginning. But it wasn't really until I met my director of photography, which was I think a really fateful meeting, that this whole avenue of expression was made available. So it was through them initially, and then, you know, as you follow in line it just sort of expands on itself. And all of a sudden there are production designers or art directors or prop people or post-production people who see the work and are interested in becoming involved.

Holtzman Who's your director of photography, and how did you meet?

Crewdson His name is Rick Sands. It's one of the strangest coming together stories for me. I was working in Massachusetts, and I was just finishing the Hover pictures, which are these black and white pictures taken from an elevated crane. So they're already cinematic. And I met him through a mutual friend. Rick had just removed to the area after working in Hollywood for years and years, and I was introduced to him as someone who's a brilliant lighting director, or director of photography. And as soon as I saw what we could do together, inside my mind, you know … So, we've been working together ever since, and it's a really interested relationship. As I'm sure it is with other directors and cinematographers, you build up a shorthand where the less said the better. So we barely have to speak at this point.

One of the things about a movie set is that everyone has a specialized activity. And that's, to a certain extent, what happens here. It's funny, because it goes from me driving around by myself, which is a very isolated experience, to the end when there's like forty people working on a single image. But it takes everyone's role to get it done. One of our biggest issues is location management, as you can imagine, because sometimes we have forty or fifty or sixty different lighting positions, so we have to close down whole streets. But it's all these things, these tiny little things that all come together to create that perfect moment [...]

Holtzman Were you always a photographer or did you have another career before that?

Crewdson Always a photographer. And that's why I'm so hesitant to do anything else, because I really think like a photographer. You know, there's always questions about me ever doing a movie or something, which in the back of my mind is a possibility. But I actually hhave many friends who are film directors, and I know I think differently than they do. They really think in terms of plot and story and linear time,, and montage and sound. And I don't think that way. I just think in terms of single images. The idea of even moving the camera is terrifying. [*laughs.*]

Anna Holtzman, Interview with Gregory Crewdson, *Eyemazing*, issue 3, August 2006. www.eyemazing.info

AS WE WATCH A FILM,
THE CONTINUOUS ACT
OF RECOGNITION IN
WHICH WE ARE
INVOLVED IS LIKE A
STRIP OF MEMORY
UNROLLING BENEATH
THE IMAGES OF THE
FILM ITSELF, TO FORM
THE INVISIBLE
UNDERLAYER OF AN
IMPLICIT DOUBLE
EXPOSURE

Maya Deren, 'Cinematography: The Creative Use of Reality', *Daedalus*, Winter 1960

Susan Sontag
On Photography//1977

To collect photographs is to collect the world. Movies and television programmes light up walls, flicker, and go out; but with still photographs the image is also an object, lightweight, cheap to produce, easy to carry about, accumulate, store.

In Godard's *Les Carabiniers* (1963), two sluggish lumpen-peasants are lured into joining the King's Army by the promise that they will be able to loot, rape, kill, or do whatever else they please to the enemy, and get rich. But the suitcase of booty that Michel-Ange and Ulysse triumphantly bring home, years later, to their wives turns out to contain only picture postcards, hundreds of them, of Monuments, Department Stores, Mammals, Wonders of Nature, Methods of Transport, Works of Art, and other classified treasures from around the globe.

Godard's gag vividly parodies the equivocal magic of the photographic image. Photographs are perhaps the most mysterious of all the objects that make up, and thicken, the environment we recognize as modern.

Photographs really are experience captured, and the camera is the ideal arm of consciousness in its acquisitive mood.

Susan Sontag, *On Photography* (New York: Farrar, Straus & Giroux, 1977) 1–2.

Chris Marker
La Jetée//2003

It was a funny-shaped object. A small tin box with irregularly rounded ends, a rectangular aperture in the middle and on the opposed side a small lens, the size of a nickel. You had to insert gently a piece of film – real film, with sprockets and all – in the upper part, then a tiny rubber wheel blocked it, and by turning the corresponding knob the film unrolled, frame by frame. To tell the truth, each frame represented a different shot, so the whole thing looked more like a slide show than a home cinema, yet the shots were beautifully printed stills out of celebrated pictures: Chaplin's, *Ben Hur*, Abel Gance's *Napoléon* ... If you were rich you could lock that small unit in a sort of magic lantern and project it on your wall (or screen, if you were very rich). I had to content myself with the minimal version: pressing my eye against the lens, and watching. That forgotten contraption was called Pathéorama. You could read it in golden letters on black, with the legendary Pathé rooster singing against a rising sun.

The egotistic pleasure of watching by myself images pertaining to the unfathomable realm of Movieland had very soon a dialectical byproduct: when I couldn't even imagine having anything in common with the process of filmmaking (whose basic principles were naturally far beyond my comprehension), there something of the film itself was within my reach, pieces of celluloid that were not that different from the photographic negatives when they came back from the lab. Something I could touch and feel, something of the real world. And why (insinuated my own dialectical Jiminy Cricket) couldn't I in turn make something of the same kind? All I needed was translucent material and the right measurements. (The sprockets were there to look good, the rubber wheel just ignored them). So, with scissors, tracing paper and glue, I managed to get a proper copy of the Pathéorama model tape. Then, screen by screen, I began to draw a few postures of my cat (who else?) with captions in-between. And all of a sudden, the cat belonged to the same universe as the characters in *Ben Hur* or *Napoléon*. I had gone through the looking-glass.

Of all my school buddies, Jonathan was the most prestigious; he was mechanical-minded and quite inventive, he made up maquettes of theatres with rolling curtains and flashing lights, and a miniature big band emerging from the abyss while a cranked Gramophone was playing *Hail the Conquering Hero*. So it was natural that he was the first to whom I wished to show my masterwork. I was rather pleased with the result, and I unrolled the adventures of the cat Riri which I presented as 'my movie'. Jonathan managed to get me sobered up.

'Movies are supposed to move, stupid' he said. 'Nobody can do a movie with still images'.

Thirty years passed. Then I made *La Jetée*.

Chris Marker, 'La Jetée', Brochure for DVD of *La Jetée* and *Sans Soleil*, edited by Nouveaux Pictures, Argos Films, 2003.

Uriel Orlow
Photography as Cinema: *La Jetée* and the Redemptive Powers of the Image//1999/2006

Chris Marker's short science fiction film *La Jetée*, made in 1962 and released in 1964, inhabits a somewhat peculiar position both in post-war European cinema as well as in his own oeuvre. For, even though it is mainly known to initiated cinephiles, *La Jetée* is regarded as one of the bright stars in the sky of auteur-cinema; amongst many exegetical studies, it even provoked a Hollywood remake by Terry Gilliam, *Twelve Monkeys* (1996). Moreover, being the only fiction-film made by this prolific documentary filmmaker who is also a writer and photographer, *La Jetée* stands out of Marker's politically engaged oeuvre. Above all, *La Jetée*'s singularity and continuing spell must be attributed to its compelling story and intriguing imagery. The fascination of *La Jetée*'s plot stems at once from the narrative simplicity of its tragic love story as well as from the conceptual complexity of its time-travel paradigm. *La Jetée*'s representational apparatus is similarly engaging, with its balancing act on the thin line between photography and film. The unique, near-exclusive use of beautifully shot still photographic images presented as a film defies what is commonly understood to be the cinematic norm – movement, the *kiné* of kinematography. Yet *La Jetée* cannot be considered only in terms of photography either, as it paradoxically reaffirms the cinematic with its photo-novel technique (montage), as well as through the soundtrack.[1] As such it is a seminal work combining photography and cinema, allowing us to interrogate the specificities of both as well as their close interrelations. In the following, however, I shall not propose another position in the long ontological struggle to define the photographic or cinematic image respectively, but, rather, try to show how *La Jetée* powerfully turns this *quest for* an essence into a *question of* essence, defying the laws and definitions of both photography and film. It presents us with an attempt to define the image no longer in terms of a single essence, be that a photographic or cinematic one, nor in terms of a single genre – *La Jetée* bears attributes of the comic-strip, photo-album, fiction-film and documentary. Instead, the image is construed as an interplay of dialectical and often paradoxical forces. By embracing contradiction and freeing the image from the ontological constraints of singular and deterministic conceptions, *La Jetée* reveals a dialectical power of the image.

The contradictions that are played out on *La Jetée*'s image track are in many ways analogous to those played out by the story itself. The struggle between arrest and movement is not only that of photographic images under the aegis of

cinema (or to put it the other way around, of cinematic motion threatened by photographic stillness), but also that of *La Jetée*'s plot, which takes place between the same two poles of stasis and mobility: The *setting*, the narrative starting point, is one of double inertia; that of a world in post-nuclear stasis, and that of an immobilized protagonist, both physically – he is imprisoned in an underground camp by victorious survivors – and mentally, as he is bound by his love for a woman in the past. Because space is completely devastated after a future World War III the survivors attempt to find help in time and use him for their experiments. The crystal-clearness of a memory image which he retained from his childhood – the face of a woman standing at the end of the jetty at Orly airport in Paris – is the force which catapults him into time. After a series of journeys through time, mainly into the past, where he meets the woman from his memory and an impossible love starts to grow between them, he eventually finds help in the future, which cannot refuse its own past the means of survival. Having completed his mission and waiting to be liquidated by his oppressors, the people he contacted in the future come back to him to receive him amongst them and in their pacified time. He declines their offer, and instead asks to be brought back to the time of his childhood, to the woman who might be waiting for him in the past. Back on the jetty at Orly airport he sees the face of the woman and runs towards her. Just before being reunited with her, he is assassinated by a guard who followed him from/since the underground camp, from which he tried to escape. 'He understood, that one couldn't escape from Time, and that this moment he had been given to see as a child, which had never ceased to obsess him, was the moment of his own death.'[2] He realizes that the child he had been is there too and will live on with the memory of his own death.

Whilst the protagonist's travel through and struggle with time in *La Jetée* is also a journey to and through the image (of the woman, and of his own death), the image's struggle between movement and arrest, between the cinematic and the photographic is, in turn, a struggle with, and journey through time. *La Jetée* opens up questions about experiential temporality and personal memory, ending in a moment of existential suspense, a kind of vertigo of life and death. This mirrors what is going on at the level of the representational apparatus, which is caught in the contradiction of the still yet moving images, interrogating assumptions about the temporal modus of both photography and cinema. Generally, the photograph is thought to extract a moment from the flux of time, to cut out a slice of a time-space continuum and thus to have no duration of its own.[3] The cinematic image, whilst sharing with photography its chemical production as well as its claim to represent reality indexically, apparently does not stop and preserve a moment of time, but rather, through the addition of movement, is considered to represent the very unfolding of time, thus giving the

illusion of the same duration as our experience. Whereas the perpetually refreshed and ever changing image of film is a *reproduction* of the vitality of the present (even if past events are depicted), the photograph is a *representation* of the past and of mortality (even if the subject is still alive).[4] There have been two interpretations of the photograph's indexicality of the past. First, the photograph has been considered as a proof of a *there and then*, indicating both that *this-has-been* and that in a sense it is *no-more*.[5] The metaphors used to describe this notion of the photograph range from time-fossil to death-mask whose subject is long gone and can only be narrated but not reanimated. The second interpretation takes the photograph to embalm and preserve time (like insect bodies in amber)[6] and thus to eternalize the past. This photograph is a *time-mummy*, a living trace whose subject somehow is still there and could, possibly, be reanimated at any moment.

The very first image of *La Jetée* is of Orly airport near Paris. As soon as the image appears it begins to expand rapidly by way of a zoom-out, starting on the horizon-line, moving along the diagonal perspectival axis of the image and finally comes to a rest, displaying a grey and grainy bird's-eye-view of the airport grounds, with parked planes and cars and an oblong airport-building on whose roof a few tiny figures can be discerned. In the first instance it is probably the fixity of those figures that exposes the unchanging nature of the image, leading to the realization that the moving lens has not recorded this image directly from reality – where some movement would inevitably occur and be mirrored in the image – but is re-presenting an already recorded image. The image's initial zoom is exposed, in retrospect, as a supplementary or external rather than an inherent and internal movement; the image is thus identified as a still photograph – one which remains on screen for almost a minute (the first minute of the 29-minute film). The commentary's allusion to *a violent incident* underlines the assertion of 'photographicity' in this image – a triangulation of reality, past and death. The inscription of the photographic image in an economy of death continues to manifest itself in the following images. After the opening image of the airport, a series of stills follow which continue to depict or display immobility or fossilization (rather than merely being motionless images), giving a strong sense of anticipation or dread, of a catastrophe to come which has somehow already happened. They evoke fate, a reality which is still to come but is already sealed, already fixed – hovering above it all, beneath it all, is death, both imminent and already accomplished: an airport tower and an opaque, matte sun behind it (a *frozen* sun as the commentary tells us); again the airport; a grounded plane; then, a family standing still on the jetty and looking out towards the runways; the boy as if fastened to the railings; his immobile legs; three flight attendants on the tarmac, their movement suspended; and finally, the jetty itself, the *stage-*

setting at the end of the pier, where the protagonist is about to die and has already died, the calm before *and* after the storm.

Despite the assertion of 'photographicity' the cinematic is never far off in *La Jetée*. Already the initial zoom over the airport image registers as a cinematic movement and thus, somewhat paradoxically, problematizes the image's 'photographicity' at the same time as affirming it. The still images of *La Jetée* are not just single photographs collaged together into a slide show but are also profoundly cinematic. They are images-in-sequence, bound in a syntagmatic interrelation that projects them from the two-dimensional plane of photography into a cinematic illusion of a four-dimensional space-time continuum. Also, the sequences themselves are created with filmic styles: fades and dissolves create a seamless flow out of the still images. And not just between but also within the images themselves cinematic conventions unsettle the photograph, as in the addition of movement through zooms and pans. Even the formal composition of the images bears witness to the cinema: long shots of the jetty, a bird's eye view of the ruins of Paris, of a park or a museum take turns with close-ups of faces, statues and room-fixtures. In *La Jetée* the cinematic ceases to be identified by movement (and thus in opposition to photography, as defined by lack of movement) and its illusion of a time-space continuum and narrative flow becomes associated with the conventions of montage; rhythm, angles, repeated shots from different points of view, shots and counter-shots, fades and dissolves. This notion of the cinematic is not threatened by static photographic images as it no longer relies on the suppression or repression of its own photographic or photogrammatic base (the still image). Moreover, the notion of montage also challenges photography's association with death – as ultimate ontological horizon or arbiter – and cinema's consequent identification with life. Bazin had already alluded to cinema's own kinship with death based on montage, when he wrote as early as 1951 (almost pre-empting *La Jetée*): 'Death is one of the rare events which justify the notion [...] of cinematographic specificity. An art of time, cinema has the exorbitant privilege of repeating it [death].'[7] And if the possibility for the repetition of death is what in his view marks cinema's complicity with death, the condition of this repetition is montage. This also echoes Pasolini: 'Editing performs on the material of the film (which is composed of fragments that can be extremely long or infinitesimal, of many sequence shots understood as possible infinite subjective shots) the same operation that death performs on life.'[8]

Cinema's own claim on death does not propose a medium specificity and thus an inverted opposition to photography in a binary ontological system. Montage – the operation of choice, assemblage, repetition, overlapping – is not an exclusively cinematic operation, even if some of its conventions are. Indeed,

it extends to the presentation of all photographic images, be they in a photo-album, on a wall, or through a cinema-projector. The self-confessed medium of *La Jetée*, the photo/ciné-roman, proves exactly this point, by proposing a middle ground, an undecidability between photography and cinema, which is simply defined by the presence of photographic images (moving or not) and their assemblage into a story. *La Jetée* defies the binary oppositions between photography's kinship with death and film's association with life, between past and present, the fossil and the mummy, by making use of both photographic and cinematic conventions. This proposes a powerful critique of an essentialist medium-specificity of photography and cinema which relies on the opposition of movement and stillness. To be sure, *La Jetée*'s images never quite achieve cinematic movement. Instead, they constantly unveil the smallest unit of the film, the film still, the photographic frame. As such, they expose the illusion of duration in cinema which is achieved through a 'false' movement.[9] After all, cinematic movement is always just a very fast succession of immobile images (frames). In *La Jetée* photography reminds cinema that ,like itself, it cannot but fall short of representing real duration – whose flow can neither be halted nor divided into equal parts (instants, frames, photographs). *La Jetée* strips cinema of that element which emancipated it from photography, that is of its very core, movement. By doing so it proposes a different kind of temporality which doesn't only rely on movement and combines the photographic *this was and perhaps still is* with the cinematic *this is or will be*. The photograph-as-cinema encompasses all times at once, an image proclaiming *this was, is and will be* at the same time.

This liberation of the image from a rigid syntactical tense structure and its consequent immersion into a new kind of 'holistic' time, of course mirrors the narrative of *La Jetée*, whose mental time travel shatters linear chronology and diffuses the separation of past, present and future and their alignment on an (unavoidably spatially imagined) continuum. Once chronology has exploded (or imploded for that matter) the splinters of time light up like so many facets of a crystal. Indeed, Gilles Deleuze calls the cinematic image, which represents time directly and not just as a measure of movement, i.e. linearity, the crystal-image.[10] Even though Deleuze never mentioned *La Jetée* in his cinema books it seems to be an emblematic example of the crystal-image. It portrays both the protagonist's rebellion against the tyranny of the present and unidirectional time, as well as the image's struggle to free time from its subordination to movement. The image, no longer relying on an internal movement to *represent* time, instead *produces* time through its relations to other images. In *La Jetée*, the transition from the movement-image to the time-image literally becomes visible: through a continual arresting of cinematic movement, the viewer is held in contemplation, in a kind of 'pure' spatial exploration of the image, which in

turn is rendered 'purely' temporal, as the image is linked to other images. Watching *La Jetée* can be likened to taking part in an archaeological expedition, where, by digging through space a temporal dimension is excavated, one independent of forward motion or action, but rather embedded in the labyrinthine circuits of memory.[11] *La Jetée*'s photographs-as-film incorporate both the flow of time as a present which always passes (cinema), as well as a past which is being preserved (photography).

As time-images that refer both to the present and to the past, and as images that can neither be attributed exclusively to photography nor film, *La Jetée*'s images are, above all, dialectical. Walter Benjamin described the dialectical image like this: 'It is not so, that the past throws its light onto the present, or the present its light onto the past, but the image is that in which the past coincides with the now and in a flash becomes a constellation. In other words: the image is dialectics at a standstill.'[12] *La Jetée* does not propose a synthesis of the dialectic of photography and cinema, but rather, after presenting the ontological, binary mechanism of that dialectics, it undoes the opposition itself and stops the dialectic in its tracks, showing time in the image independently of its medium. If we are, then, to push these reflections on the status of the images in *La Jetée* a step further, away from the questions of medium, genre or structure towards a notion of pictorial *operation*, that is image-dialectics, the notion of stillness can be reconsidered once more. The arrest of the images in *La Jetée* represents the power to interrupt the flow of narrative (so dear to the cinema), to insert a hesitation between the image and its meaning, and between one single image and the whole of the film. It is not just a pause within time, but rather an active halt, which works upon the image. The stopped image is transported out of time and is thus given the power to expose time, and this is a fundamentally redemptive power.

The image-in-arrest, or cinema-as-a-series-of-photographs having gained autonomy not only from movement but also from time, does not, however, claim any kind of self-sufficient authority. Rather, it shows all the more strongly how temporality, or indeed any meaning, is produced not *in* the image, but *between* itself and another, i.e. through montage. However, *La Jetée* by the same token warns of a simplistic notion of montage, as merely putting images together and ordering them according to chronology or a-chronology. Beyond the practice of organization or juxtaposition of the visible, the most powerful aspect of montage is the gap, whose potential resides in the invisible and its force to transcend the image. The gap or interval between (the meaning, or time of) one image and another is not just a founding principle of narrative cinema (and literature for that matter) but is also the means to produce a qualitative leap or change, that is to insert a kind of revolutionary energy into the film. Whereas there is a tendency in mainstream cinema to hide the assemblage of different

images, *La Jetée* turns montage inside out and shows the seams which hold the images together. Through long fades it exposes the black interval present between all cinematic images and focuses our attention onto the fabric, operational mode, and redemptive potential of the gap and the image alike. The dialectical interplay between image and gap is, of course, very much analogous to a certain conception of memory, which presents us with as many images (from the past) as gaps. And indeed, the stage of this interplay is also where the protagonist of *La Jetée* fights for freedom from the constraints and oppression of 'wrong', linear and irreversible time in order to fulfil his love for a woman once glimpsed in the past. Crucial in this quest for lost love, and thematizing the notion of redemption, is the moment of their closest intimacy in the middle of the film, when he watches her sleeping, turning her head in an ever accelerating replacement and superimposition of images, and finally opening her eyes, in an image which is famous for being the only *moving* image of the entire film. Yet, contrary to the general assumption that this 'climax of the eye' coincides with the achievement of the 'truly' cinematic through the reanimation of the stasis of photography, this short moving image after the fast succession of still frames, rather creates a kind of (ar)rest, or stoppage. Thus it does not so much represent the victory of cinema over photography, but reveals a dialectical image at a standstill, an image defined by photography and cinema, and paradoxically autonomous from both, a redemptive image.

1 There are a number of studies which deal with this problem, one of the most detailed being Roger Odin's 'Le film de fiction menacé par la photographie et sauvé par la bande-son', in *Cinémas de la Modérnité*, ed. Dominique Chateau et al. (Paris: Klinksieck, 1981) which was further elaborated by Réda Bensamaïa in 'From the Photogram to the Pictogram', *Camera Obscura*, no. 24 (September 1990).

2 Chris Marker, *La Jetée*, 1962. Zone Books have published a book with the off-screen film commentary of *La Jetée* and a selection of images (New York, 1996).

3 This also relates to the temporal lexis of the image: in a way a photograph only *lasts* as long as we are looking at it

4 'The snapshot, like death, is an instantaneous abduction of the object out of the world into another world, into another kind of time – unlike cinema which replaces the object, after the act of appropriation, in an unfolding time similar to that of life.' Christian Metz, 'Photography and Fetish', in *October*, no. 34 (Fall 1985) 83; essay reprinted in this volume, 124–33.

5 See Roland Barthes, *Camera Lucida* (New York: Hill & Wang, 1981).

6 See André Bazin, 'The Ontology of the Photographic Image', in *What is Cinema? 1* (Berkeley and Los Angeles: University of California Press, 1967)

7 André Bazin, 'Mort tous les après-midi', in *Qu'est-ce que le cinéma*, vol. 1 (Paris: Cerf, 1958) 68 (first published in *Cahiers du cinéma*, 1951). 'An intolerable spectacle, not so much due to its

objective horror but rather due to its ontological obscenity. The profanation of cadavers and the rape of burial places was known before cinema. But thanks to film, the only temporally non-alienatable thing we have, can today be exposed at will. Deaths without requiem, eternal re-deaths of cinema!' (70; my translation). The notion of death as cinematic specificity was perhaps first articulated in Cocteau's famous dictum: 'Cinema is death 24 times a second.'

8 Pier Paolo Pasolini, 'Observations on the Long Shot (1967)', in *Heretical Empiricism*, trans. Ben Lawton and Louise K. Barnett (Bloomington and Indianapolis: Indiana University Press, 1988). 237. 'Dying is absolutely necessary, because, as long as we are alive, we lack meaning, and the language of our life [...] is untranslatable: a chaos of possibilities, a search for connections and meanings without resolved continuity. Death carries out a lightning montage of our life: it chooses from it the most significant moments (which can no longer be modified by other possible, contradictory or incoherent moments) and puts one next to the other [...].' 236. Earlier in the same essay Pasolini shows how, if cinema always shows the present, it must consequently create a multiplication of presents which in turn abolishes the present. See Owens and Macafee's translation in this volume, 84–7.

9 Real movement is indivisible, which distinguishes it from the space covered, cf. Henri Bergson, *The Creative Mind* (Westport, Connecticut, Greenwood Press, 1968).

10 See Gilles Deleuze, *Cinema 2: The Time-Image* (London, Athlone, 1992). see also D.N. Rodowick, *Gilles Deleuze's Time Machine* (Durham, North Carolina: Duke University Press, 1997).

11 This metaphor is borrowed from Laura Marks, 'A Deleuzian Politics of Hybrid Cinema', *Screen*, vol. 35, no. 5 (London, 1994).

12 Walter Benjamin, *The Arcades Project*, N3.1, in *Collected Writings* (Frankfurt am Main: Suhrkamp, 1982) 578 (my own translation).

Uriel Orlow, 'Photography as cinema: *La Jetée* and the redemptive powers of the image', *Creative Camera*, no. 359 (August–September 1999), 14–17. Revised by the author for this publication, 2006.

David Campany
Safety in Numbness: Some Remarks on Problems of 'Late Photography'//2003

Several weeks into the intensive coverage of the aftermath of the collapse of the World Trade Center, Britain's Channel Four News screened a thirty-minute special report entitled 'Reflections on Ground Zero'. It followed New York photographer Joel Meyerowitz as he manoeuvred diligently around the smoking rubble and cranes with his large format camera. He had been commissioned by the Museum of the City of New York to make for posterity the 'official' images of the scene and the clean-up operation. He was granted exclusive photographic access to the site and produced a substantial body of colour photographs, exhibited in the city and later internationally. Just about everyone worldwide with access to a television had seen the fall of the towers and the ensuing news reports, through electronic images transmitted globally and instantaneously. Lower Manhattan became the most imaged and visible of places, the epicentre of a vast amount of state-of-the-art digital and video news production. Yet here was a report beamed to Britain featuring a solitary man, his tripod and his forty-five pound, sixty year old Deardorff camera. It was a slow and deliberating half-hour, imbued throughout with a sense of melancholy by the constant tinkling of a piano in a minor key. There was an air of ritual too, since this was at least part of the function of both the programme and the photographs. In being about photography the report almost managed to draw attention to the medium of television. It made much play of the contrast between the complexity of the geopolitical situation and the simplicity of Meyerowitz's camera and working method. The suggestion that photography, rather than television, is the better medium for official history was unusual. Television was deeming itself unable to perform an image task given over to photography, even while it was showing us images at least as informative as the ones being taken by the photographer. The photographs were positioned as superior to the programme in which they were presented. Meyerowitz was filmed telling us at one point 'I felt if there was no photographic record allowed, then it was history erased.'[1] No doubt the special sanctioning will symbolically structure how his pictures are seen as they tour. Even so this status will probably become less secure in the future – they will probably take up a place alongside so many other images in the constructions of history. What *may* mark them out in posterity is the very act of sanctioning itself, the idea that there was a need, a desire, to nominate an official body of images, and that these should be photographs.[2]

Meyerowitz's imagery is not so much the trace of an event as the *trace of the*

trace of an event. This 'late' photography is a particularly clear instance of a strategy I sense is becoming quite a prevalent use of the medium. What I want to do here is think through what is at stake in the rise of this kind of photograph in contemporary visual culture.

What are we to make of the highly visible turn towards photographing the aftermath of events – traces, fragments, empty buildings, empty streets, damage to the body and damage to the world? It comes to us as a particularly static, often sombre and quite 'straight' kind of picture, which assumes an aesthetic of utility closer to forensic photography than traditional photojournalism. It is a form of what Peter Wollen recently called 'cool photography' as opposed to the 'hot' photography of events.[3] Sometimes we can see that something has happened, sometimes we are left to imagine or project it, or to be informed about it by other means. The images often contain no people, but a lot of remnants of activity. If this type of image was only present in contemporary art it might be overlooked as a passing trend (of all art's media, photography is still the most subject to curatorial whim). But we see it increasingly in new photojournalism, documentary, campaign work and even news, advertising and fashion. One might easily surmise that photography has of late inherited a major role as an undertaker, summariser or accountant. It turns up late, wanders through the places where things have happened, totting up the effects of the world's activity. This is a kind of photograph that either foregoes or cannot represent events and so cedes them to other media. As a result it is quite different from the spontaneous snapshot and has a different relation to memory and to history.

The theoretical framework connecting the photograph to collective memory is as well established as it is complex. The photograph can be an aid to memory, but it can also become an obstacle that blocks access to the understanding of the past. It can paralyse the personal and political ability to think beyond the image. Proper knowledge depends not just on the photograph itself but on the place it is afforded in the always fraught project of remembrance.[4] However, in the popular culture of mass media, the frozen image is often used as a simple signifier of the memorable, as if there were a straightforward connection between the functions of memory and the 'freezing' capabilities of the still camera. Indeed this is such a well established assumption about photographs that to even question it seems a little perverse. So rather than thinking about a direct relation between the photograph and memory let us think about the two of them in relation to other media.

Television and cinema make regular use of photographic snapshots and freeze-frames as a kind of instant history or memory that they as moving images are not. Indeed it seems plausible that it is *primarily* this use of the still photograph by television and film that has cemented the popular connection of

photography with memory, rather than there being some intrinsic relation. There is nothing like the 'presentness' of the moving image to emphasize the 'pastness' of the photograph it shows us. It can do it even better than the continuum of life itself, for when the moving image presents the still, it evokes the memorable because as a technology the still is a part or a ghost of it. To presume that the still image or the freeze-frame is inherently more memorable, or closer to the nature of memory, is to overlook the fact that the very operation of our memory is changing. It is shaped by the image world around us. The structure of memory is in large measure culturally determined by the means of representation at our disposal. As our image world shifts in character, so do our conditions of remembrance.[5] It may well be that the special status granted the still photograph in the era of television and newer technologies is not so much a recognition of its mnemonic superiority as a nostalgic wish that it still has such 'power'. This is to say there is an investment in the idea that the relative primitivism of photography will somehow rescue the processes of our memory that have been made so complicated by the sheer amount of information we assimilate from a diversity of technologies.

In popular consciousness (as opposed to popular *unconsciousness*) the still image continues to be thought of as being more memorable than those that move. Yet if the frozen photograph is memorable in the contemporary mediasphere it is because it says very little itself, while allowing all that audio-visual information to support it from the wings, so to speak. Its very muteness allows it to appear somehow uncontaminated by the noise of the televisual upon which it relies.[6] While its privileged status may be imagined to stem from a natural capacity to condense and simplify things, the effects of the still image derive much more from its capacity to remain radically open. It is not that a photograph naturally says a thousand words, rather that a thousand words *can* be said about it. This is why television and film tend to use the still only for contrived and highly rhetorical moments of pathos, tension and melancholy which limit and condition its ambiguities.

That said, the static photograph taken after an event, rather than the frozen image made *of* it is the radically open image par excellence. It is 'pre-frozen' – the stillness of the image complementing the stillness of the aftermath. So of course it isn't the kind of photograph used ordinarily by television and film to evoke the memorable. Indeed television is usually very wary of this kind of image as it confuses the character of stillness … 'Is this a photograph or is this a continuous shot of an immobile scene?' When it is used, as in the case of the programme on Meyerowitz's images, it is announced and defined for us as a photograph by restless rostrum zooms into details. It has to be made to reveal its static character.

To approach the 'late' image it is instructive to think about photographs taken before, during and after events. I mean this in two senses. The first is the usual one – literally, photographs taken before, during and after a particular occurrence. But we could also think more broadly, of three phases of the social history of photography where only in the middle phase does photography shape our notion of 'event'. Over its hundred-and-sixty-year history, photography only had a finite period in which it carried the weight of events. During the first several decades the medium was slow and cumbersome both in technical procedure and social dissemination. Only from the 1920s, with the beginning of mass media, the dominance of print journalism and fast shutter speeds, was photography the definitive medium of the day and the modulator of events. It defined implicitly what an event was: a moment, an instant, something that could be frozen and examined. Good photo-reporters were thought to be those who followed the action. The goal was to be in the right place at the right time, 'as things happened'. This lasted until the standardized introduction of portable video cameras in the late 1960s and early 1970s. Over the last few decades, it has become clear that the definition of events was taken over first by video and then dispersed in recent years across a varied platform of media technologies. Now photographers often prefer to wait until the noise has died down and the events are over. The still cameras are loaded as the video cameras are packed away. The photographs taken come not just in the aftermath of the event, but in the aftermath of video. What we see first 'live' or at least in real time on television might be revisited by a photography that depicts stillness rather than freezing things. Photojournalists used to be at the centre of the event because photography was at the centre of culture. Today they are as likely to be at its aftermath because photography is, in relative terms, at the aftermath of culture. The result is that photography is much less the means by which the event is grasped. We have learned to expect more from a situation than a frozen image (even though in the climate of emotive news television we might be offered the static image as an ideological 'distillation'). Video gives us things as they happen. They may be manipulated, they may be misrepresented and undigested but they happen in the present tense. Today it is very rare that photographs actually break the news. The newspaper is a second wave of interpreted information or commentary. The illustrated magazine or gallery exhibit constitute a third wave. More importantly they might also be an opportunity to look at the overlooked or unreported.

It is not uncommon then, for late twentieth and twenty-first-century photography to take on the visual character of those celebrated nineteenth-century images of battlefields. Think of Roger Fenton's photography of the exhausted terrains of the Crimea from the 1850s, or Matthew Brady's images of

the scarred earth and corpses of the American Civil War from the following decade. Yet this is a false homology in key respects. The similarity masks the radical changes that have taken place in our image culture since then. Consider for example the question of stillness. Although it might be a scientific truism that photographs are still, the fact is always subject to cultural specifics. Those mid-nineteenth-century photographs were not still. I don't mean this in the sense that things moved during long exposures, which we all know they did. They weren't still because virtually all images of that time were still. Their immobility would be almost too obvious to mention. Stillness in images only became apparent, understandable and truly desirable in the presence of the moving image. This is why stillness only became the defining characteristic of photography with the coming of mass cinema and its newsreels. Cinema, we could say, wasn't just the invention of the moving image, it was also the invention of stillness as a sort of by-product. In the era of cinema, the frozenness of the snapshot – professionalized in photojournalism, democratized in amateurism – came to be understood as the essence of the photographic. Or as Jeff Wall has put it, 'Reportage evolves in the pursuit of the blurred parts of pictures.'[7] All of this finds its exemplary instance in the middle of the twentieth century with the notion of the Decisive Moment (a term we owe to a publisher's very rough translation of Henri Cartier-Bresson's book and essay *Images à la sauvette*, issued in 1952 but drawing on two decades of his work). The speedy modernity of the now cinematized world is arrested by the speedy modernity of the handheld, high speed still camera.

In the presence of video, photography began to lose this monopoly on stillness and immediacy. This is both a material circumstance and a social one: as a technology video was stoppable, repeatable, cheap and quick; and institutionally it was put to use in many of the roles formerly held by photography. It is interesting that a recent book on the history of photojournalism opts to conclude in the mid-1970s, in an attempt to contrive a clean and dignified end.[8] To be sure the influence of photojournalism has declined since then. Images from its heyday now find a questionable afterlife in the coffee-table book, while many of its vestigial forms have turned into pastiches of a glorious past for Sunday supplements and audiences who prefer their catastrophes with an air of aesthetic classicism. Yet announcements of the death of photojournalism are quite premature. If it met its demise in the 1970s it was only in so far as it was mistakenly assumed that its only possible significance could derive from the monopoly over stillness and over our comprehension of events. It needn't. The last couple of decades has also seen a coming to terms with its situation by many photographers and writers. Redefinitions of the possibilities of photojournalism are beginning to emerge

which seek out new contexts and touch on the kinds of photographic approach I'm discussing here. But allow me to sketch in a little more of its past.

If the war in Vietnam is regarded as the last 'photographer's war', this is as much a function of the shifting nature of warfare as its media coverage. Vietnam was chaotic on two levels. Literally, in that the environment was messy (and mess is highly photogenic), and metaphorically in that US policy was erratic. This prolonged the conflict and increased the photographer's picture-making opportunities. By contrast the 'Gulf War' is often described as the first war experienced as an image simulation. What few images we saw were satellite images from news journalists along with US military footage. Very few photographers covered the war.[9] They weren't allowed in. *After* the war many photographers went to Kuwait to document the leftovers – destroyed tanks, bodies, scarred desert and burning oil fields. Their images often had a post-traumatic disposition, and a sense of mourning and paralysis. And they were often accompanied by similarly melancholic writing. Photojournalism became elegiac, poetic and muted. No longer was it campaigning writing accompanying campaigning images. It was picking up pieces like the shell-shocked Iraqi conscripts we were never allowed to see. It gave the feeling of being outside the time of history and politics. We may have been able to see the damage we were denied seeing done, but the sense of removal was not in and of itself an actively critical position. Photography was struggling to find a way to reconcile itself with a new position beyond events and was finding that sombre melancholia was a seductive mode.

Almost a third of all news 'photographs' are frame grabs from video and digital sources. The proportion grows far larger in the coverage of conflict. This has two related consequences. There is a partial blurring of the distinction between different image technologies, and there is a radical shift in the understanding of what photography is, what it is good at and what it is for. Photography is having to find other roles. Or more accurately visual culture is leaving it certain tasks. Far from being its ultimate incarnation, the decisive moment should now be grasped as a historically specific ideal. The definition of a medium, particularly photography, is not autonomous or self-governing, but heteronomous, dependent on other media. It derives less from what it is *technologically* than what it is *culturally*. Photography is what we do with it.[10] If we do new things with it we generate a new definition for it, even when those new things are actually older things, like Joel Meyerowitz's choice of a camera made in 1942. (Interestingly, this is a photographer who first came to prominence shooting 'decisive moments' on the streets of New York, deeply influenced by Henri Cartier-Bresson. As his career moved on there was a general shift from those fleeting snapshots to a slower way of working with a large

camera, and from a photography of 'events' to a photography of longer duration.)

It seems clear that contemporary art has a predilection for the 'late photograph'. It has become a central trope in its current dialogue with documentary. The works of Willie Doherty, Paul Seawright, Sophie Ristelhueber and Richard Misrach are some of the more interesting examples, but as I write it is hard to avoid the cheaper moodiness of images of derelict buildings and urban wastelands on display in London's galleries. There is a reticent muteness in these images that leaves them open to interpretation. Moreover their status as traces of traces fulfils for art a certain modernist reflection on the indexicality of the medium. They can also offer an allegorical, distanced reflection on the photograph as evidence and the claims of mainstream documentary photography.[11] Tellingly, the best known images made of Kuwait after the Gulf War were made by the artist Sophie Ristelhueber in her series *Aftermath* exhibited in galleries and museums, and published in weekend newspapers and book form.[12]

In forfeiting any immediate relation to the event and taking up a slower relation to time, 'late' photographs appear to separate themselves out from the constant visual bit stream emitted by the convergence of modern electronic image technologies. Part of the appeal then, of these static, slow and detailed photographs is that they strike us now as being somehow a new kind of 'pure' photography that can't be confused with other kinds of image. This is no doubt another reason for their profile in museums and galleries. It looks like a very *photographic* kind of photography. They seem to do something no other medium does, although as I have said what strikes us as particularly photographic is very much subject to change. At the same time they refuse to be overtly 'creative', deploying the straight image with a mood of deliberation and detachment that chimes with a general preference in contemporary art for the slow and withdrawn.[13] It is telling that in the television programme 'Reflections on Ground Zero' Meyerowitz opts to describe his photography as an automatic process in which creativity is avoidable: 'I was just going to be there as a witness and photograph it for what it was, without trying to put on it some formal idea of how to photograph it. I was told how to photograph it by the thing itself.' Avoiding overt 'originality' in such circumstances is an admirable aim, but we would do well to bear in mind that there really is no 'ground zero' mode of taking photographs, not even of Ground Zero. Meyerowitz's images are a mixture of epic scenes, portraits and details of excavation work, all illuminated by his celebrated attention to light and atmosphere. These are skills he has honed over several decades of photography. It may be second nature to him now, but he knows what makes a good photo and can't avoid the beautiful. He certainly *does* have a very strong formal idea even though it clearly overlaps

with a popular sense of what a photograph as document should look like.[14]

As I have remarked the late photograph has a long history, and art and literature have had an interest in it at least as far back as the Surrealists' appropriation of the work of the street photographs of Eugène Atget for their stoic artlessness. Looking back over this history, writer and photographer Allan Sekula warned of the political pitfalls of decontextualizing a document in order to make it enigmatic, or melancholic, or merely beautiful:

> Walter Benjamin recalled the remark that Eugène Atget depicted the streets of Paris as though they were scenes of crime. That remark serves to poeticize a rather deadpan, non-expressionist style, to conflate nostalgia and the affectless instrumentality of the detective. Crime here becomes a matter of the heart as well as a matter of fact. Looking back, through Benjamin to Atget, we see the loss of the past through the continual disruptions of the urban present as a form of violence against memory, resisted by the nostalgic bohemian through acts of solipsistic, passive acquisition [...] I cite this example merely to raise the question of the affective character of documentary. Documentary has amassed mountains of evidence. And yet, in this pictorial presentation of scientific and legalistic 'fact', the genre has simultaneously contributed much to spectacle, to retinal excitation, to voyeurism, to terror, envy and nostalgia, and only a little to the critical understanding of the social world [...] A truly social documentary will frame the crime, the trial, the system of justice and its official myths [...] Social truth is something other than a matter of convincing style.[15]

Given Sekula's closing remark it is worth considering why it is that the 'late photograph' has become a 'convincing style' in contemporary culture. Its retreat from the event cannot be automatically taken as an enlightening position or critical stance. Its formality and visual sobriety are no guarantee of anything in and of themselves. Yet it is easy to see how, in an image world dispersed across screens and reconfigured in pieces, a detailed, static and resolutely perspectival rectangle may appear to be some kind of superior image.

Certainly the late photograph is often used as a kind of vehicle for mass mourning or working through (as is the case with Meyerowitz's Ground Zero project). The danger is that it can also foster an indifference and political withdrawal that masquerades as concern. Mourning by association becomes merely an aestheticized response. There is a sense in which the late photograph, in all its silence, can easily flatter the ideological paralysis of those who gaze at it without the social or political will to make sense of its circumstance. In its apparent finitude and muteness it can leave us in permanent limbo, suspending even the *need* for analysis and bolstering a kind of liberal melancholy that shuns

political explanation, like a vampire shuns garlic.[16]

If the banal matter-of-factness of the late photograph can fill us with a sense of the sublime, it is imperative that we think through why this might be. There is a fine line between the banal and the sublime, and it is a political line. If an experience of the contemporary sublime derives from our experience of being in a world beyond our own incomprehension, then it is a reified as much as a rarefied response.

1 To further extend and deepen the tension between photography and other technologies that incorporate it, let me say right away that I have had my closest look at Meyerowitz's images via the internet, having seen them firstly on television and secondly in exhibition at The Museum of London (*After September 11: Images From Ground Zero. Photographs by Joel Meyerowitz. An Exhibition by the Bureau of Educational and Cultural Affairs of the US Department of State in conjunction with the Museum of the City of New York*).

2 Meyerowitz says at another point in the programme, 'I had to do this so that people in future generations could look at this site and see the wound that was received here, the aftermath of the blow, and to see what it took to repair it, what it looked like everywhere in this sixteen-acre site. Somebody had to have the consciousness to do it.' I shall say a little more about his consciousness later on.

3 Peter Wollen, 'Vectors of Melancholy', in Ralph Rugoff, ed., *The Scene of the Crime* (Cambridge, Massachusetts: The MIT Press, 1997). See also Thierry de Duve's 'Time Exposure and Snapshot: The Photograph as Paradox', October, no. 5, 1978, which makes a similar opposition; reprinted in this volume, 52–61.

4 See in particular Roland Barthes, *Camera Lucida. Reflections on Photography* (New York: Farrar, Strauss & Giroux, 1981) and Walter Benjamin, 'The Work of Art in the Age of Mechanical Reproduction' (1936) in Benjamin, ed. Hannah Arendt, *Illuminations* (London: Jonathan Cape, 1970). For broader discussions of the subject see Celia Lury, *Prosthetic Culture: photography, memory, identity* (London: Routledge, 1997); Scott McQuire, *Visions of Modernity* (London: Sage, 1998) and Eduardo Cadava, *Words of Light: Theses on the Photography of History* (New Jersey: Princeton University Press, 1997).

5 See Laura Mulvey's discussion of the reconfiguration of memory by the new technologies of spectatorship in her essay in this volume, 134–9.

6 An unnamed New Yorker in the TV programme I'm discussing declares at one point, 'People will come back to Joel's [Meyerowitz's] photographs. They have a very powerful silence in them. They are very still.'

7 Jeff Wall, '"Marks of Indifference": Aspects of Photography in, or as, Conceptual Art', in Anne Goldstein and Anne Rorimer, eds, *Reconsidering the Object of Art: 1965–1975* (Los Angeles: The Museum of Contemporary Art, Los Angeles/Cambridge, Massachusetts: The MIT Press, 1995).

8 Robert Lebeck and Bodo von Dewitz, eds, *Kiosk: A History of Photojournalism* (Gottingen: Steidl verlag, 2002).

9 For an account of those press photographs that were made during the Gulf War see John Taylor's 'The Gulf War in the Press', *Portfolio Magazine*, no. 11, Summer 1991. For an account of the more virtual representation see Jean Baudrillard, *The Gulf War Did Not Take Place* (Power Publications, 1995) and Tim Druckrey, 'Deadly Representations,' or Apocalypse Now', in *Ten8*, vol. 2, no. 2, 1991.

10 For a useful discussion of this see Stanley Cavell, *The World Viewed*. Enlarged Edition (Cambridge, Massachusetts: Harvard University Press, 1979).

11 For a rich discussion of allegory in recent documentary work see Justin Carville's 'Re-negotiated territory: the politics of place, space and landscape in Irish photography', *Afterimage*, vol. 29, no. 1 (July–August 2001).

12 Sophie Ristelhueber, *Aftermath* (London: Thames & Hudson, 1992). The original French title was *Fait*. The artist had made a similar book in the previous decade entitled *Beirut* (London: Thames & Hudson, 1984).

13 Even the moving images in today's art don't move very much. For a more detailed discussion of this see Peter Osborne's paper in *Where is the Photograph?*, ed. David Green (Brighton: Photoworks/Photoforum, 2003).

14 Looking back over Meyerowitz's career I found myself returning to a book called *Annie on Camera* from 1982. He was one of nine photographers commissioned to make images during the production of John Huston's film *Annie*, the cheesecake musical, set in depression-era New York. Meyerowitz's folio includes an image of piles of concrete rubble and broken paper-thin walls lying at the foot of slanted architectural buttresses. It was refuse discarded by set builders. He made a strikingly similar image at Ground Zero. As photographers we tend to carry visual templates around with us wherever we go, however much we feel subject matter dictates the form of our images. I wonder if Meyerowitz had the form of his knowingly fake image from *Annie* in mind when he came across the same scene twenty years later in a very different situation. (See Nancy Grubb, ed., *Annie on Camera* (New York: Abbeville, 1982).

15 Allan Sekula, 'Dismantling Modernism, Reinventing Documentary (Notes on the Politics of Representation)', in Terry Dennett and Jo Spence, eds, *Photography/Politics: 1* (London: Photography Workshop, 1980).

16 I borrow the simile and the general critique of the passivity of liberal ideology from Slavoj Zizek's 'Self-Interview', in *The Metastases of Enjoyment. Six Essays on Woman and Causality* (London: Verso, 1994).

David Campany, 'Safety in Numbness. Some remarks on problems of "Late Photography"', in *Where is the Photograph?*, ed. David Green (Brighton: Photoworks/Photoforum, 2003) 123–32.

Chantal Akerman
In Her Own Time: Interview with Miriam Rosen//2004

Chantal Akerman When you read a text, you're in your own time. That is not the case in film. In fact, in film, you're dominated by my time. But time is different for everyone. Five minutes isn't the same thing for you as it is for me. And five minutes sometimes seems long, sometimes seems short. Take a specific film, say, *D'Est* (1993): I imagine the way each viewer experiences time is different. And at my end, when I edit, the timing isn't done just any way. I draw it out to the point where we have to cut. Or take another example, *News from Home* (1976): How much time should we take to show this street so that what's happening is something other than a mere piece of information? So that we can go from the concrete to the abstract and come back to the concrete – or move forward in another way. I'm the one who decides. At times I've shot things and I've said, '*Now* this is getting unbearable!' And I'll cut. For *News from Home* it's something else, but I have a hard time explaining it. [...]

When you're editing, something happens that tells you *this* is the moment to cut. It's not theoretical, it's something I feel. Afterwards, explaining it is always very difficult. In the beginning, especially with *Jeanne Dielman* (1975), a lot of people thought I was a great theoretician. Quite the contrary. Later, when people would meet me, they'd realize that. Everyone thought, for example, that *Jeanne Dielman* was in real time, but the time was totally recomposed, to give the impression of real time. There I was with Delphine [Seyrig], and I told her, 'When you put down the Wiener schnitzels like that, do it more slowly. When you take the sugar, move your arm forward more quickly.' Only dealing with externals. When she asked why, I'd say, 'Do it, and you'll see why later.' I didn't want to manipulate her. I showed her afterwards and said to her, 'You see, I don't want it to "look real", I don't want it to look natural, but I want people to *feel* the time that it takes, which is not the time that it really takes.' But I only saw that after Delphine did it. I hadn't thought of it before.

That's for gestures, actions, let's say. There's also the case of static shots where nothing happens, like in *Hôtel Monterey* (1972), where you see a hallway and nothing else. How long will we hold this shot of the hallway? In the montage, you can feel it. Obviously, it's very personal, because someone else would have held it half as long or three times as long. How do you explain that? You have to be very, very calm. When I edit, when I sense that I'm at the quarter mark or halfway through the film, I begin to screen it for myself, with my editor, Claire Atherton, with whom I've worked for years – almost by osmosis. We close

I DON'T WANT IT TO LOOK
REAL
I DON'T WANT IT TO LOOK
NATURAL
BUT I WANT PEOPLE TO
FEEL
THE TIME THAT IT TAKES
WHICH IS NOT THE TIME
THAT IT REALLY TAKES

Chantal Akerman, 'In Her Own Time', Interview with Miriam Rosen, 2004

the curtains, take the phones off the hook, and try to have a floating gaze, as an analyst might call it. And we say, 'That's it!' Why? It's inexplicable. And that's why it's difficult for me to talk about it. [...]

Miriam Rosen On the question of time, I'd have thought that today people would be more used to your way of working. It doesn't conform to the norm of dominant cinema, but it embodies what's most normal and most human.

Akerman You know, when most people go to the movies, the ultimate compliment – for them – is to say, 'We didn't notice the time pass!' With me, you see the time pass. And feel it pass. You also sense that this is the time that leads towards death. There's some of that, I think. And that's why there's so much resistance. I *took* two hours of someone's life.

Rosen But we've experienced those two hours, instead of sitting in a traffic jam or in front of the TV.

Akerman Yes, I agree. And not only that. I find that, on the contrary, during this time, we feel our existence. Just by the fact that we're somewhere beyond the merely informative. For example, in *D'Est*, we see people standing in line, and the shot lasts seven or eight minutes. Now, whenever my mother sees news about Russia she says, 'I couldn't help but think of your film. I'll never see news about Russia in the same way again.' That's something. For people of my mother's generation, they recognize themselves in the film; for example, in *D'Est* she recognizes clothes she used to wear, she recognizes faces. These images exist in her already. When I made the film I – who was born after the war – often wondered why I shot this and not that. I didn't know. But afterwards, when the film was finished, I understood that those particular images were already in my head, and I was looking for them.

I'm speaking here of what we call documentaries. In all these so-called documentary films, there are always different layers. These are just people waiting for a bus, but they still evoke other things. They may evoke the lines in the camps or in wartime. In *Sud* (*South*, 1999), a tree evokes a black man who might have been hanged. If you show a tree for two seconds, this layer won't be there – there will just be a tree. It's time that establishes that, too, I think. [...]

Miriam Rosen, 'In Her Own Time: An Interview with Chantal Akerman', translated from French by Jeanine Herman, *Artforum* (New York, April 2004).

Victor Burgin
Possessive, Pensive and Possessed//2006

The cinematic heterotopia

Early in the history of cinema, André Breton and Jacques Vaché spent afternoons in Nantes visiting one movie house after another: dropping in at random on whatever film happened to be playing, staying until they had had enough of it, then leaving for the next aleatory extract. Later in the history of cinema, Raúl Ruiz went to see films set in classical antiquity with the sole desire of surprising an aircraft in the ancient heavens, in the hope he might catch 'the eternal DC6 crossing the sky during Ben Hur's final race, Cleopatra's naval battle or the banquets of *Quo Vadis*'[1] – and Roland Barthes at the cinema found himself most fascinated by 'the theatre itself, the darkness, the obscure mass of other bodies, the rays of light, the entrance, the exit'.[2] Such viewing customs customize industrially produced pleasures. Breaking into and breaking up the film, they upset the set patterns that plot the established moral, political and aesthetic orders of the entertainment form of the *doxa*.[3] During the more recent history of cinema, less self-consciously resistant practices have emerged in the new demotic space that has opened between the motion picture palace and consumer video technologies. Few people outside the film industry have had the experience of 'freezing' a frame of acetate film, or of running a film in reverse – much less of cutting into the film to alter the sequence of images. The arrival of the domestic video cassette recorder, and the distribution of industrially produced films on videotape, put the material substrate of the narrative into the hands of the audience. The *order* of narrative could now be routinely countermanded. For example, control of the film by means of a VCR introduced such symptomatic freedoms as the *repetition* of a favourite sequence, or *fixation* upon an obsessional image.[4] The subsequent arrival of digital video editing on 'entry level' personal computers exponentially expanded the range of possibilities for dismantling and reconfiguring the once inviolable objects offered by narrative cinema. Moreover, even the most routine and non-resistant practice of 'zapping' through films shown on television now offers the sedentary equivalent of Breton's and Vaché's ambulatory *dérive*. Their once avant-garde invention has, in Viktor Shklovsky's expression, 'completed its journey from poetry to prose'. The decomposition of fiction films, once subversive, is now normal.

Films are today dismantled and dislocated even without intervention by the spectator. The experience of a film was once localized in space and time, in the finite unreeling of a narrative in a particular theatre on a particular day. But with

time a film became no longer simply something to be 'visited' in the way one might attend a live theatrical performance or visit a painting in a museum. Today, as I wrote in a previous book:

> a 'film' may be encountered through posters, 'blurbs', and other advertisements, such as trailers and television clips; it may be encountered through newspaper reviews, reference work synopses and theoretical articles (with their 'film-strip' assemblages of still images); through production photographs, frame enlargements, memorabilia, and so on. Collecting such metonymic fragments in memory, we may come to feel familiar with a film we have not actually seen. Clearly this 'film' – a heterogeneous psychical object, constructed from image scraps scattered in space and time – is a very different object from that encountered in the context of 'film studies'.[5]

The 'classic' narrative film became the sole and unique object of film studies only through the elision of the *negative* of the film, the space beyond the frame – not the 'off screen space' eloquently theorized in the past, but a space formed from all the many places of transition between cinema and other images in and of everyday life. Michel Foucault uses the term 'heterotopia' to designate places where 'several sites that are in themselves incompatible' are juxtaposed.[6] The term 'heterotopia' comes via anatomical medicine from the Greek *heteros* and *topos*, 'other' and 'place'. I am reminded of the expression *einer anderer Lokalität* by which Freud refered to the unconscious. Although Foucault explicitly applies the concept of 'heterotopia' only to real external spaces, he nevertheless arrives at his discussion of heterotopias via a reference to *utopias* – places with no physical substance other than that of representations: material signifiers, psychical reality, fantasy. What we may call the 'cinematic heterotopia' is constituted across the variously virtual spaces in which we encounter displaced pieces of films: the Internet, the media, and so on, but also the psychical space of a spectating subject that Baudelaire first identified as 'a *kaleidoscope* equipped with consciousness'.

Roland Barthes describes how one evening, 'half asleep on a banquette in a bar', he tried to enumerate all the languages in his field of hearing: 'music, conversations, the noises of chairs, of glasses, an entire stereophony of which a marketplace in Tangiers ... is the exemplary site'. He continues:

> And within me too that spoke ... and this speech ... resembled the noise of the marketplace, this spacing of little voices that came to me from outside: I myself was a public place, a souk; the words passed through me, small syntagms, ends of formulae, and *no sentence formed*, as if that were the very law of this language.[7]

Eyes half closed, Barthes sees an homology between the cacophony of the bar and his involuntary thoughts, where he finds that no 'sentence' forms. When Stanley Kubrick's film *Eyes Wide Shut* (1999) was released one reviewer compared it unfavourably to its source in Arthur Schnitzler's novella *Dream Story*.[8] He observed that Schnitzler's narrative consists of a series of disconnected incidents which the writer nevertheless unifies into a meaningful whole through the continuous presence of the narrator's voice. The reviewer complained that Kubrick's retelling of the story suffers from the absence of this device, and that as a result the narrative remains disturbingly disjointed. The 'disjointedness' that the reviewer found in Kubrick's film might be seen as a structural reflection within the film of its own immediate exterior, the *mise-en-abyme* of its existential setting. A short trailer for *Eyes Wide Shut* played in cinemas for several weeks before the film was released. It showed the two principal actors embracing in front of a mirror while a pulsing rock and roll song plays on the soundtrack. A still from this same sequence appeared throughout the city (Paris in this instance) on posters advertising the film. For several weeks *Eyes Wide Shut* was no more than this poster and this trailer. When the film finally came to the movie theatre the short sequence was discovered embedded in it. From poster to trailer to film there was a progressive unfolding: from image, to sequence, to concatenation of sequences – as if the pattern of industrial presentation of commercial cinema were taking on the imprint of psychical structures: from the most cursorily condensed of unconscious representations to the most articulated conscious forms, as if the 'noise of the marketplace' in the most literal sense was conforming to the psychological sense of Barthes' metaphor. Opened onto its outside by the publicity system the film spills its contents into the stream of everyday life, where it joins other detritus of everyday experience ('small syntagms, ends of formulae') and where no sentence forms.

The sequence-image

Barthes on the banquette compares his inner 'souk' with the noise of his immediately external surroundings. Phenomenologically, 'inner' and 'outer' form a single continuum where perceptions, memories and fantasies combine. In 1977 sociologists at the University of Provence began a ten-year oral history research project in which they conducted more than four hundred recorded interviews with residents of the Marseille/Aix-en-Provence area. They asked each interviewee to describe her or his personal memories of the years 1930 to 1945. They found an almost universal tendency for personal history to be mixed with recollections of scenes from films and other media productions. 'I saw at the cinema' would become simply 'I saw'.[9] For example, a woman speaks of her experiences as a child amongst refugees making the hazardous journey from the

North of France down to Marseille. She recalls the several occasions when the column of refugees in which she was travelling was strafed by German aircraft. In recounting these memories she invokes a scene from René Clément's film of 1952, *Jeux Interdits*, in which a small girl in a column of refugees survives an air attack in which her parents are killed. The woman's speech however shifts between the first and the third person in such a way that it is unclear whether she is speaking of herself or of the character in the film. The interviewer learns that the woman had in reality been separated from her parents on the occasion of such an attack and had been reunited with them only after many anxious days without news. As the interviewer comments, 'It is reasonable to think that the death of the parents in the film figured the possible death of her real mother.'[10] From the confusion of subject positions in the woman's speech we might suppose that the scene in the film in which the parents of the young heroine are killed, when they place their bodies between her and the German guns, has come to serve as a screen memory covering her repressed fantasy of the death of her own parents. A 'screen memory' is one which comes to mind in the place of, and in order to conceal, an associated but repressed memory.[11] Freud remarks that screen memories are marked by a vivid quality that distinguishes them from other recollections. It seems that the woman's memory of the film has similarly become fixed on this one brilliant scene of the attack from the air, as if it were the only scene from the film she remembered.

We probably all have early memories of images from films that are invested with personal significance, but often a significance that remains opaque to us. For example, here is what I believe is my own earliest memory of a film:

A dark night, someone is walking down a narrow stream. I see only feet splashing through water, and broken reflections of light from somewhere ahead, where something mysterious and dreadful waits.

The telling of the memory, of course, betrays it. Both in the sense of there being something private about the memory that demands it remain untold, and in the sense that to tell it is to misrepresent, to transform, to diminish it. Inevitably, as in the telling of a dream, it places items from a synchronous field into the diachrony of narrative. What remains most true in my account is what is most abstract: the description of a sequence of such brevity that I might almost be describing a still image. Although this 'sequence-image' is in itself sharply particular, it is in all other respects vague: uniting 'someone', 'somewhere' and 'something', without specifying who, where and what. There is nothing before, nothing after, and although the action gestures out of frame, 'somewhere ahead', it is nevertheless self-sufficient. I can recall nothing else of this film – no other

sequence, no plot, no names of characters or actors, and no title. How can I be sure the memory is from a film? I just know that it is.

The memory I have just described is of a different kind from my memory of the figure of Death 'seen' by the small boy in Ingmar Bergman's film *Fanny and Alexander*, or – from the same film – my memory image of the boy's grandmother seated in a chair by a window. These examples were what first came to mind when I 'looked' in memory for a film I saw recently. They are transient and provisional images, no doubt unconsciously selected for their association with thoughts already in motion (childhood, the mother, death), but no more or less suitable for this purpose than other memories I might have recovered, and destined to be forgotten once used. The 'night and stream' memory is of a different kind. It belongs to a small permanent personal archive of images from films I believe I saw in early childhood, and which are distinguished by having a particular affect associated with them – in this present example, a kind of apprehension associated with the sense of 'something mysterious and dreadful' – and by the fact that they appear unconnected to other memories. If I search further in my memories of childhood I can bring to mind other types of images from films. What I believe to be the earliest of these are mainly generically interchangeable pictures of wartime Britain. They form a library of stereotypes which represent what must have impressed me as a child as the single most important fact about the world around me (not least because it was offered to me as the reason for my father's absence). In addition to a small collection of enigmatic images, and a larger library of images from wartime films, I also retain other types of images from visits to the cinema in later childhood. These are neither mysterious nor generic, they tend to be associated with events in my personal history: either in direct reaction to a film, or to something that happened shortly after seeing a film. Later still, from adulthood, I can recall sequences from films that have most impressed me as examples of cinematic art, and from films seen for distraction which I expect I shall soon forget. The totality of all the films I have seen both derive from and contribute to the 'already read, already seen' stereotypical stories that may spontaneously 'explain' an image on a poster for a film I have not seen, or images of other kinds encountered by chance in the environment of the media.

So far, the examples I have given are of images recalled voluntarily, and I have not spoken of their relations to actual perceptions. But mental images derived from films are as likely to occur in the form of involuntary associations, and are often provoked by external events. For example: I am travelling by rail from Paris to London. As the train slices through the French countryside, I glimpse an arc of black tarmac flanked by trees on a green hillside. A white car is tracing the curve. This prompts the memory of a similar bend in a road, but now seen from the

driver's seat of a car I had rented the previous year in the South of France, where I was vacationing in a house with a swimming pool. I am reminded of a scene from a film on television the previous night. A young woman executes a perfect dive into a swimming pool; the image then cuts to the face of a middle-aged woman who (the edit tells me) has watched this. I read something like anxiety in her face. Earlier in my journey, a middle-aged couple had passed down the carriage in which I was sitting. Something in the woman's expression had brought to mind the woman in the film. The car on the curve in the road has disappeared from view, but the complex of associations it provoked remains like an after-image superimposed upon the scene that slides by beyond the carriage window. Already, the image is fading. A train journey interrupted by a train of associations: a concatenation of images raises itself, as if in low relief, above the instantly fading, then forgotten, desultory thoughts and impressions passing through my mind as the train passes through the countryside. The 'concatenation' does not take a linear form. It is more like a rapidly arpeggiated musical chord, the individual notes of which, although sounded successively, vibrate simultaneously. This is what led me to refer to my earliest memory of a film as a 'sequence-image' rather than an 'image sequence'. The elements that constitute the sequence-image, mainly perceptions and recollections, emerge successively but not teleologically. The order in which they appear is insignificant (as in a rebus) and they present a configuration – 'lexical, sporadic' – that is more 'object' than narrative. What distinguishes the elements of such a configuration from their evanescent neighbours is that they seem somehow more 'brilliant'.[12] In a psychoanalytic perspective this suggests that they have been attracted into the orbit of unconscious signifiers, and that it is from the displaced affect associated with the latter that the former derive their intensity. Nevertheless, for all that unconscious fantasy may have a role in its production, the sequence-image as such is neither daydream nor delusion. It is a *fact* – a transitory state of percepts of a 'present moment' seized in their association with past affects and meanings.

The same old story
According to the French philosopher Bernard Stiegler, all living beings embody two types of memory: the memory of the species, and the memory of the individual. The former is the equivalent of what we know as the 'genome', the totality of the genetic information that an individual organism inherits from its parents; the latter is the repository of 'experience', that 'neuronal plasticity' which allows learning to take place. But the human being alone has developed an external, 'prosthetic', third memory in the form of techniques that allow the transmission of experience across generations. The technical activity of the

human being therefore marks it out from other living beings which evolve only within the terms dictated by the history of their genetic programs. Stiegler writes:

> Man is a cultural being to the extent that he is also essentially a technical being: it is because he is enveloped in this technical third memory that he can accumulate the intergenerational experience which one often calls culture – and this is why it is absurd to oppose technique to culture: technique is the condition of culture in that it allows its transmission. On the other hand, there is that epoque of technique called technology, which is our epoque, where culture enters into crisis, precisely because it becomes industrial and as such finds itself submitted to the imperatives of market calculation.[13]

The industrialization of memory began in the nineteenth century – most significantly with sound recording, photography and film. Stiegler notes that since the second half of the twentieth century there has been an exponential growth of industries – cinema, television, advertising, video games and popular music – that produce synchronised collective states of consciousness through the agency of the *temporal object*. The 'temporal object', a concept Stiegler takes from Husserl, is one that elapses in synchrony with the consciousness that apprehends it. (Husserl gives the example of a melody.) For Stiegler, cinema is the paradigm of the industrial production of temporal objects, and of the consciousnesses that ensue. What most concerns Stielger is the question of the production of a 'we' (*nous*) as a necessary sense of communality in relation to which an 'I' (*je*) may be produced and sustained. He argues that the communality produced by the global audio-visual industries to which cinema belongs today results not in a 'we' (*nous*) – a collectivity of individual singularities – but in a 'one' (*on*), a homogeneous and impersonal mass who come to share an increasingly uniform common memory. For example, the person who watches the same television news channel every day at the same time comes to share the same 'event past' (*passé événementiel*) as all the other individuals who keep the same appointment with the same channel. In time, Stiegler argues: 'Your past, support of your singularity ... becomes the same past consciousness (*passé de conscience*) as the *one* (*on*) who watches.'[14] Those who watch the same television programmes at the same time become, in effect, the same person (*la même personne*) – which is to say, according to Stiegler, *no one* (*personne*).[15]

Stiegler devotes a long chapter of his book of 2004 *De la misère symbolique: 1. L'époque hyperindustrielle* to Alain Resnais' film *On Connaît la Chanson* (1997), which he sees as the mise-en-scène of 'the unhappiness in being [*mal-être*] of our epoch'.[16] One of the characters in the film, Nicolas, carries a

photograph of his wife and children in his wallet; each time he shows it to someone he gets much the same reaction to the snapshop – as in this exchange early in the film between Nicolas and Odile:

> Odile – But what does it remind me of, this photo? Ah yes! The coffee advert, that's it! You see what I mean?
> Nicolas – The coffee advert? No ... I don't see.
> Odile – That family, you know, having its breakfast in a field of corn?
> Nicolas – Oh yes, I think I know, yes ...[17]

The actors in Resnais' film lip-synch to popular songs much as actors do in the films of Dennis Potter, to whom Resnais pays hommage in his opening titles. The characters in Resnais' film however produce only fragments of songs. Resnais has commented: 'I'd say it's a realistic film, because that's the way it happens in our heads.' One of the film's two screenwriters, Agnès Jaoui, has said, '...we used [the fragments] like proverbs. 'Every cloud has a silver lining', 'Don't worry, be happy', readymade ideas, commonplaces that summarize a feeling and, at the same time, impoverish it.'[18] Asked how the songs had been chosen, the film's other screenwriter, Jean-Pierre Bacri, replied: 'We looked for very familiar songs with words that everyone can identify with, *les vraies rengaines*.' The sense of the French word *rengaine* is conveyed in the English version of the title of Resnais' film: '*Same Old Song*'. Bernard Stiegler uses this same word in describing the advent of the recorded song as 'the most important musical event of the twentieth century'. He writes: 'The major musical fact of the twentieth century is that masses of ears suddenly start listening to music – ceaselessly, often the same old songs (*les mêmes rengaines*), standardized, ... produced and reproduced in immense quantities, ... and which will often be interlaced for many hours a day with global consciousnesses, producing a daily total of many milliards of hours of consciousness thus "musicalized".'[19] The *rengaines* sung by the actors in *Same Old Song*, songs their French audience are sure to know, conjure a commonality that ultimately devolves upon no subject other than the subject-in-law that is the corporation that produced it. For Stiegler, this is a source of the very unhappiness that the characters express in song: 'It is *the already-there of our unhappiness-in-being* (*le déja-là de notre mal-être*) that certain of these songs express so well, which are therefore (these songs that we receive so *passively*), in certain respects, at the same time the *cause*, the *expression*, and the possibility, if not of cure, at least of *appeasement*.'[20] Resnais' musical fiction film is set in present day Paris, apart from a brief opening scene, which takes place in 1944 towards the end of the German occupation of the city, and which represents a historical event. General von Scholtitz receives by

telephone a direct order from Hitler to destroy Paris. He sets down the receiver, and with a look of shocked gravity on his portly face ventriloquizes in perfect lip-synch the voice of Josephine Baker singing 'J'ai deux amours'. The effect is simultaneously comic and uncanny, clearly played for laughs and yet utterly chilling. Throughout the light comedy that ensues, the singing voices that issue from the mouths of Resnais' characters are indifferent to the gender, race and age of their host bodies – in unequivocal demonstration that we are witnessing the possession of a subject by its object.

Three ecologies and three spectatorial modes

In his book of 1989 *Les trois écologies* Félix Guattari urges that our understanding of 'ecology' be expanded to embrace 'the three ecologies' of the *environmental*, the *social* and the *mental* – three overlapping domains subject to what he calls 'integrated world capitalism' (IWC). Guattari argues that capitalist market values and relations have not only penetrated the economic, social and cultural life of the planet, they have also infiltrated the unconscious register of subjectivity. He writes: 'Today, the object IWC has to be regarded as all of a piece: it is *simultaneously* productive, economic and subjective' (my emphasis).[21] Contestation of Integrated World Capitalism at the environmental level addresses such issues as the degradation or destruction of human and animal habitats by the unregulated pursuit of profits; at the socio-economic level it entails the elimination of poverty and the defence, recovery or invention of alternative forms of sociability to those created by and for the marketplace; at the subjective-psychological level it requires a reaffirmation of individual autonomy and singularity in respect of the dominant discursive regimes and representational forms that create the taken-for-granted horizons of what may be thought and felt. It is in much the same terms that Bernard Stiegler describes how the global 'media' industries produce an 'ecology of the mind' (*écologie de l'esprit*) which: 'rests upon the industrial exploitation of times of consciousnesses ... as masses of *ego* endowed with the bodies of *consumers* ...[which] exploited to the limits of their temporal possibilities, are *degraded* by this exploitation just as may be certain territories or certain animal species.'[22] Starting from questions of the 'technic', therefore, Stiegler arrives at much the same concept of 'mental ecology' that Guattari arrives at from his own point of departure in the psychoanalytic. What is at issue in the work of both of these writers is the question of the autonomy of the subject of civil society in modern, media saturated, democracies. Renewing Deleuze's vision of a 'society of control'[23] Stiegler's prospectus is bleak, it conjures a world in which the global audio-visual industries, now in virtual command of our memories, determine what is visible and invisible, what may be heard and said, and what must remain

inaudible and unutterable. Stiegler's essay about Alain Resnais' film conjures a world in which the spectator is *possessed* by cinema. The predicament of the 'possessed spectator' however may be attentuated by the exercise of other modalities of spectatorship. I began by talking about the various ways in which a film may be broken up. Where subjective agency is involved the subject corresponds to what Laura Mulvey has called the *possessive spectator*.[24] Mulvey writes: 'The possessive spectator commits an act of violence against the cohesion of a story, the aesthetic integrity that holds it together, and the vision of its creator.'[25] I went on to describe some of the ways in which memory and fantasy may weave fragments of films into more or less involuntary, insistent and enigmatic reveries. The subject position here may be assimilated to what Raymond Bellour has called the *pensive spectator*.[26] Bellour writes: 'As soon as you stop the film, you begin to find time to add to the image. You start to reflect differently on film, on cinema. You are led to the photogram – which is itself a step further in the direction of the photograph.'[27]

Nevertheless, the doubts and questions raised by such writers as Guattari and Stiegler are not easily dispelled. The possessive spectator may take advantage of the fact that the same technology that has constructed the audiovisual machine has put the means of reconfiguring its products into the hands of the audience. As Colin MacCabe observes: 'in a world in which we are entertained from cradle to grave whether we like it or not, the ability to rework image and dialogue … may be the key to both psychic and political health.'[28] However, we are rarely allowed to own the memories we are sold. When two thirds of global copyrights are in the hands of six corporations[29] the capacity to rework ones memories into the material symbolic form of individual testament and testimony is severely constrained. Moreover, if the Guattari-Stiegler prognosis is correct, and if the society of the spectacle has installed itself even in the unconscious registers of psychical activity, then the choices we exercise in breaking up and reconfiguring the media-imaginary will be framed within the same parameters, subject to the same determinarions, of this same imaginary. The challenge presented to any artist today who would take a critical stance towards history and memory is succinctly expressed by Jacques Rancière in the conclusion of his review of the 2004 São Paulo Bieñal: 'The problem is that this irreproachable effort by many artists to break the dominant consensus and to put the existing order into question tends to inscribe itself within the framework of consensual descriptions and categories.'[30]

1 Raoul Ruiz, *Poétique du Cinéma* (Paris: Dis Voir, 1995) 58.

2 Roland Barthes, 'En sortant du cinéma', *Communications*, n. 23 (Paris: Seuil, 1975) 106-7.

3 The term Barthes appropriates from Aristotle to denote 'Common Sense, Right Reason, the

Norm, General Opinion'.

4 Repetition as a mode of spectatorship was established early in the history of cinema, in the 'continuous programming' that allowed spectators to remain in their seats as the programme of (typically) newsreel, 'short' and main-feature recycled. See Annette Kuhn, *An Everyday Magic: Cinema and Cultural Memory* (London: I.B. Tauris, 2002) 224–5. We may also think of typical forms of television spectatorship, with the broadcast film interrupted by such things as commercial breaks, telephone calls and visits to the kitchen.

5 Victor Burgin, *In/Different Spaces: place and memory in visual culture* (Berkeley and Los Angeles: University of California Press, 1996) 22–3.

6 Michel Foucault, 'Of Other Spaces', *Diacritics*, vol. 16, no. 1. Foucault's suggestive essay 'Des Espaces Autres' was originally given as a lecture in 1967 and he did not subsequently review it for publication. Many of the ideas in it remain undeveloped, and my own use of them here is partial.

7 Roland Barthes, *Le plaisir du texte* (Paris: Seuil, 1973) 67, my translation.

8 Arthur Schnitzler, *Dream Story* (1926) (London: Penguin, 1999).

9 Marie-Claude Taranger, 'Une mémoire de seconde main? Film, emprunt et référence dans le récit de vie', *Hors Cadre*, 9, 1991.

10 Ibid. 55–6.

11 In the most common type of screen memory discussed by Freud an early memory is concealed by the memory of a later event. It is possible for an earlier memory to screen a later one. Freud also remarks on a third type, 'in which the screen memory is connected with the impression that it screens not only by its content but also by contiguity in time: these are contemporary or contiguous screen memories'. Sigmund Freud, *The Psychopathology of Everyday Life* (1901), *The Standard Edition of the Complete Psychological Works of Sigmund Freud*, vol. 6 (London: The Hogarth Press/Institute of Psychoanalysis, 1955–74) 44.

12 What I characterize here as 'brilliance' is a characteristic of the 'psychical intensity' of the 'screen memory'. [See the Editor's Appendix, *Standard Edition*, vol. 3, 66 ff. for a discussion of Freud's use of the expression 'psychical intensity', and Freud's essay 'Screen Memories' (1899), *The Standard Edition of the Complete Psychological Works of Sigmund Freud*, vol. 3, London: The Hogarth Press/Institute of Psychoanalysis, 1955–74) 311–12.

13 Bernard Stiegler, *Philosopher par accident* (Paris: Galilée, 2004) 59–60.

14 Bernard Stiegler, *Aimer, s'aimer, nous aimer: du 11 septembre au 21 avril* (Paris: Galilée, 2003) 53.

15 Bernard Stiegler, *De la misère symbolique: 1. L'époque hyperindustrielle* (Paris: Galilée, 2004) 51.

16 Ibid., 41.

17 Bernard Stiegler, *Philosopher par accident*, op. cit., 85.

18 Catherine Wimphen, 'Entretien avec Agnès Jaoui et Jean-Pierre Bacri', http://perso.wanadoo.fr /camera-one/chanson/html/int1.htm (Jaoui's examples are: 'Après la pluie, le beau temps', 'Dans la vie faut pas s'en faire'.)

19 Bernard Stiegler, *De la misère symbolique*, op. cit., 2004, 52–3.

20 Bernard Stiegler, *De la misère symbolique*, op. cit., 69.

21 Félix Guatarri, 'The Three Ecologies', *New Formations*, no. 8 (Summer 1989) 138. (Félix Guattari,

Les trois écologies, Paris, Galilée, 1989.)

22 Bernard Stiegler, *Philosopher par accident*, op. cit., 74.

23 Gilles Deleuze, *Pourparlers* (Paris: Minuit, 1990).

24 Laura Mulvey, 'Aberrant movement: between film frame and film fiction', unpublished conference paper, 2004.

25 Laura Mulvey, *Death 24x a Second* (London: Reaktion, 2006) 171.

26 Laura Mulvey, 'The pensive spectator revisited: time and its passing in the still and moving image', in David Green, ed., *Where is the Photograph?*, Photoworks/Photoforum, 2003.

27 Raymond Bellour, 'The Pensive Spectator', *Wide Angle*, vol. 9, no. 1 (1987) 10. (We may here recall Roland Barthes' remark that the film is illusion, whereas the photograph is hallucination.)

28 Colin MacCabe, *Godard: a portrait of the artist at 70* (London: Bloomsbury, 2003) 301.

29 Ibid., 302.

30 Jacques Rancière, *Chroniques des Temps Consensuels* (Paris: Seuil, 2005) 198.

Victor Burgin, 'Possessive, Pensive and Possessed', revised version of essay from David Green and Joanna Lowry, eds., *Stillness and Time: Photography and the Moving Image* (Brighton: Photoworks/Photoforum 2006), 165–76.

Biographical Notes

Chantal Akerman is a Belgian film director and artist based in Paris. Her films include *Saute ma ville* (1968), *Hotel Monterrey* (1973), *Je, tu, il, elle* (1974), *Jeanne Dielmann, 23 quai du Commerce, 1080 Bruxelles* (1975) and *Sud* (*South*, 1998). She has exhibited video installations since 1998 (Frith Street Gallery, London) and was included in the 49th Venice Biennale (2001) and Documenta 11, Kassel (2002).

Jean Baudrillard is a French cultural and social theorist, philosopher and photographer. His works include *Le système des objets* (1968), *Pour une critique de l'économie du signe* (1972; *For a Critique of the Political Economy of the Sign*, 1981), *Simulacres et simulations* (1981; *Simulations*, 1983), *Cool Memories* (1987), *The Gulf War Did Not Take Place* (1991), *The Conspiracy of Art* (2005) and *Photographs 1985–1998* (1999).

Raymond Bellour is a French critic and theorist of cinema and literature who has also written extensively on and curated contemporary video work. In 1963 he founded the cinema journal *Artsept* and is now co-editor of the journal *Trafic*. His essays on film and video are collected in *L'Entre-image: Photo, cinéma, vidéo* (1990) and *L'Entre-image 2: Mots, images* (1999). He is Director of Research at the Centre National de Recherches Scientifiques, Paris.

Anton Giulio Bragaglia (1890–1960) was an Italian theorist of Futurist aesthetics and performance, filmmaker, theatre designer and photographer. His writings include *Fotodinamismo Futurista* (1912). In 1917 he produced the Futurist film *Il perfido incanto* (*The Wicked Enchantment*).

Victor Burgin is a British artist and writer on the filmic and photographic in contemporary culture. Retrospectives include Fundacío Antoni Tàpies, Barcelona (2001). His books include *In/different Spaces: Place and Memory in Visual Culture* (1996) and *The Remembered Film* (2004).

Henri Cartier-Bresson (1908–2004) was a French photographer and painter who greatly influenced the development of both photojournalism and genres such as street photography. In 1947 he co-founded the first photojournalists' cooperative picture agency, Magnum Photos. Retrospectives include Bibliothèque Nationale, Paris (international tour, 2003–5).

Gregory Crewdson is an American artist whose intensively constructed tableaux and scenarios generate a dialogue between effects such as the uncanny conveyed by arrested moments in cinema and photography. Solo exhibitions include Fotomuseum Winterthur (2006), Kunstverein Hannover (2005) and SITE Santa Fe (2001).

Catherine David is a French curator and art historian based in Berlin. Formerly curator at the Musée national d'art moderne, Centre Georges Pompidou (1981–90) and the Galerie nationale du Jeu de Paume, Paris (1990–94), in 1997 she curated Documenta X, Kassel, and was Director of Witte de With, Rotterdam (2002–6).

Gilles Deleuze (1925–95) was a French philosopher influential both for his work on Bergson, Kant, Leibniz, Spinoza and Foucault and his co-authored studies with Félix Guattari such as *Capitalisme et schizophrénie* (vol. 1, 1972; vol. 2, 1980). His writing also encompassed the visual fields of painting (*Francis Bacon: Logique de la sensation*, 1981; trans. 2003) and film (*Cinéma 1: L'Image-mouvement*, 1983; trans. 1986 and *Cinéma 2: L'Image-temps*, 1985; trans. 1989).

Régis Durand is a French curator, critic and historian of photography. Director of the Centre National de la Photographie, Paris, he is the author of *Essais sur l'expérience photographique* (3 vols: *La Part de l'ombre*, 1990; *Disparitées*, 2002; *L'Excés et le reste*, 2006), *Le Temps de l'image* (1995) and *Le Regard pensif: Lieux et Objets de la photographie* (2002).

Thierry de Duve is a Belgian art historian, critic and curator whose work focuses on the philosophical and pedagogical implications of developments in art and visual discourse from Duchamp onwards. His books include *Pictorial Nominalism: On Duchamp's Passage from Painting to the Readymade* (1991) and *Kant after Duchamp* (1998).

Sergei Eisenstein (1898–1948), the Soviet director and theorist of film, was particularly influential on cinema in the 1920s and 30s due to his innovative theoretical analysis and use of montage in silent films such as *Strike* (1925), *Battleship Potemkin* (1925) and *October* (1927).

Mike Figgis is a British film director, writer and composer. His experience of directing at Hollywood studios from 1988 culminated in *Leaving Las Vegas* (1995). Since the innovative digital video film *Timecode* (2000), he has focused in a number of works on the use of new technologies to explore filmic experiences of time.

Susanne Gaensheimer is curator of the collection of the Städtische Galerie im Lenbachhaus, Munich. Among the published monographs to which she has contributed are *Thomas Demand. New Work* (2002) and *James Coleman* (2002).

Nan Goldin is an American photographer whose work from the early 1970s onwards has taken the form of an intimate visual diary, such as *The Ballad of Sexual Dependency* (1980–86), originally projected as an ongoing slide sequence in nightclubs with records selected as soundtracks. Retrospectives include Musée national d'art moderne, Centre Georges Pompidou, Paris (2002).

Tom Gunning is a distinguished historian of early cinema and of film culture. The author of *D.W. Griffith and the Origin of American Narrative Film* (1991) and co-author of *An Invention of the Devil? Religion and Early Cinema* (1992), he is Professor of Art History, Cinema and Media Studies at the University of Chicago.

Anna Holtzman is a New York-based artist, journalist and filmmaker. Her first film is *Subway Dreams* (2006).

Chris Marker is a French filmmaker who studied philosophy under Jean-Paul Sartre before making his first political and anticolonial films in the early 1950s. His most influential work includes *La Jetée* (1962), *Sans Soleil* (1983), *Level 5* (1996) and *IMMEMORY* (1998). His video installation *Owls at Noon* was shown at The Museum of Modern Art, New York, in 2005.

Jonas Mekas is a Lithuanian-born filmmaker and writer on film based in New York since the 1950s, where he became a catalyst and spokesperson for American avant-garde cinema. He originated *Film Quarterly* magazine (1954), the *Village Voice* 'Movie Journal' column from 1958, and co-founded the Filmmakers' Cooperative (1962) and Anthology Film Archives, New York (1970).

Christian Metz (1931–93) was a French film critic and theorist. His books include *Essais sur la signification au cinéma* (1968; *Film Language: A Semiotics of the Cinema*, 1974) and *Le Signifiant imaginaire: psychanalyse et cinéma* (1977; *The Imaginary Signifier: Psychoanalysis and the Cinema*, 1986).

Laura Mulvey is a British theorist of film and experimental filmmaker whose key texts include 'Visual and Narrative Pleasure' (1973) and the essays collected in *Visual and Other Pleasures* (1989) and *Death 24x a Second: Stillness and the Moving Image* (2006). She is Professor of Film and Media Studies at Birkbeck College, London.

László Moholy-Nagy (1895–1946) was a Hungarian-born artist associated with Constructivism from 1919 and then the Bauhaus school, where he taught and practised 1923–28 in the fields of photography, painting, sculpture, film, graphic and industrial design. In 1937 he moved to Chicago after two years in London and in 1939 opened the School (from 1944, Institute) of Design at Illinois Institute of Technology.

Beaumont Newhall (1908–93) was an art historian, curator and photographer, whose 1937 exhibition and catalogue *The History of Photography* at the Museum of Modern Art, New York inaugurated its photography collection. From 1940 he was the first director of its photography department. From 1948–58 he was curator, then from 1958–71 director of the International Museum of Photography at George Eastman House, Rochester, New York.

Uriel Orlow is a Swiss-born artist and writer based in London, whose work investigates the way experience is mediated through archives, libraries, language and other systems. His projects addressing the problematic of making art as a means to produce remembrance of the Holocaust are collected and discussed in the monograph *Deposits* (2006).

Pier Paolo Pasolini (1922–75) was a filmmaker, artist and intellectual whose writings against the grain of the prevailing structuralism, such as 'Cinema as Poetry' (in *Empirismo eretico*, 1972) anticipated the later work of Deleuze. In films such as *Accatone* (1961) he eschewed such devices as close-ups, using techniques such as long shots and slow pans to distance and 'contaminate' prevailing cinematic conventions.

Constance Penley is a feminist scholar of film and contemporary visual media. Her books include *Feminism and Film Theory* (1988) and, with Raymond Bellour, *The Analysis of Film* (2002). She is Professor of Film Studies and Director of the Center for Film, Television and New Media, University of California at Santa Barbara.

Richard Prince is an American artist whose early work of the late 1970s introduced the rephotography of existing photographs from advertising posters and other found sources. Retrospectives include the Whitney Museum of American Art, New York (1992). Selected works can be viewed online at his website www.richardprinceart.com

Steve Reich is an American composer who was among the pioneers of process music and Minimalist composition in the mid 1960s. Many of his pieces use multiple tape loops of recorded sound or speech elements, played in and out of phase, with segments cut and rearranged. Various experiences of speed or slowness of duration are an important aspect of his work.

Carlo Rim (Jean-Marius Richard, 1905–89) was a script writer and scene director for French cinema from 1934 (*Zouzou*) until the early 1960s when he moved into television. Originally a cartoonist, he worked as a journalist in the early 1930s. He became chief editor of *Vu* in 1931 and of *L'Intransigeant* in 1933.

Miriam Rosen is a film critic and writer based in Paris. Film seasons she has curated include the 1991

Maghreb section of Moroccan, Tunisian and Algerian cinema at Filmfest DC, Washington.

Susan Sontag (1933–2004), the American essayist, writer and intellectual, published *On Photography* in 1977. Her essays, often first published in *The New Yorker* or literary periodicals, are collected in *Against Interpretation* (1966), *Styles of Radical Will* (1969), *Under the Sign of Saturn* (1980) and *Where the Stress Falls* (2001).

Blake Stimson teaches art history and critical theory at the University of California, Davis. He is the co-editor with Alexander Alberro of *Conceptual Art: A Critical Anthology* (2000) and the author of *The Pivot of the World: Photography and Its Nation* (2006), a study of three projects that emerged in the 1950s: *The Family of Man*, Robert Frank's *The Americans*, and Bernd and Hilla Bechers' typological document of industrial architecture.

Michael Tarantino (1948–2003) was an American curator of contemporary art whose background in cinema studies enabled him to be a pioneer in exhibiting video works and creating dialogues, in group exhibitions and writings, between cinema and contemporary art. In 1988 he moved from Boston, Massachusetts, to Belgium. He was head of exhibitions at the Museum of Modern Art, Oxford, from 1998 to 2001.

Agnès Varda is a French film director based in Paris who was among the founders of new wave cinema. *Cléo de 5 à 7* (1962) explores existential problems through the documentation of two hours in the life of a young pop singer, Cléo, awaiting the results of a biopsy. Other notable films include *Vagabond* (1985) and *Les Glaneurs et la glaneuse* (*The Gleaners*, 2000).

Jeff Wall is a Canadian artist based in Vancouver whose work since the 1970s has explored dialogues between photography and pictorial narrative in painting and cinema. Solo exhibitions include Galerie nationale du Jeu de Paume, Paris (1995), Whitechapel Gallery, London (1998), Museum für Moderne Kunst, Frankfurt am Main (2001), Schaulager, Basel; Tate Modern, London (2005).

Wim Wenders is a German film director, photographer and writer on cinema. His films include *Die Angst des Tormanns beim Elfmeter* (*The Goalkeeper's Fear of the Penalty*, 1972), *Alice in den Städten* (*Alice in the Cities*, 1974), *Paris, Texas* (1984) and a collaboration with other film directors exploring time, *Ten Minutes Older* (2002).

Peter Wollen is a film theorist, filmmaker and writer on art, culture and politics. In film studies his key work is *Signs and Meaning in the Cinema* (1969). His films include *Penthesilea: Queen of the Amazons* (1974) and *Riddles of the Sphinx* (1977), both co-directed with Laura Mulvey, and *Friendship's Death* (1987). His writings on art are collected in *Paris Manhattan* (2004).

Bibliography

Andrew, Dudley, ed, *The Image in Dispute: Art and Cinema in the Age of Photography*, University of Texas Press, Austin, 1997

Baetens, Jan, *Le Roman-photo*, Les Impressions Nouvelles, Paris and Brussels, 1994

Barthes, Roland, *Mythologies*, Éditions du Seuil, Paris, 1957; trans. Annette Lavers, Hill & Wang, New York, 1972

Barthes, Roland, *Image-Music-Text*, trans. Stephen Heath, Hill & Wang, New York/Fontana, London, 1977

Baudrillard, Jean, *Cool Memories II, 1987–1990*, Duke University Press, Durham, North Carolina, 1996

Bazin, André, 'The Ontology of the Photographic Image', *What is Cinema?* vol. 1, ed. and trans. Hugh Gray, University of California Press, Berkeley and Los Angeles, 1967

Bellour, Raymond, ed., *Le Temps d'un mouvement: Aventures et mésaventures de l'instant photographique*, Centre National de la Photographie, Paris, 1986

Bellour, Raymond, *L'Entre-image: Photo, cinéma, vidéo*, La Difference, Paris, 1990

Bellour, Raymond, 'The Film Stilled', *Camera Obscura*, no. 24, 1991

Bellour, Raymond 'The Pensive Spectator', *Wide Angle*, vol. 9, no. 1, 1987

Benjamin, Walter, *Illuminations*, ed. Hannah Arendt, Jonathan Cape, London, 1970

Bozovic, Miran, 'The Man Behind His Own Retina' in Slavoj Zizek, ed., *Everything You Always Wanted to Know about Lacan, but Were Afraid to ask Hitchcock*, Verso, London and New York, 1992

Bragaglia, Anton Giulio, *Fotodinamismo futurista*, Natala Editore, Rome, 1913

Brodovitch, *Ballet*, J.J. Augustin, New York, 1945

Brougher, Kerry, ed., *Hall of Mirrors; Art and Film since 1945*, The Museum of Contemporary Art, Los Angeles, 1996

Brougher, Kerry, ed., *Notorious: Alfred Hitchcock and Contemporary Art*, Museum of Modern Art, Oxford, 1999

Burgin, Victor, *Shadowed*, Architectural Association, London, 2001

Burgin, Victor, *Between*, Institute of Contemporary Arts, London/Blackwell, Oxford, 1986

Burgin, Victor, *The Remembered Film*, Reaktion, London, 2005

Burri, René; Maselli, Francesco; Girard, Thierry, eds., *La Photo fait du Cinéma*, Centre National de la Photographie, Paris, 1985

Campany, David, 'Once more for Stills' in Christoph Schifferli, ed., *Paper Dreams: The Lost Art of Hollywood Stills Photography*, Steidl, 2006

Campany, David, *Photography and Cinema*, Reaktion, London, 2007

Cartier-Bresson, Henri, *The Decisive Moment*, Simon & Schuster, New York, 1952

Cavell, Stanley, *The World Viewed*, Viking Press, New York, 1971

Crewdson, Gregory, interview with Anna Holtzman, *Eyemazing*, issue 3, August 2006. www.eyemazing.info

David, Catherine, 'Photography and Cinema', trans. Joy Fischer, in *Die Photographie in der Zeitgenössischen Kunst. Eine Veranstaltung der Akademie Schloss Solitude. 6/7 Dezember 1989*,

Edition Cantz, Ostfildern-Ruit, 1990

de Duve, Thierry 'Time Exposure and Snapshot: the Photograph as Paradox', *October*, no. 5, Summer 1978

Deleuze, Gilles, *Cinema 1: The Movement-Image; Cinema 2: The Time-Image*, 2 vols, Athlone Press, London, trans. 1986; 1989

Divola, John, *Continuity*, Ram Publications, Los Angeles, 1998

Doane, Mary Anne. 'The Close-up: Scale and detail in the cinema', *Differences: A Journal of Feminist Cultural Studies*, vol. 14, no.3, Fall 2003

Doane, Mary Anne, *The Emergence of Cinematic Time: Modernity, Contingency, the Archive*, The MIT Press, Cambridge, Massachusetts, 1999

Dudley, Andrew, ed., *The Image in Dispute: Art and Cinema in the Age of Photography*, University of Texas Press, Austin, 1977

Durand, Régis, 'Cindy Sherman: le caméléonisme mélancolique des *Film Stills*/Cindy Sherman: The Melancholy Chameleonism of the *Film Stills*', *Art Press*, Paris, February 1996

Durden, Mark, 'Defining the Moment', *Creative Camera*, no. 350, February/March 1998

Eisenstein, Sergei, *Film Form*, Harcourt Brace, New York, 1949

Folie, Sabine; Glasmeier, Michael, *Tableaux Vivants. Lebende Bilder und Attituden in Fotografie, Film und Video*, Kunsthalle Wien, 2002

Frampton, Hollis, *Circles of Confusion. Film, Photography, Video. Texts 1968–80*, The MIT Press, Cambridge, Massachusetts, 1984

Frank, Robert, *The Americans*, Grove Press, New York, 1959

Gidal, Peter, *Structural Film Anthology*, British Film Institute, London, 1976

Green, David, ed., *Where is the Photograph?*, Photoforum/Photoworks, Brighton, England, 2004

Green, David; Lowry, Joanna, eds., *Stillness and Time: Photography and the Moving Image*, Photoforum/Photoworks, Brighton, England, 2006

Greenough, Sarah; Brookman, Philip, *Robert Frank: Moving Out*, National Gallery of Art, Washington, DC, 1994

Heiferman, Marvin; Keaton, Diane, *Still Life*, Fireside, New York, 1983

Hollander, Anne, *Moving Pictures*, Alfred A. Knopf, New York, 1989

Horak, Jan-Christopher, *Making Images Move: Photographers and Avant-garde Cinema*, Smithsonian Institution, Washington, DC, 1997

Hürlimann, Annemarie; Müller, Alois Martin, eds., *Film Stills. Emotions Made in Hollywood*, Edition Cantz/Museum fur Gestaltung, Zürich, 1993

Huss, Roy, ed., *Focus on* Blow-Up, Spectrum/Prentice Hall, New York, 1971

Gaensheimer, Susanne, 'Moments in Time: On narration and slowness in the works of James Coleman, Tacita Dean, Stan Douglas, Douglas Gordon, Steve McQueen, Bruce Nauman, Rosemarie Trockel and Bill Viola', in *Moments in Time: On Narration and Slowness*, ed. Helmut Friedel, Städtische Galerie im Lenbachhaus/Kunstbau München, Munich/Hatje Cantz Verlag, Ostfildern-Ruit, 1999

Gunning, Tom, 'A Cinema of Attractions: Early Film, Its Spectator and the Avant-Garde', *Wide Angle*,

vol. 8, no. 3–4, 1985

Gunning, Tom, 'Never Seen This Picture Before: Muybridge in Multiplicity' in Phillip Prodger, ed., *Time Stands Still: Muybridge and the Instantaneous Photography Movement*, The Iris B. Gerald Cantor Center For Visual Arts/Oxford University Press, New York, 2003

Kozloff, Max, 'Through the Narrative Portal', *Artforum*, vol. 24, no. 8, April 1986

Kracauer, Siegfried, *The Mass Ornament: Weimar Essays*, Harvard University Press, Cambridge, Massachusetts, 1995

Leighton, Tanya; Buchler, Pavel, eds., *Saving the Image: Art after Film*, Centre for Contemporary Arts Glasgow/Manchester Metropolitan University, 2003

Marder, Elsa, 'Blade Runner's Moving Still', in *Camera Obscura*, no. 27, September 1991

Meadows, Daniel, *Set Pieces: being about film stills, mostly*, British Film Institute, London, 1994

Mekas, Jonas, *Movie Journal: The Rise of the New American Cinema 1959–1971*, Collier Books, New York, 1972

Mellor, David, *Germany: The New Photography 1927–33*, Arts Council of Great Britain, London, 1978

Metz, Christian, 'Photography and Fetish', *October*, no. 34, Fall 1985

Moholy-Nagy, László, *Vision in Motion*, Institute of Design, Chicago, 1947

Moholy-Nagy, László, *Painting, Photography, Film* (1925), The MIT Press, Cambridge, Massachusetts, 1969

Moore, Rachel, *Hollis Frampton: (nostalgia)*, Afterall Boooks/The MIT Press, Cambridge, Massachusetts, 2006

Mulvey, Laura, *Death 24x a Second: Stillness and the Moving Image*, Reaktion, London, 2006

Newhall, Beaumont, *Photography: A Short Critical History*, The Museum of Modern Art, New York, 1937

Olivares, Rosa, ed., *EXIT*, no. 3, *Fuera de escena/Off Screen*, Olivares & Associated, Salamanca, Spain, 2001

Orlow, Uriel, 'Photography as cinema: *La Jetée* and the redemptive powers of the image', *Creative Camera*, no. 359, August/September, 1999

Pasolini, Pier Paolo, 'Observations on the Long Take', *October*, no. 13, 1980

Pauli, Lori, ed., *Acting the Part: Photography as Theatre*, National Gallery of Canada, Ottawa/Merrell, London, 2006

Penley, Constance, 'The Imaginary of the Photograph in Film Theory', *Photographies*, no. 4, April 1984

Petro, Patrice, ed., *Fugitive Images: From Photography to Video*, Indiana University Press, 1994

Phillips, Christopher, ed., *Photography in the Modern Era: European Documents and Critical Writings 1913–1940*, Metropolitan Museum of Art/Aperture, New York, 1989

Pollock, Griselda, 'Dreaming the Face, Screening the Death: Reflections for Jean-Louis Schefer on *La Jetée*', *Journal of Visual Culture*, vol. 4, no. 3, 2005

Prince, Richard, *Why I Go to the Movies Alone*, Tanam Press, New York, 1983; second printing, Barbara Gladstone Gallery, New York, 1993, 55–7.

Rim, Carlo, 'De l'instantané', *L'Art vivant*, no. 137, Paris, 1 September 1930

Rosen, Miriam, 'In Her Own Time: An Interview with Chantal Akerman', translated from French by Jeanine Herman, *Artforum*, April 2004

Ruiz, Raúl, *Poetics of Cinema*, Dis Voir, Paris, 1995

Ryan, Marie-Laure, *Narrative across Media: The Language of Storytelling*, University of Nebraska Press, 2004

Scott, Clive, *The Spoken Image: Photography and Language*, Reaktion, 1999

Sherman, Cindy, *Complete Untitled Film Stills*, The Museum of Modern Art, New York, 2003

Silverman, Kaja, 'Back to the Future', *Camera Obscura*, no. 27, September 1991

Silverman, Kaja, *The Threshold of the Visible World*, Routledge, London and New York, 1995

Sitney, P. Adams, *Visionary Film*, Oxford University Press, New York, 1974

Snow, Michael, *The Michael Snow Project. Presence and Absence. The Films of Michael Snow 1956–1991*, Art Gallery of Ontario, Toronto, 1995

Stewart, Garrett, 'Photogravure: Death, Photography and Film Narrative', *Wide Angle*, vol. 9, no.1, 1987

Stewart, Garrett, *Between Film and Screen: Modernism's Photo Synthesis*, University of Chicago Press, 1999

Stezaker, John, *Fragments*, The Photographers' Gallery, London, 1978

Stimson, Blake, *The Pivot of the World: Photography and its Nation*, The MIT Press, Cambridge, Massachusetts, 2006

Sutcliffe, Thomas, 'Freeze Frame', in *Watching*, Faber & Faber, London, 2000

Tabrizian, Mitra, *Beyond the Limits*, Steidl verlag, Göttingen, 2004

Tarantino, Michael, 'A Few Brief Moments of Cinematic Time', in *Moments in Time: On Narration and Slowness*, ed. Helmut Friedel, Städtische Galerie im Lenbachhaus und Kunstbau München, Munich/Hatje Cantz Verlag, Ostfildern-Ruit, 1999

Varda, Agnès, response to '3 Questions sur: Photo et Cinéma', *Photogénies*, no. 5, Centre National de la Photographie, April 1984

Virilio, Paul, *The Vision Machine*, British Film Institute, London, 1994

Wall, Jeff, 'My Photographic Production' (1989), in David Campany, ed., *Art and Photography*, Phaidon Press, London and New York, 2003

Wall, Jeff, 'Cinematography: a prologue', in Rainer Crone, ed., *Stanley Kubrick: Photographs 1945–50*, Phaidon Press, London and New York, 2005

Wall, Jeff; Figgis, Mike, 'An email exchange between Jeff Wall and Mike Figgis', *Contemporary*, no. 65, 2005

Waters, John; Heiferman, Marvin; Phillips, Lisa, *Change of Life*, New Museum of Contemporary Art, New York, 2004

Wiehager, Renate, ed., *Moving Pictures: Photography and Film in Contemporary Art*, Hatje Cantz, Ostfildern-Ruit, 2001

Weinberg, Adam D., ed., *Vanishing Presence*, Walker Art Center, Minneapolis/Rizzoli, New York, 1989

Wenders, Wim, *The Logic of Images*, Faber & Faber, London, 1991

Wollen, Peter, 'Fire and Ice', *Photographies*, no. 4, April 1984

ACKNOWLEDGEMENTS

Editor's acknowledgements
The assembly of this anthology was shaped by conversations over the last few years with many people. Among them are David Bate, Victor Burgin, Shez Dawood, David Evans, David Green, Mark Haworth-Booth, Sophie Howarth, Joanna Lowry, Mark Lewis, Laura Mulvey, Michael Newman, Uriel Orlow, John Stezaker and Jeff Wall. Thanks to the University of Westminster for granting me research time and thanks above all to the filmmakers, photographers, artists and writers who have granted the reprinting of their texts here.

Publisher's acknowledgements
Whitechapel is grateful to all those who gave their generous permission to reproduce the listed material. Every effort has been made to secure all permissions and we apologize for any inadvertent errors or ommissions. If notified, we will endeavour to correct these at the earliest opportunity.

We would like to express our thanks to all who contributed to the making of this volume, especially: Chantal Akerman, Victor Burgin, Fondation Cartier-Bresson, Gregory Crewdson, Catherine David, Régis Durand, Thierry de Duve, Mike Figgis, Susanne Gaensheimer, Nan Goldin, Tom Gunning, Jonas Mekas, Estate of László Moholy-Nagy, Laura Mulvey, Uriel Orlow, Constance Penley, Richard Prince, Steve Reich, Blake Stimson, Jeff Wall. We also gratefully acknowledge the cooperation of: Argos Films, Paris; *Artforum*, New York; Artists' Rights Society, New York; Carcanet, London; Centro Studi Bragaglia, Rome; Centre National de la Photographie, Paris; Christie's, New York; *Contemporary*, London; Continuum, London; Duke University Press, Durham, North Carolina; *Eyemazing*, Amsterdam; Farrar, Straus & Giroux, New York; Frith Street Gallery, London; Garzanti, Milan; Gladstone Gallery, New York; Harcourt, New York; Brian Holmes, Paris; Städtische Galerie im Lenbachhaus, Munich; Magnum, Paris; Matthew Marks Gallery, New York; Metropolitan Museum of Art, New York; The MIT Press, Cambridge, Massachusetts; The Museum of Modern Art, New York; University School, Ohio; Simon & Schuster, Inc., New York.

Whitechapel Ventures gratefully acknowledges the support of
Venturesome
Whitechapel Gallery is supported by
Arts Council England